Antique Purses

Revised Second Edition

A History, Identification and Value Guide

Richard Holiner

COLLECTOR BOOKS
P.O. Box 3009
Paducah, KY 42002-3009

The current values in this book should be used only as a guide. They are not intended to set prices, which vary from one section of the country to another. Auction prices as well as dealer prices vary greatly and are affected by condition as well as demand. Neither the Author nor the Publisher assumes responsibility for any losses that might be incurred as a result of consulting this guide.

Printed in Singapore — Four Colour Imports, Ltd.

A special thanks to Teresa White for her inspiration and help.

Contents

History

From the earliest times, some type of bag (almoner, pouch, purse, reticule, or handbag), has been carried or worn to contain money, keys and other personal items.

In the middle ages, purses, pouches or bags were usually attached to the belt or girdle. At first a pouch or small bag without metal attachments was used for carrying money. These were susceptible to being cut by thieves. As was the custom for both sexes, the pouch might be visible, hung or slung on or from the belt or might be attached to the belted undertunic for safety and so was not visible on the exterior to attract the notice of thieves. These bags were made of leather, silk, wool or linen and were often embroidered, fringed or tasselled. They were known by various names: the almoner, worn by nobles or used especially for alms; the gipser; the script or wallet or merely purse, pouch or bag.

In Europe, for long periods such containers were superfluous because the dress itself was so bulky that it was easy to insert many pockets which would hold all such valuable and personal items. These periods included much of the sixteenth, seventeeth and eighteenth centuries and then the nineteenth century from about 1835 forward. Bags and purses are to be seen in dress especially from the 1780s to 1830s and into the twentieth century.

In the later eighteenth century, the bag was received since the dress for both men and women was fitting and slender. The stocking purse was popular, a long knitted purse which had a good capacity. For ladies the reticule was fashionable, especially in the late 1700s and early 1800s. These were attached to a ladies belt or waistband by a brooch. Later this brooch became a decorative silver or gold pin with hooked ends called chatelaines on which the bags were hung. Reticules were dainty, made of delicate fabrics such as velvet, silk or satin and were embroidered or beaded. The top was often gathered with a draw cord and usually contained handkerchief, perfume bottle, a fan and a purse. Chatelaines later evolved into having four or more linked chains with swivel ends made to hold such items as keys, charms, sewing items and small mesh bags. Chatelaines usually were made for the dance with a program, fan or mirror attached. Some were made for household use with a pair of scissors, datebook, thimble, keys or other items which the lady of the house would find useful in her everyday chores. After the first World War in the 1920s with the reversion to a more slender silhouette, the handbag came into its own. The American woman was entering the jazz age; her dress took on a completely new look and the small beaded bag and mesh bag became an important accessory to her attire. For evening wear, a more expensive bag was usually imported from Europe with frames of sterling silver or gold set with semi-precious stones. Many of the beaded purses were made at home from kits containing directions, thread and many colored beads. They could be purchased inexpensively compared to the price of the finished purse.

In the succeeding years, styles or designs changed from the beaded bags and flat metal mesh envelope bags in the 1920s and early 1930s to shoulder bags in the 1940s to zip-fashioned box-shaped to a tremendous variety in forms by the 1960-1970s. In the twentieth century, there have been purse and handbag designs too numerous to mention, made specifically for certain occasions and functions. The evening bag of gold, silver or brocade, the beachbag, the shopping bag, the casual bag, the smart town bag, etc. Interior fittings have become more important with compartments for mirror, comb, lipstick, purse or wallet, compact or cigarettes.

We will go into further detail about the flat metal mesh envelope bag because they make up a large part of this collection. Mesh bags were fashionable in the late 1800s and continued in popularity into the 1930s. In the 1890s mesh purses with silver, rolled gold or gilded tops and necks of mesh metal bars that opened and closed in an accordian manner were being offered. Most of these were smaller and attached to them was a chain and ring by which they could be fastened to chatelaines. There were also mesh hand purses with snap tops. At the turn of the twentieth century, soldered mesh and sterling silver mesh purses were becoming popular. Sometime before World War I in both Europe and America, fine mesh metal bags could be found everywhere. Sterling and German silver were popular and were used in both frames and mesh. Featured was an opened ring mesh; others were made of a fine baby mesh. Some bags had silver-plated frames and gold trimmings, while most had a snap closure and carrying chain. Some of the frames were embossed with flowers, scrolls or geometric designs, others had a draw-string-type ring mesh. Around 1920, mesh bags started featuring fringed bottoms or tassels. Enameled mesh bags became popular in the late 1920s and into the 1930s. Art Deco designs featuring colorful stripes, flowers and birds were most popular for evening wear.

Most of the mesh bags featured in this collection were made by Whiting & Davis, Plainville, Massachusetts or Mandalian Manufacturing Company, North Attleboro, Massachusetts. Whiting & Davis was founded in 1876 and at that time the firm was known as Wade, Davis & Company. It is the oldest purse company in the United States and is still in business today manufacturing purses and accessories. Mr. C.A. Whiting began working in July

of 1880. By 1896, he and Edward Davis had taken over the firm. By 1907, Mr. Whiting had purchased Mr. Davis' interest.

Whiting & Davis started as a jewelry firm but in 1892, they made the first mesh bag. It was a small, plated and unsoldered bag made completely by hand. The method at this time was to wind the wire in a coil about twelve to fifteen inches long, then put the coil on a steel arbor and saw the entire length of the metal into small sections which would make the rings-a long and costly process thereby limiting production.

In 1908 Whiting & Davis perfected a method of winding long lengths of coiled wire on a spit. The wire was fed into a sawing machine which cut the rings, increasing production greatly. The soldered mesh was made by women workers, linking one link at a time and putting a piece of solder on the joint. Each ring was held in a pair of pliers and soldered in a gas flame "one by one" until the bag was completed. The women could join about 1,000 links a day.

Charles Whiting reminisced in a contemporary newsletter "up to year 1909 we sent the rings to homes where entire families would work at odd times linking the rings together." It was no unusual sight in the summer to ride through the country and see groups of women and girls sitting under the trees in their yards making bags, just as you would see them spending an afternoon sewing.

"This method of manufacture was not only slow, but uncertain and costly. We could not plan on any special production, for women's ways are peculiar and they would work when they felt like it."

In 1912, President Charles Whiting, working with a young inventor, Mr. A.C. Pratt of Sloan & Chase, Newark, New Jersey, developed the first automatic mesh machine. Each machine could produce 400,000 links a day in comparison to 1,000 per day, by hand. The first machine made #1 and #2 mesh. Later new machines were designed and built which could make a size #7 mesh, this being the smallest. Such a mesh bag consisted of wire 9/1000 of an inch and contained as many as 100,000 individual, soldered links. From 1912 to 1925, ring mesh was made by machine, mostly in precious metals. These early bags were made of an extremely fine silk-like ring mesh and were almost exclusively of sterling silver or vermeil (gold plated sterling silver). They were small silk-lined little wrist bags. It's hard to imagine what women put in them. Frames from this era were hand engraved as opposed to "stamped" by machine. Most of the clasps were stone-set with small sapphires. Many of the bags were "special edition" and numbered. Whiting & Davis has informed me that the gem stones (sapphires etc.) used on the frames of their purses, were genuine, not synthetics. Gradually, Charles Whiting

attempted to broaden the appeal and lessen the price by moving into base metals; silver or gold plated brass; copper and nickel-silver. Higher priced bags in interesting combinations of metals in stripes and patterns, combining sterling silver and 1/10 gold-filled were also available. Whiting & Davis continued improving their methods. They introduced bags made of several different colored links, which were reminiscent of Victorian bags - copies of the multi-colored Persian and Indian mesh armor. Most of the bags shown from 1929 to 1932 were patterned by silk screening. The flat mesh took strong lines and patterns. Silk screening on ring mesh took on a soft, hazy, romantic appearance as the edges of the patterns blurred. The silk screening was all done by hand over a period of several days. One color was applied, allowed to dry for at least 24 hours, then the next color was applied.

In 1929, Whiting & Davis produced a huge collection of mesh costume bags designed in conjunction with Paul Poiret, a famous French designer. Both Whiting & Davis and Mandalian stopped making metal mesh envelope-style bags in the middle 1930s. Probably the most important asset that Whiting & Davis has is the large inventory of machines designed for mail mesh and the fact they are the only company in the world with a capacity that comes close to the necessity for modern production.

In 1951, Whiting & Davis made a 21 pound mesh gilt gown for Jane Russell for a scene in the movie *Macao* which co-starred Robert Mitchum. Recently they made a chain mail suit for Ron and Valerie Taylor who are noted for their fifteen years of underwater filming of sharks. Valerie Taylor wore the suit believing that if the steel mesh bonding gloves (which Whiting & Davis makes) protects knife-welding butchers, that the same material would work against shark teeth as well. Whiting & Davis craftsmen welded 150,000 stainless-steel rings into a covering weighing fifteen pounds. The suit was effective. In years past, Whiting & Davis provided bags for the Music Box revue. They made a gold bag for Mrs. Calvin Coolidge who carried it to her husbands inauguration. They made mesh costumes for Cecil B. De Mille's production *The Crusades*. In more recent years, they made costumes for Ingrid Bergman who starred in the film *Joan of Arc*. Aluminum mesh was used to lessen the weight.

Very little was learned about the Mandalian Manufacturing Company other than that it was founded around 1922 and stopped production around 1935. Rumor has it that Whiting & Davis owned Mandalian Manufacturing Company and that it was started to avoid a monopoly anti-trust suit by the government. In the early 1940s, Whiting & Davis obtained all the Mandalian machines.

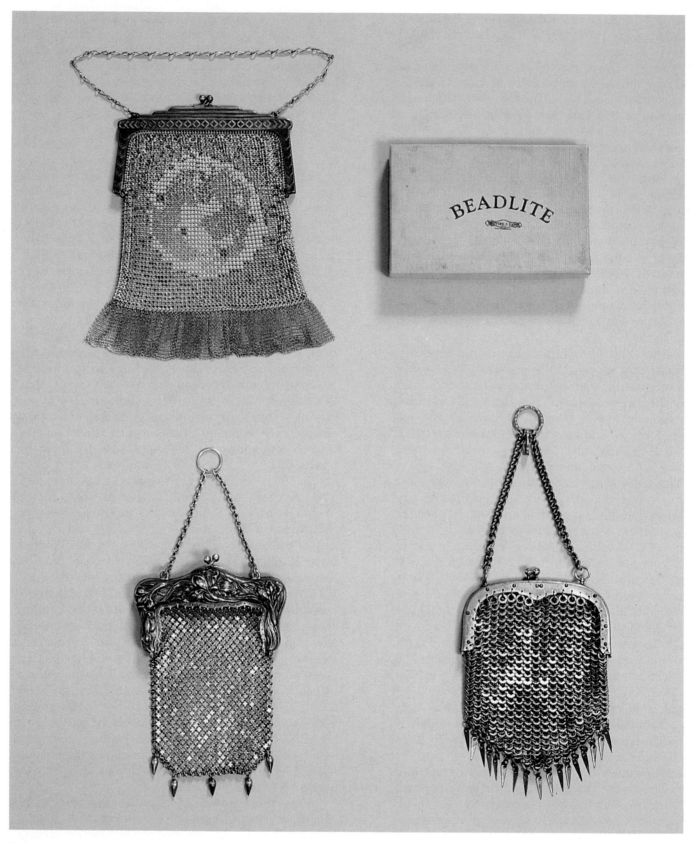

Top Row:
Original Whiting & Davis Bead-lite purse with box

Bottom Row:
Examples of early mesh and frame styles

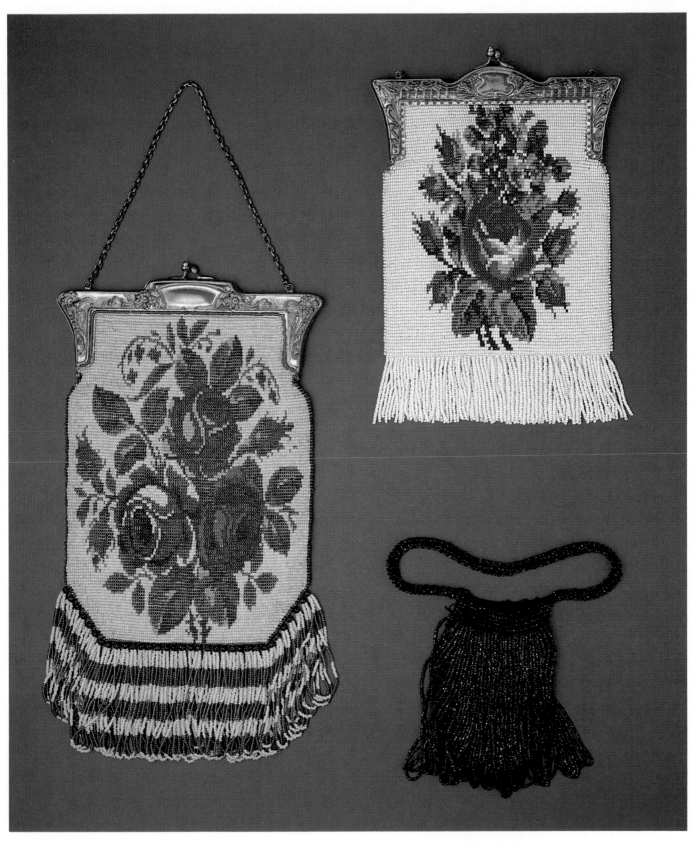

Left Center:
Size - 8″ x 14¼″

Top Right:
Size - 7″ x 10¾″

Bottom Right:
Size - 5¾″ x 3¾″

Beaded

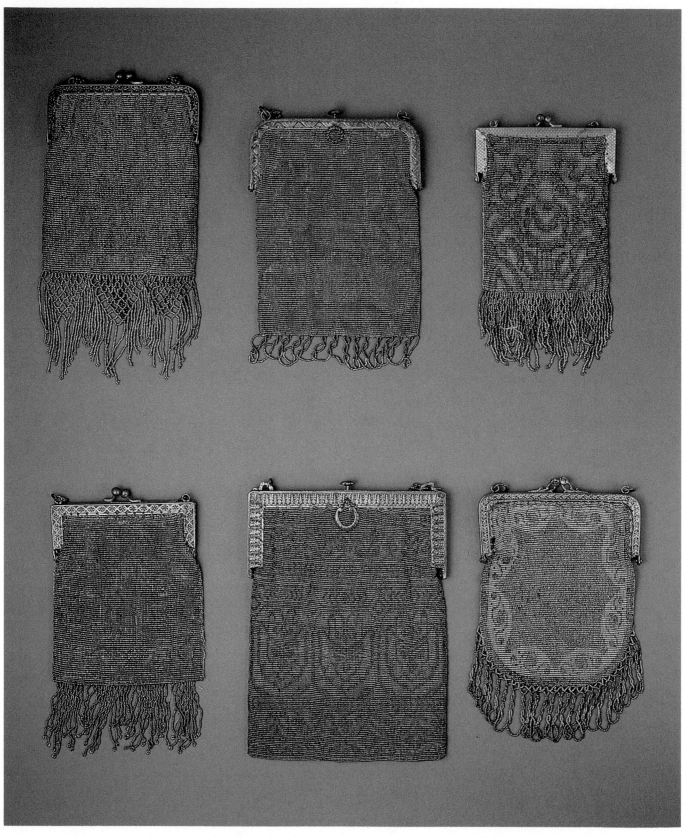

Top Left:
Maker - France
Size - 4¼″ x 9″

Top Center:
Maker - France
Size - 4¾″ x 7¼″

Top Right:
Maker - France
Size - 4″ x 7″

Bottom Left:
Maker - France
Size - 4¼″ x 7¾″

Bottom Center:
Maker - France
Size - 5½″ x 8″

Bottom Right:
Maker - France
Size - 4½″ x 7½″

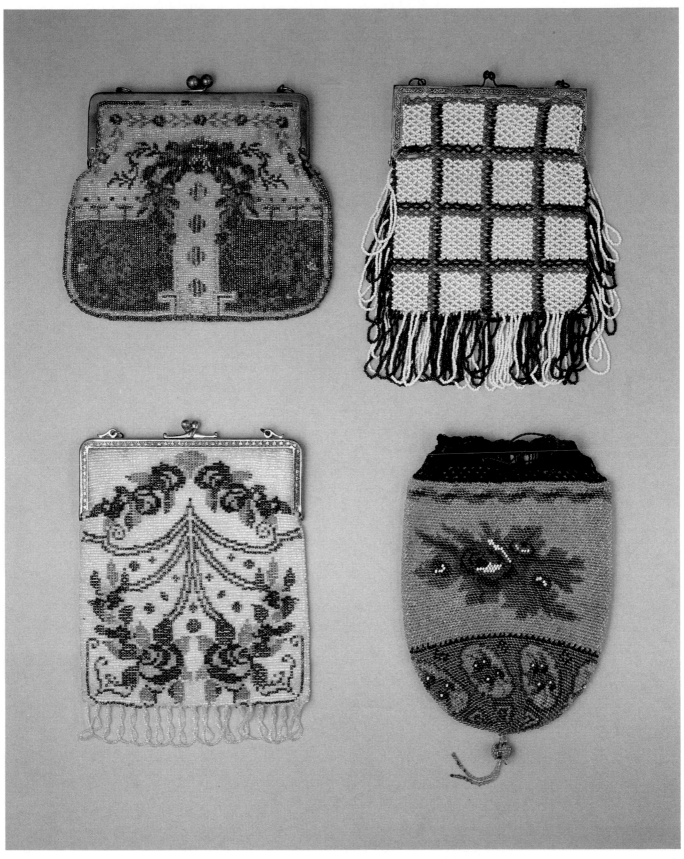

Top Left:
Size - 7¾″ x 7″

Bottom Left:
Maker - Germany
Size - 6¼″ x 9¼″

Top Right:
Maker - Czechoslovakia
Size - 7″ x 9″

Bottom Right:
Size - 6″ x 8¾″

Beaded

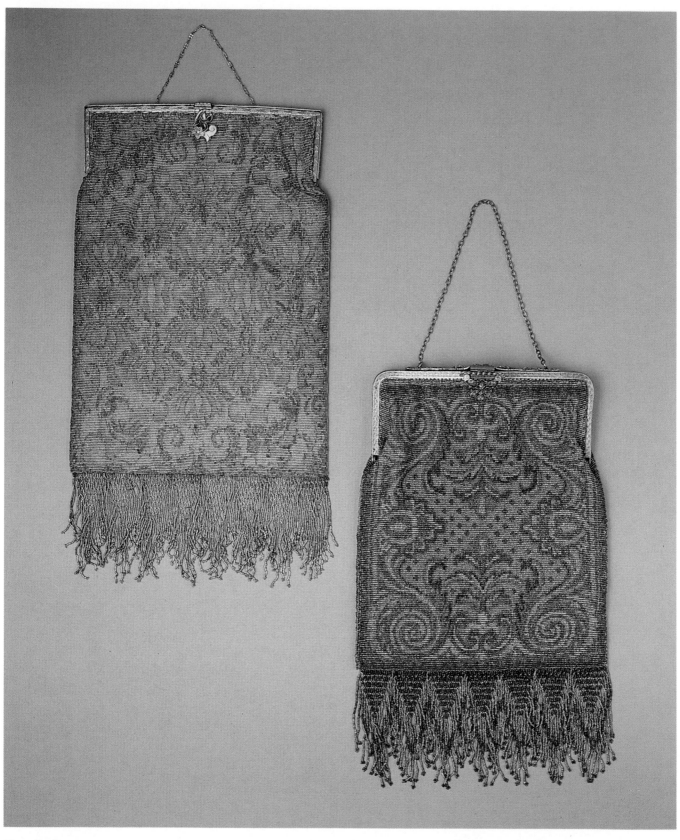

Top Left:
Maker - France
Size - 7½" x 13¾"

Right:
Maker - France
Size - 7¼" x 12"

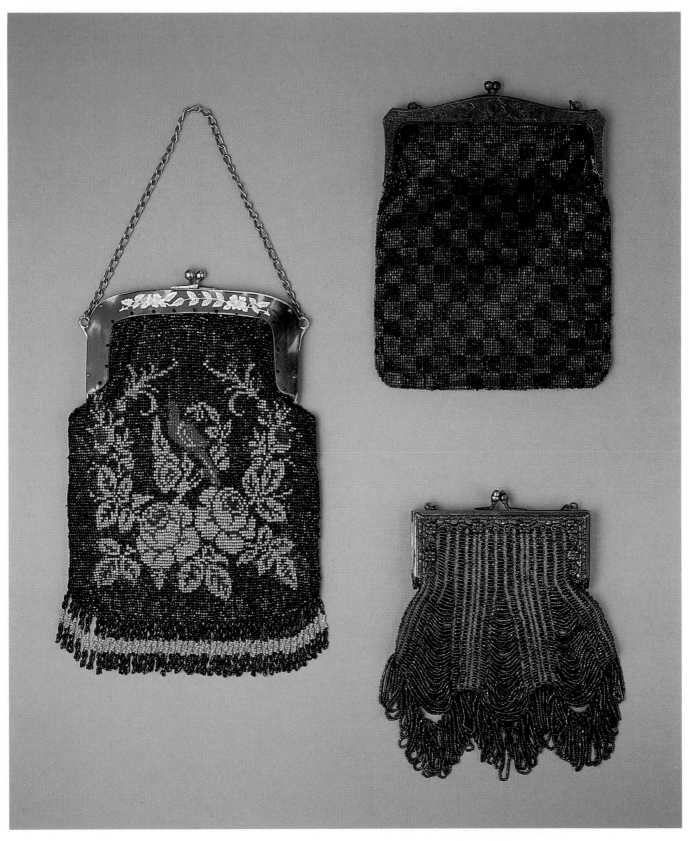

Left Center:
Size - 7½" x 11½"

Top Right:
Size - 6¾" x 8¾"

Bottom Right:
Size - 7" x 8¼"

Beaded

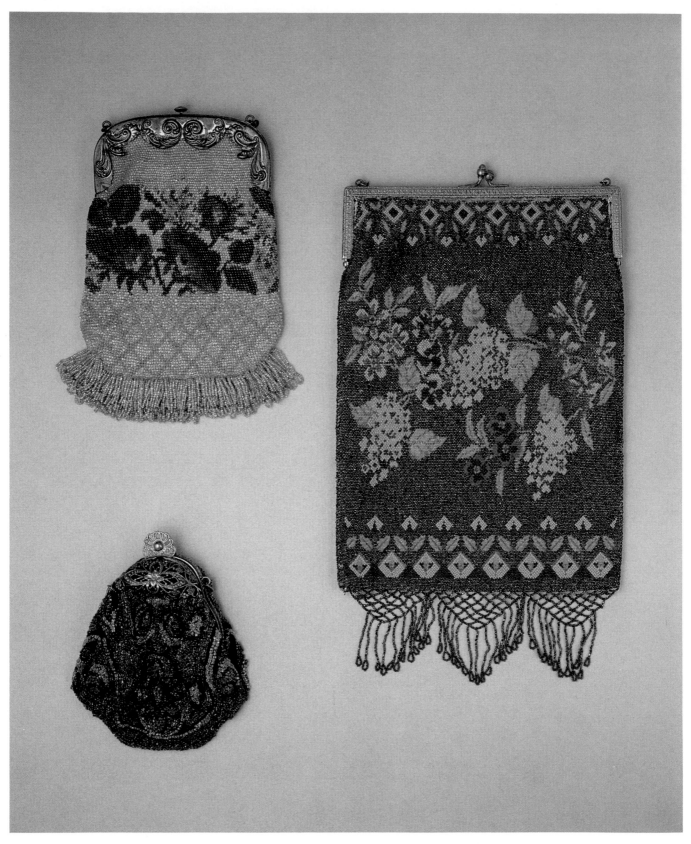

Top Left:
Size - 6″ x 8¾″
Style - German Silver

Bottom Left:
Maker - France
Size - 4¾″ x 6¼″

Center Right:
Size - 8″ x 14½″

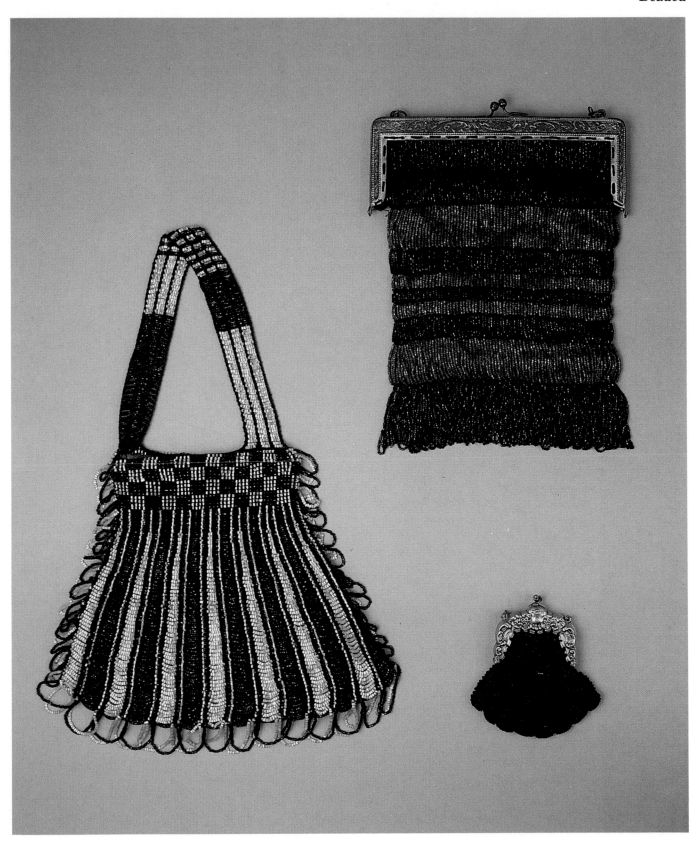

Bottom Left:
Size - 9″ x 9″

Top Right:
Size - 7¼″ x 10″

Bottom Right:
Size - 3¾″ x 4″
Style - German Silver

Beaded

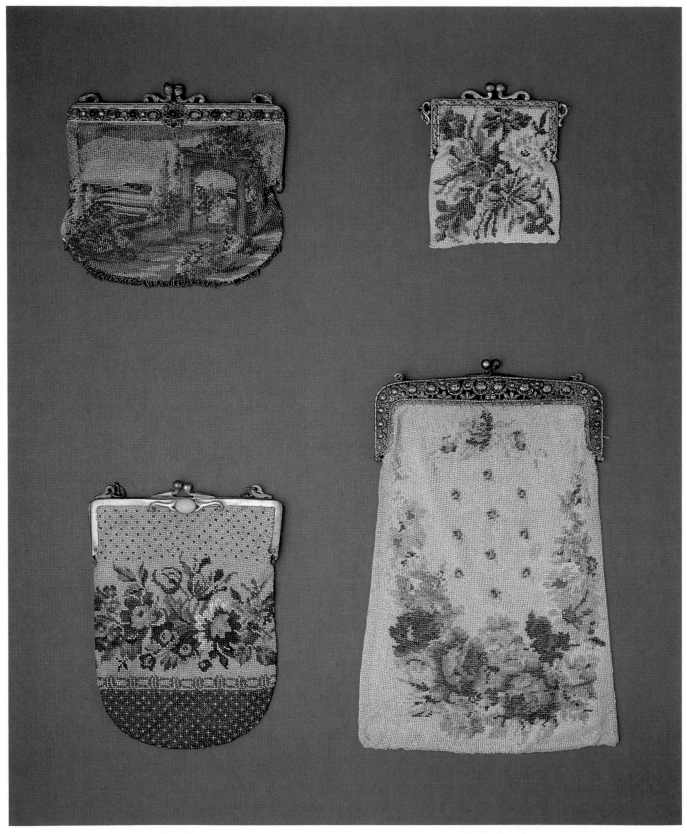

Top Left:
Size - 6¼" x 6"

Bottom Left:
Size - 5½" x 7½"

Top Right:
Maker - France
Size - 4" x 4½"

Bottom Right:
Size - 7½" x 11"

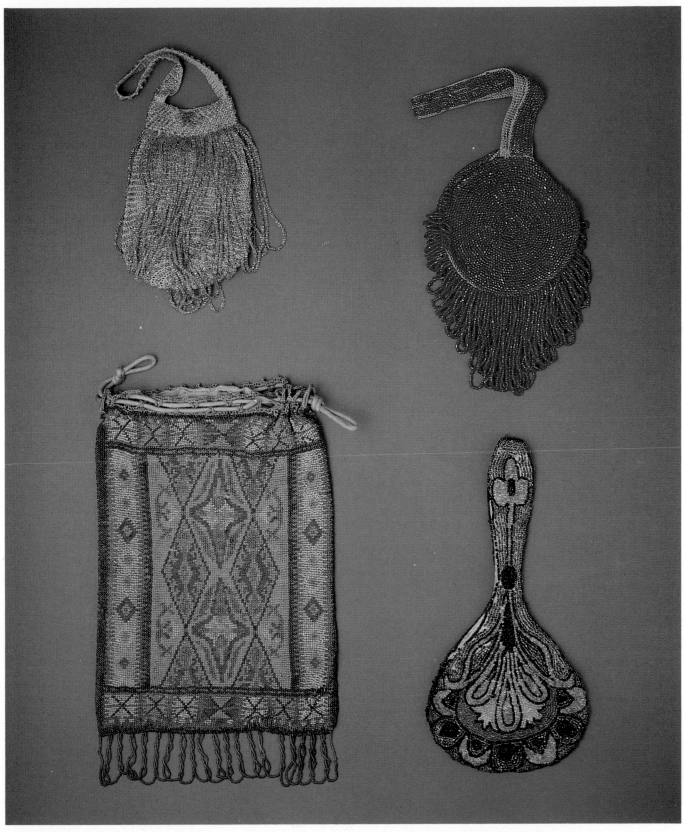

Top Left:
Size - 4″ x 6″

Top Right:
Size - 4¾″ x 7″

Bottom Left:
Size - 6¾″ x 11½″

Bottom Right:
Size - 4½″ x 9¼″

Beaded

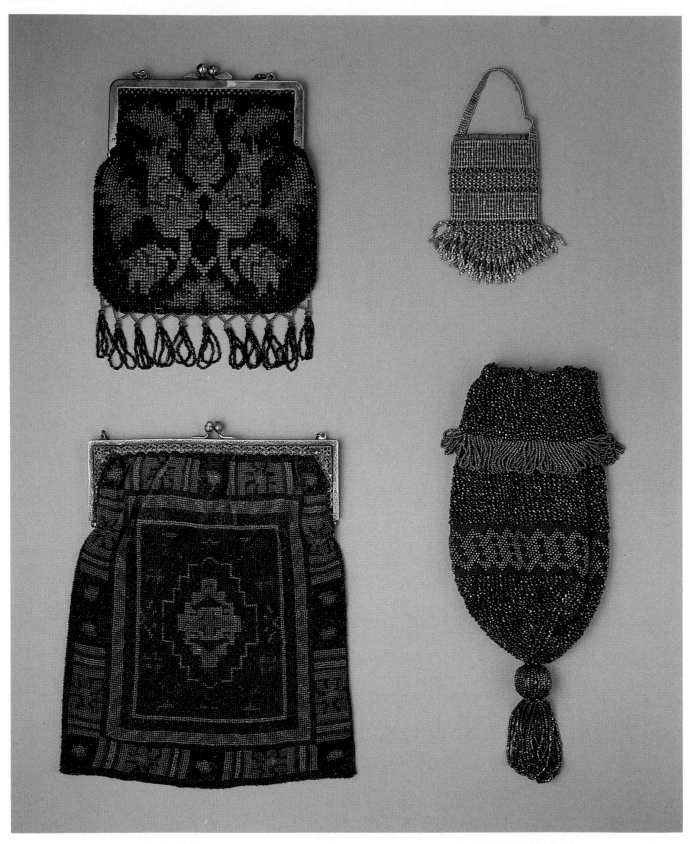

Top Left:
Maker - Germany
Size - 6¼″ x 8¾″

Bottom Left:
Size - 8¾″ x 10½″

Top Right:
Size - 3″ x 4¼″

Bottom Right:
Size - 6″ x 11¾″

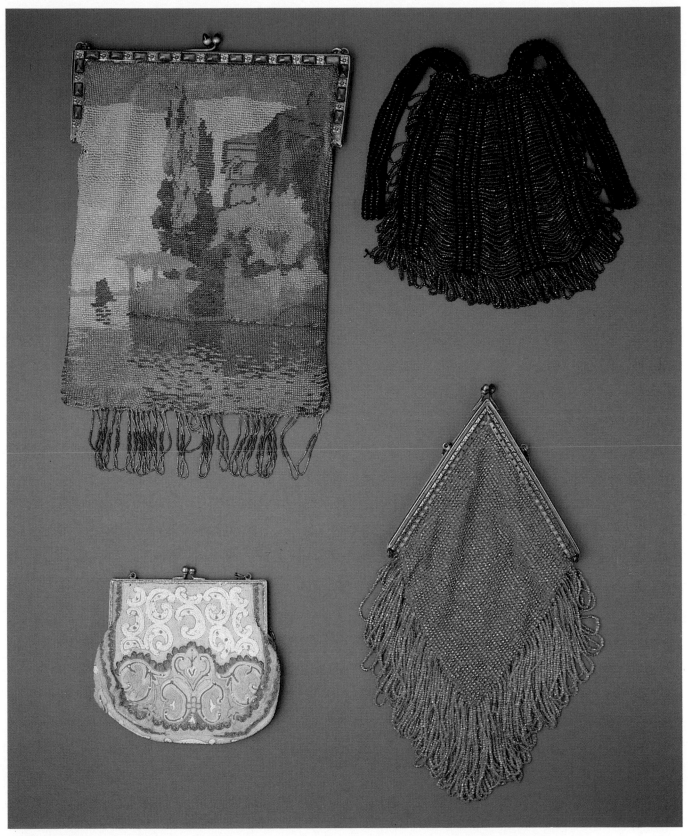

Top Left:
Maker - Germany
Size - 8″ x 12¾″

Bottom Left:
Size - 5¼″ x 5″

Top Right:
Size - 6¼″ x 6½″

Bottom Right:
Size - 6¾″ x 12″

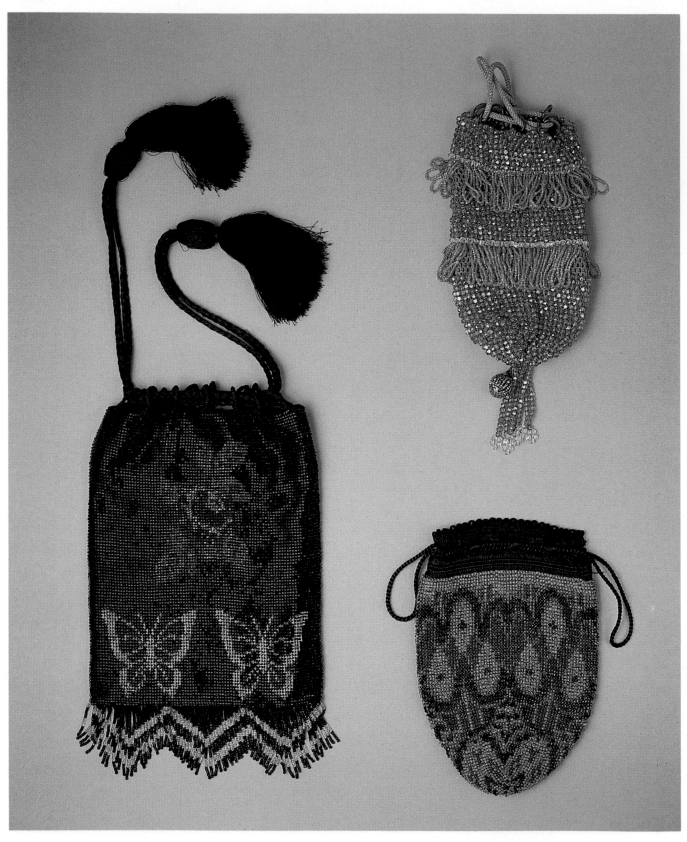

Center Left:
Size - 6¾″ x 11¼″

Top Right:
Size - 4½″ x 9¼″

Bottom Right:
Size - 5¼″ x 7¾″

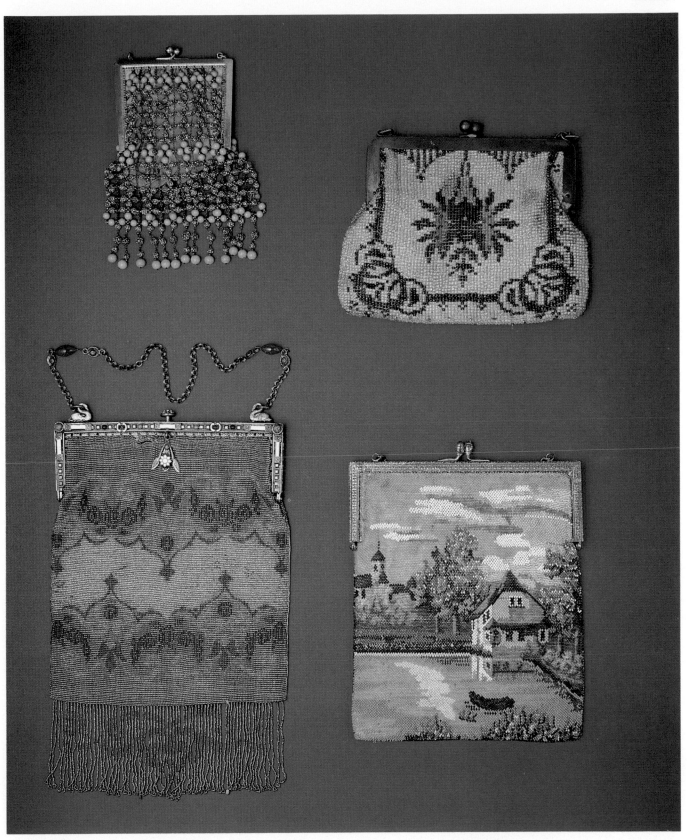

Top Left:
Size - 4¼″ x 6¼″

Top Right:
Size - 7¼″ x 5¾″

Bottom Left:
Size - 6¾″ x 11″

Bottom Right:
Size - 6½″ x 8½″

Beaded

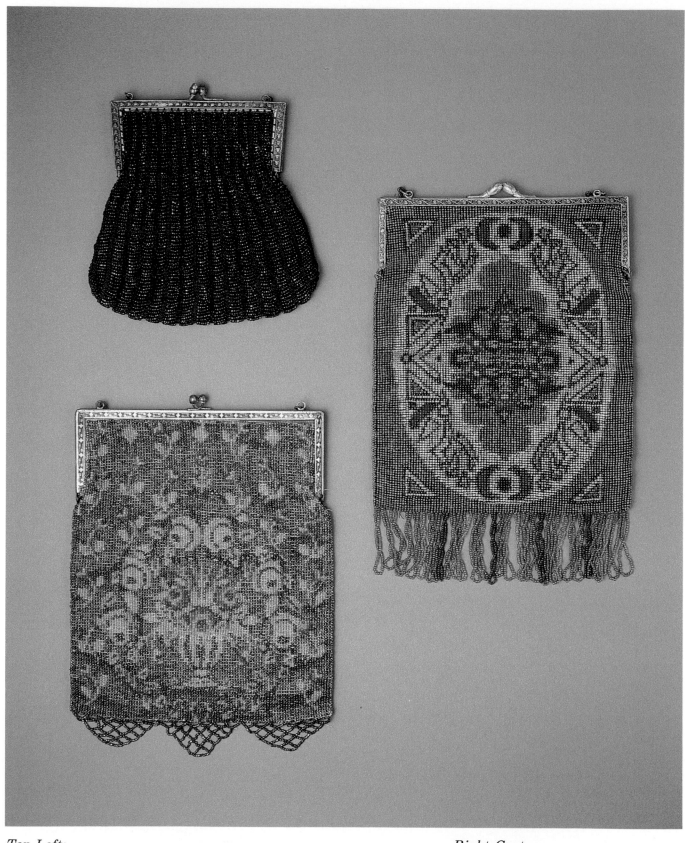

Top Left:
Size - 6½" x 7"

Bottom Left:
Size - 7½" x 10¼"

Right Center:
Maker - Germany
Size - 7¼" x 11¼"

22

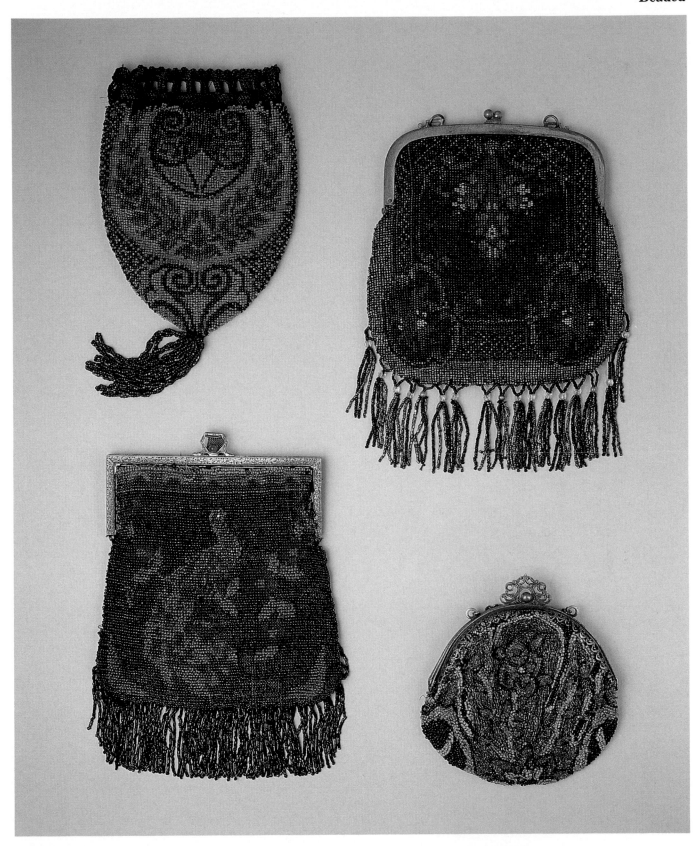

Top Left:
Size - 5¾″ x 10¾″

Top Right:
Size - 7½″ x 10¼″

Bottom Left:
Size - 7¼″ x 10″

Bottom Right:
Maker - France
Size - 5½″ x 6″

Beaded

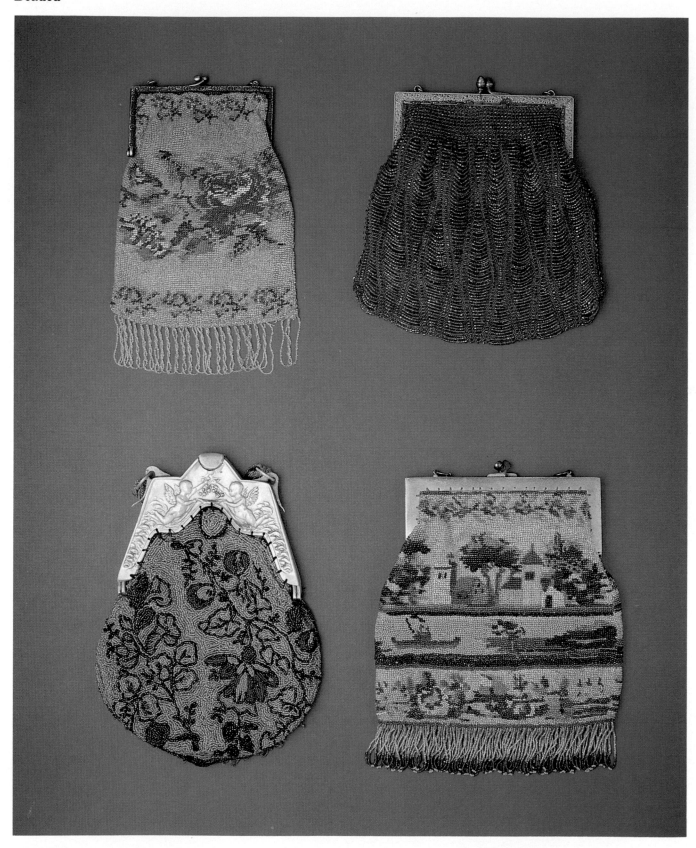

Top Left:
Maker - Germany
Size - 5¼″ x 8¼″

Bottom Left:
Size - 6½″ x 10½″

Top Right:
Size - 7″ x 7½″

Bottom Right:
Size - 7″ x 9″
Style - German Silver

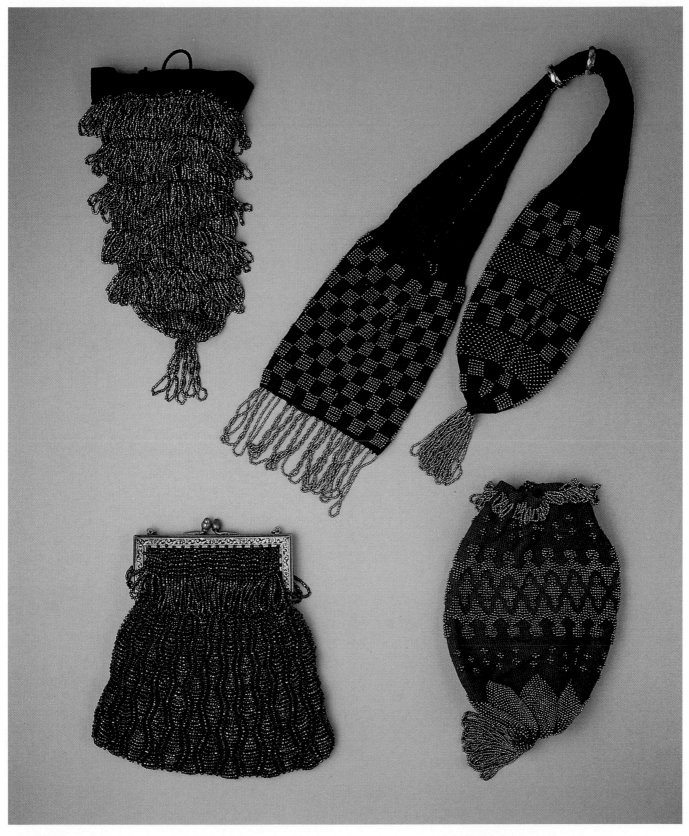

Top Left:
Size - 4½" x 9½"

Top Right:
Size - 7½" x 14"

Bottom Left:
Size - 6¾" x 7½"

Bottom Right:
Size - 5" x 9½"

Beaded

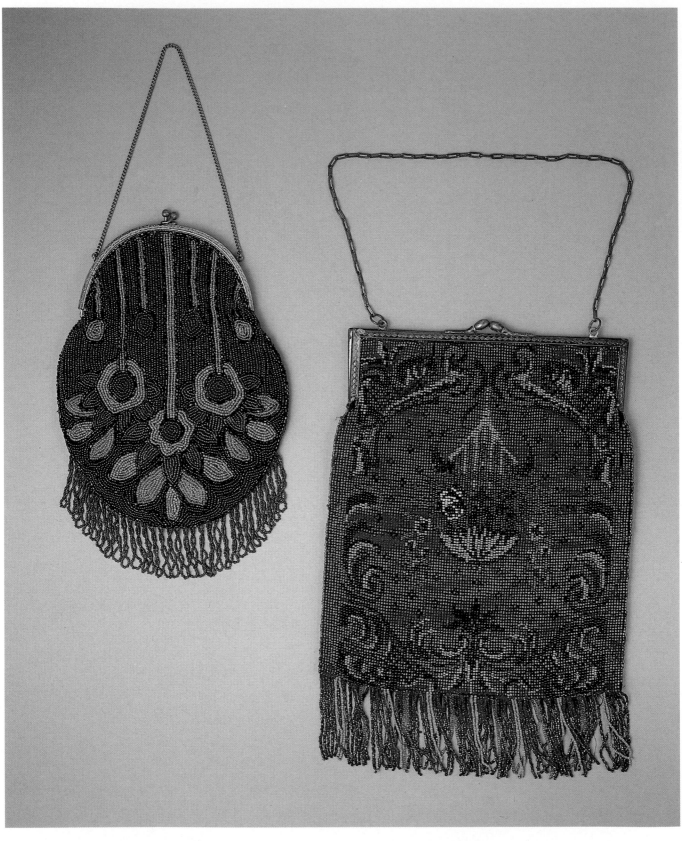

Left:
Maker - France
Size - 6¾″ x 10¼″

Right:
Size - 8¾″ x 13″

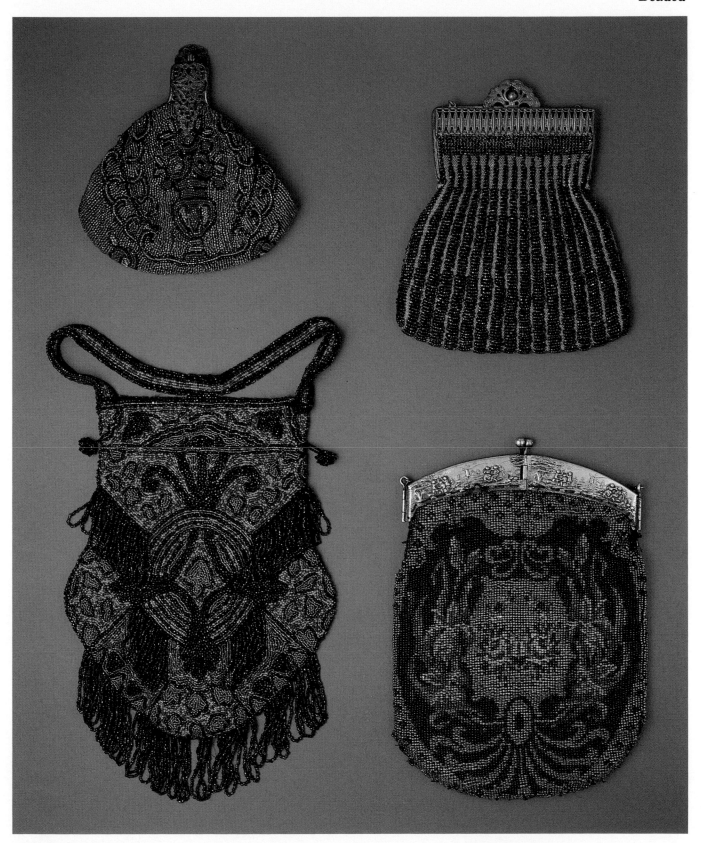

Top Left:
Maker - France
Size - 6″ x 6¾″

Bottom Left:
Size - 7¾″ x 11½″

Top Right:
Size - 6¾″ x 7½″

Bottom Right:
Size - 7″ x 10¼″

Beaded

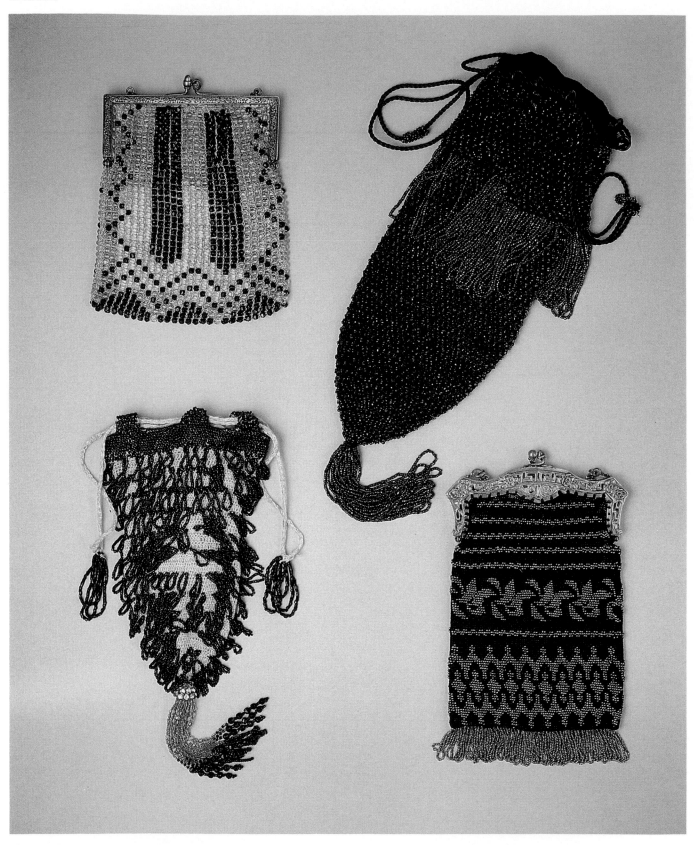

Top Left:
Size - 5¾″ x 7¼″

Top Right:
Size - 4½″ x 16½″

Bottom Left:
Size - 4¾″ x 11¾″

Bottom Right:
Size - 5¼″ x 9″

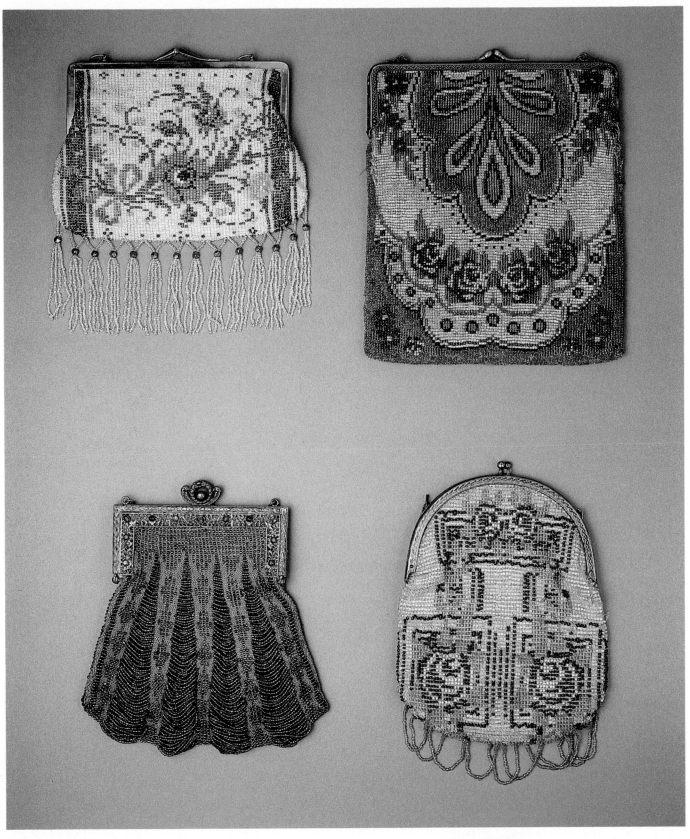

Top Left:
Size - 7¼″ x 8″

Bottom Left:
Size - 6¾″ x 7¾″

Top Right:
Size - 7¼″ x 9″

Bottom Right:
Size - 6″ x 9″

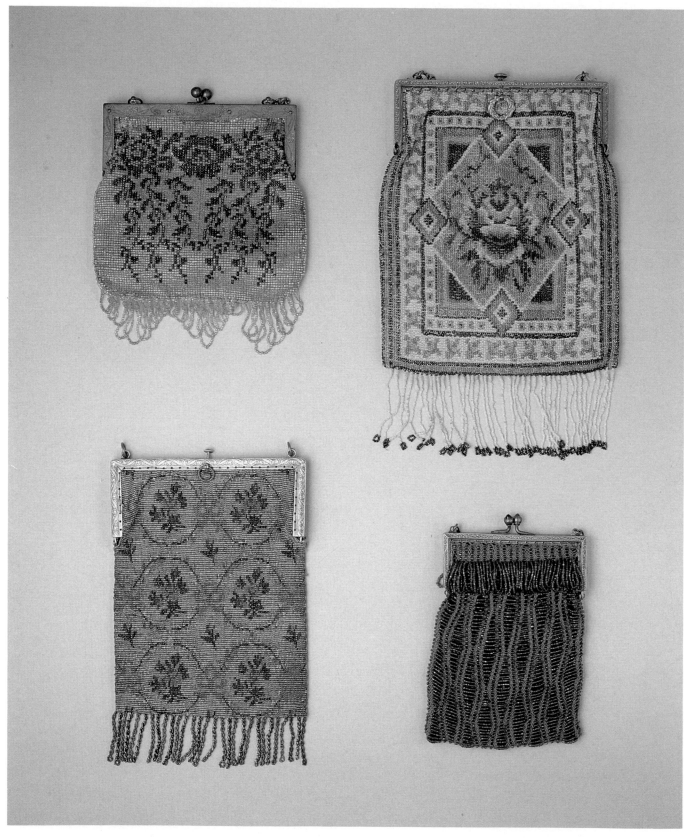

Top Left:
Size - 6″ x 7¼″

Top Right:
Size - 6¾″ x 10¾″

Bottom Left:
Size - 5½″ x 9″

Bottom Right:
Size - 4½″ x 6¾″

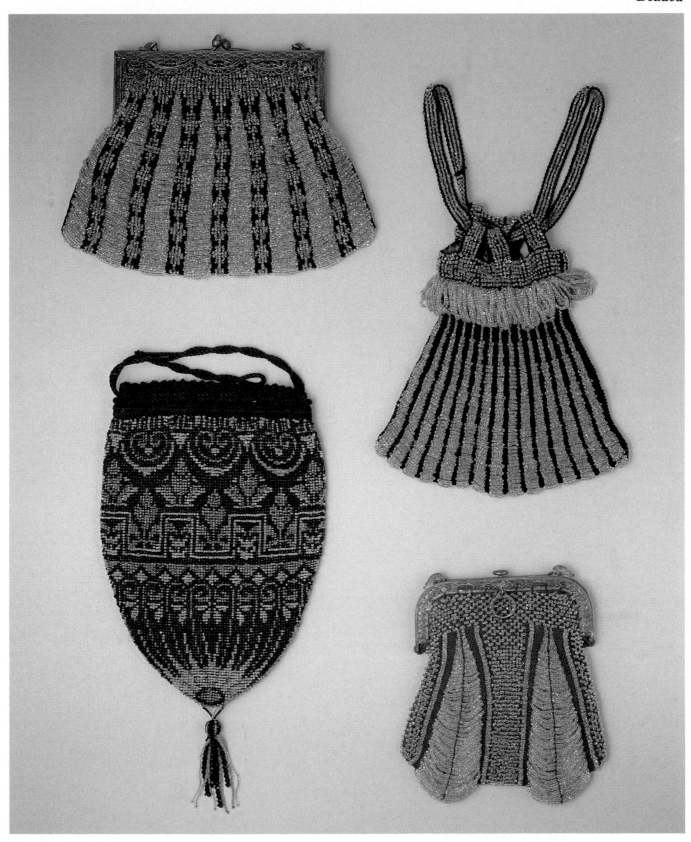

Top Left:
Size - 9″ x 6¾″

Top Right:
Size - 7½″ x 7½″

Bottom Left:
Size - 6¼″ x 12″

Bottom Right:
Size - 6¼″ x 6½″

Beaded

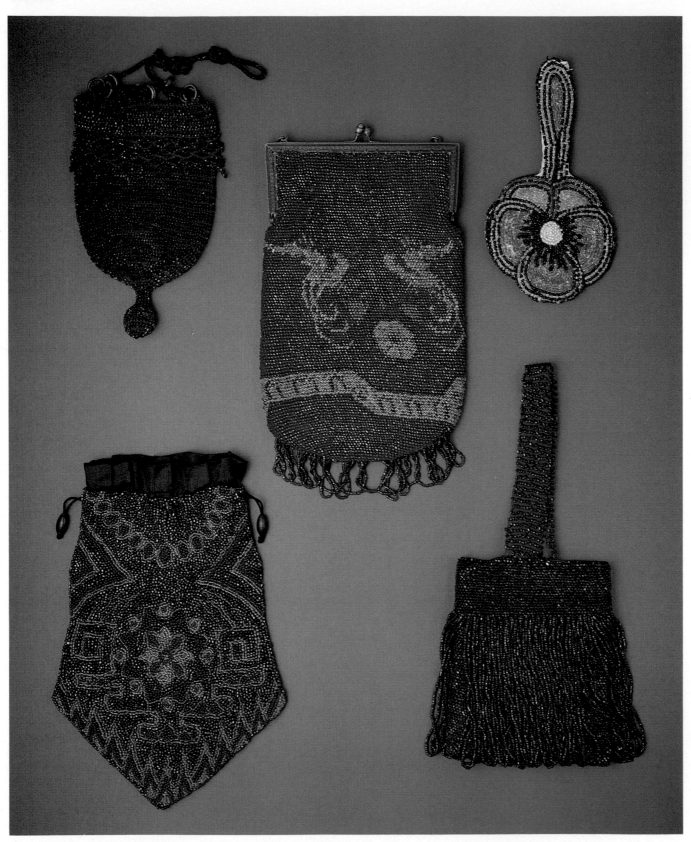

Top Left:
Size - 4¼″ x 6¾″

Center:
Size - 5¾″ x 10½″

Top Right:
Size - 3½″ x 7″

Bottom Left:
Maker - Germany
Size - 6¾″ x 10″

Bottom Right:
Size - 5″ x 6″

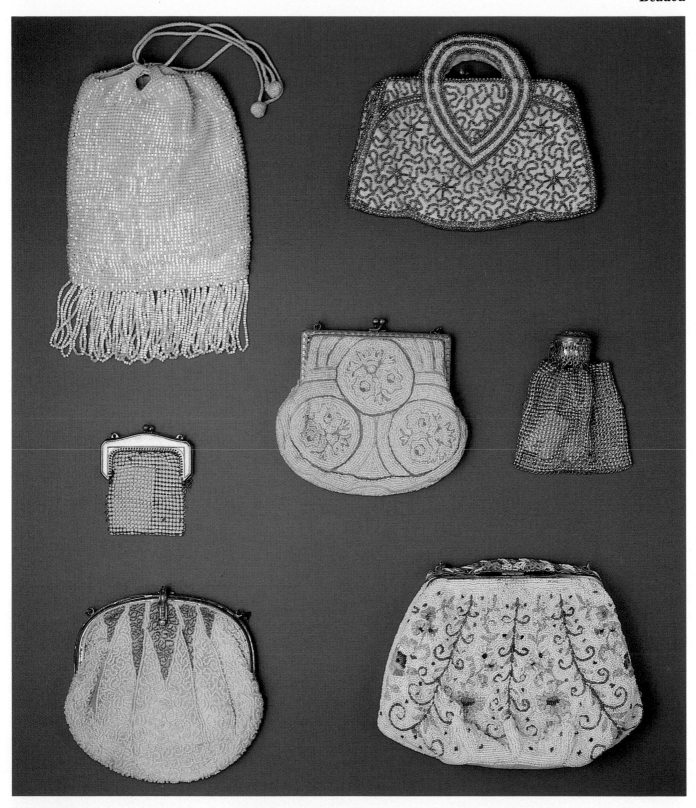

Top Left:
Size - 5¼″ x 8½″

Center Left:
Maker - Whiting & Davis
Size - 2½″ x 3¼″
Style - Bead-lite

Bottom Left:
Size - 5½″ x 5½″

Center:
Maker - France
Size - 5½″ x 5″

Top Right:
Maker - Belgium
Size - 7″ x 5¾″

Center Right:
Maker - Whiting & Davis
Size - 3½″ x 4″
Style - Bead-lite

Bottom Right:
Maker - France
Size - 7½″ x 5¾″

Beaded

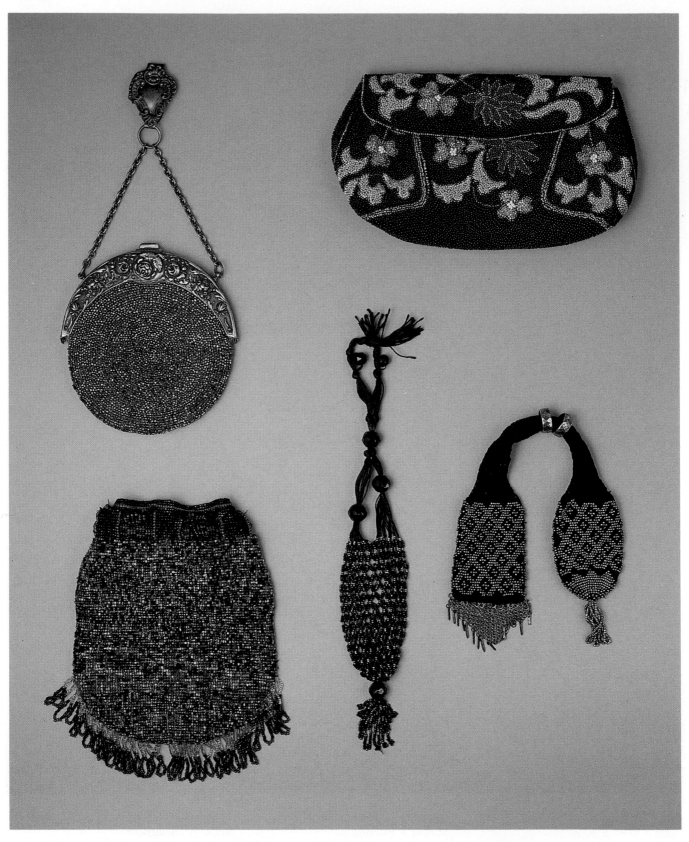

Top Left:
Size - 5″ x 5½″

Center:
Size - 6″ x 2″

Top Right:
Size - 8½″ x 5″

Bottom Left:
Size - 6″ x 8¼″

Bottom Right:
Size - 4″ x 6¾″

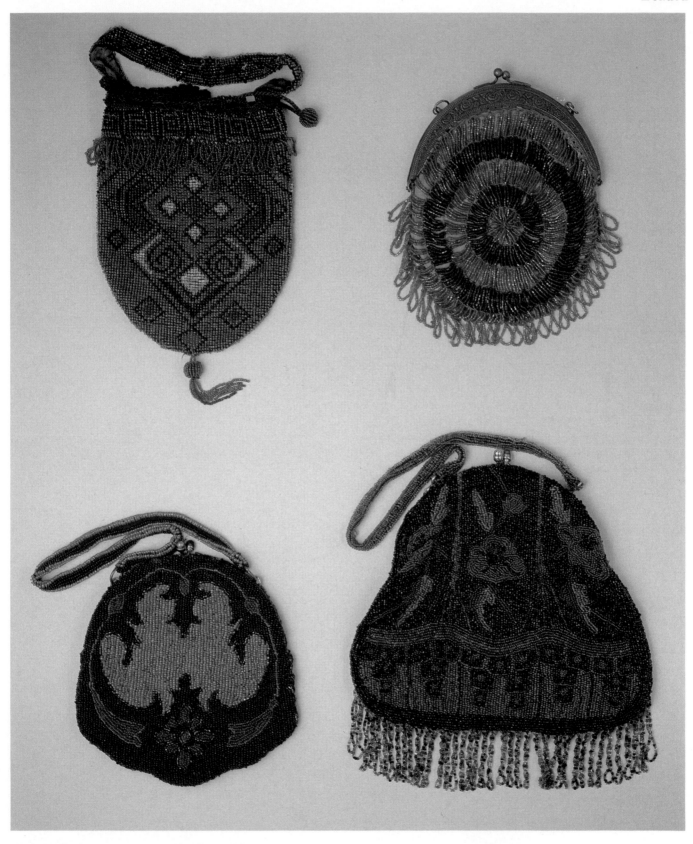

Top Left:
Size - 5½″ x 9¾″

Top Right:
Size - 5½″ x 7½″

Bottom Left:
Size - 6¼″ x 7″

Bottom Right:
Size - 8½″ x 9¾″

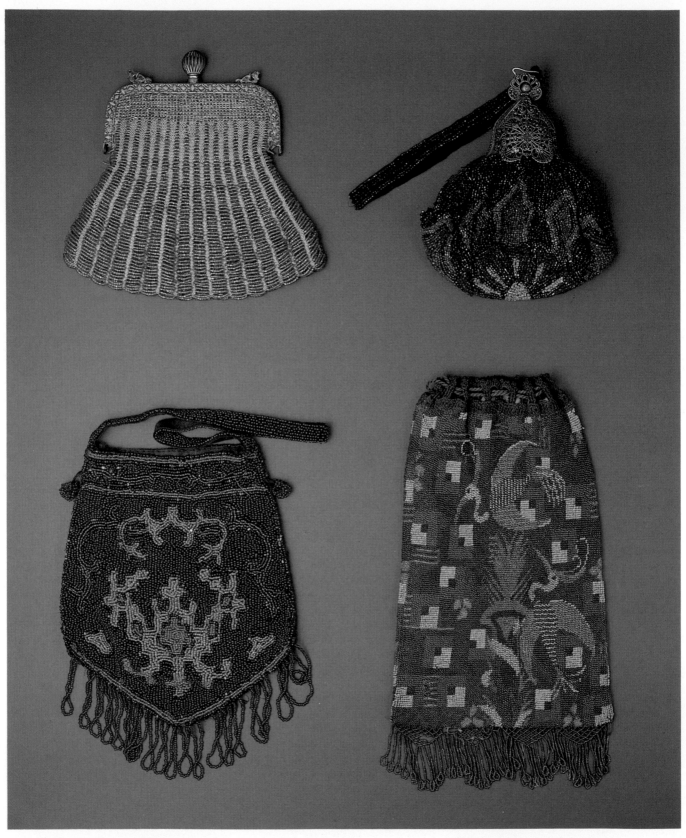

Top Left:
Size - 7¼″ x 7″

Bottom Left:
Size - 6¾″ x 9½″

Top Right:
Maker - France
Size - 5½″ x 6½″

Bottom Right:
Size - 6½″ x 11½″

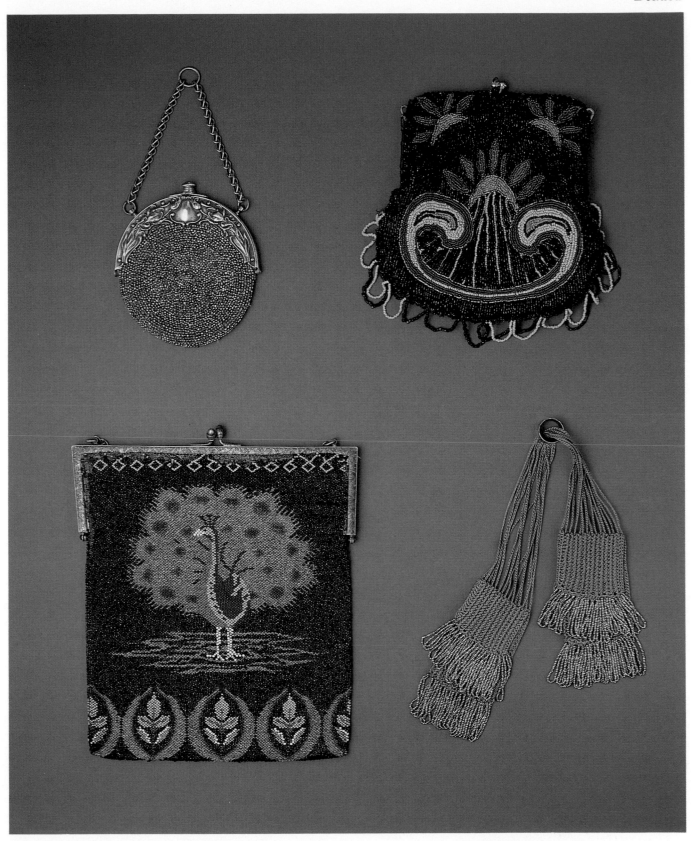

Top Left:
Size - 4″ x 4¾″

Top Right:
Size - 6½″ x 7¾″

Bottom Left:
Size - 8″ x 9½″

Bottom Right:
Size - 4″ x 8½″

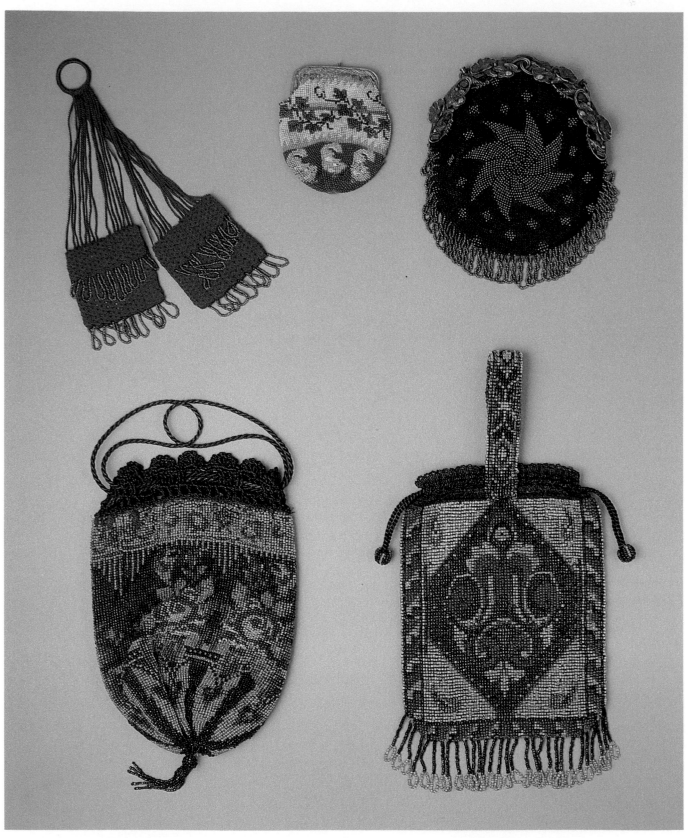

Top Left:
Size - 4¾″ x 8″

Center:
Size - 3″ x 3¾″

Top Right:
Size - 5¼″ x 6½″

Bottom Left:
Size - 5¾″ x 10½″

Bottom Right:
Size - 5¾″ x 9″

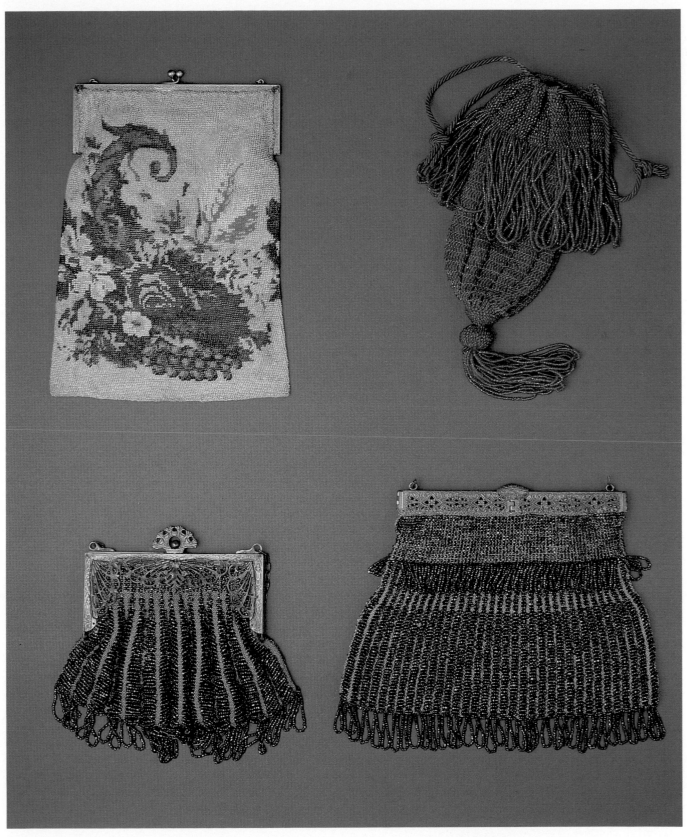

Top Left:
Size - 6¾″ x 9½″

Bottom Left:
Size - 7″ x 6¾″

Top Right:
Size - 4½″ x 10¾″

Bottom Right:
Size - 9″ x 7¾″

Beaded

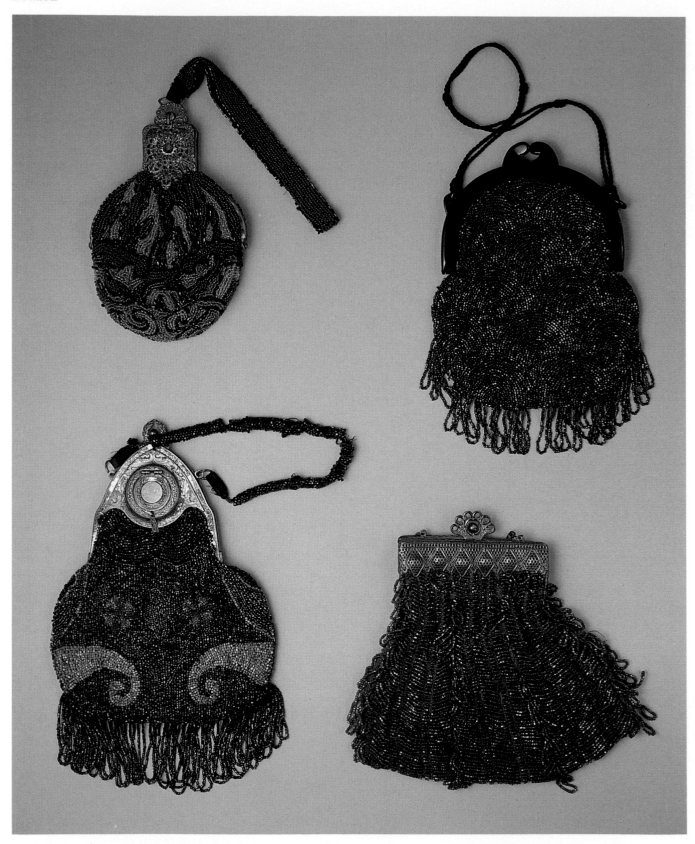

Top Left:
Maker - France
Size - 4½″ x 7″

Bottom Left:
Size - 6¾″ x 10¾″

Top Right:
Size - 6″ x 8½″

Bottom Right:
Size - 8″ x 7½″

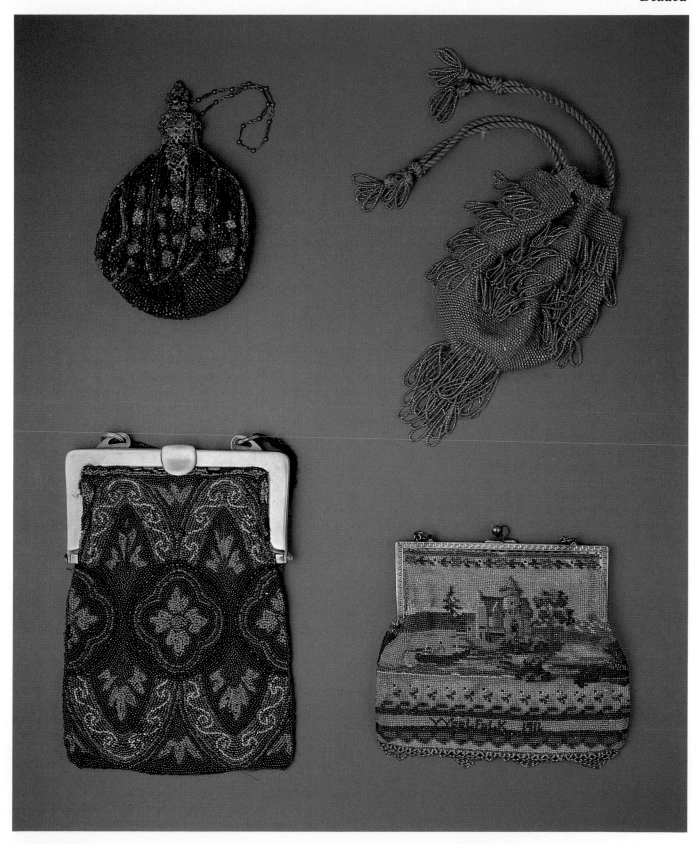

Top Left:
Maker - France
Size - 4½″ x 6¾″

Bottom Left:
Size - 6½″ x 9¼″

Top Right:
Size - 5¾″ x 8½″

Bottom Right:
Size - 7¼″ x 7″
Style - German Silver

Beaded

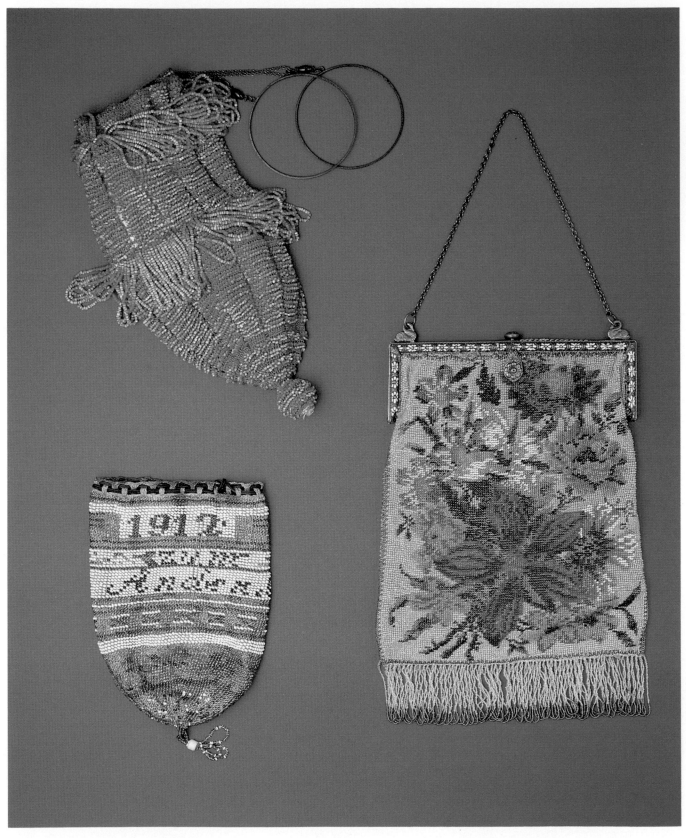

Top Left:
Size - 5½" x 10½"

Right:
Size - 7¾" x 11"

Bottom Left:
Size - 5" x 8¾"

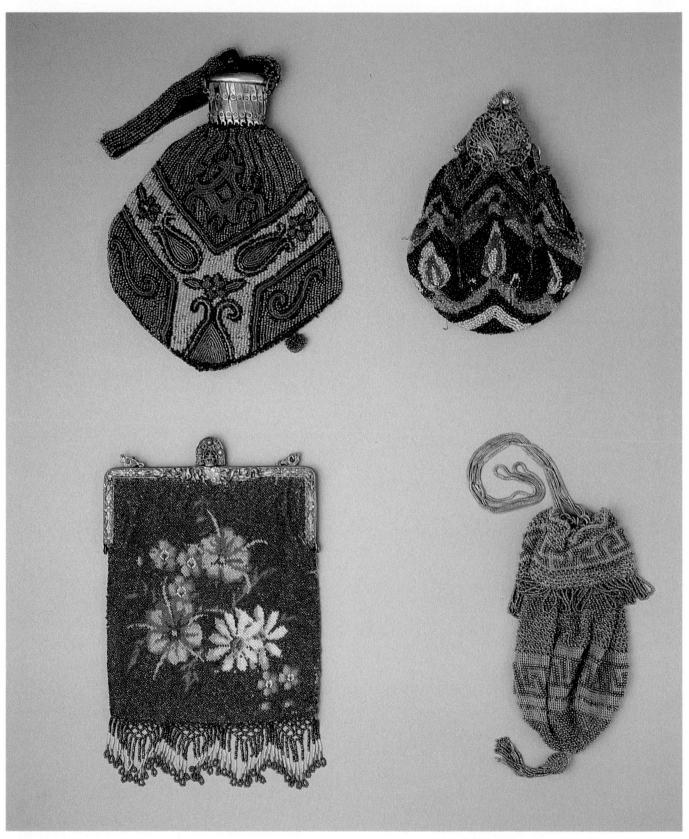

Top Left:
Size - 7¼″ x 8½″

Bottom Left:
Size - 6″ x 10″

Top Right:
Maker - France
Size - 5″ x 6¾″

Bottom Right:
Size - 4½″ x 9½″

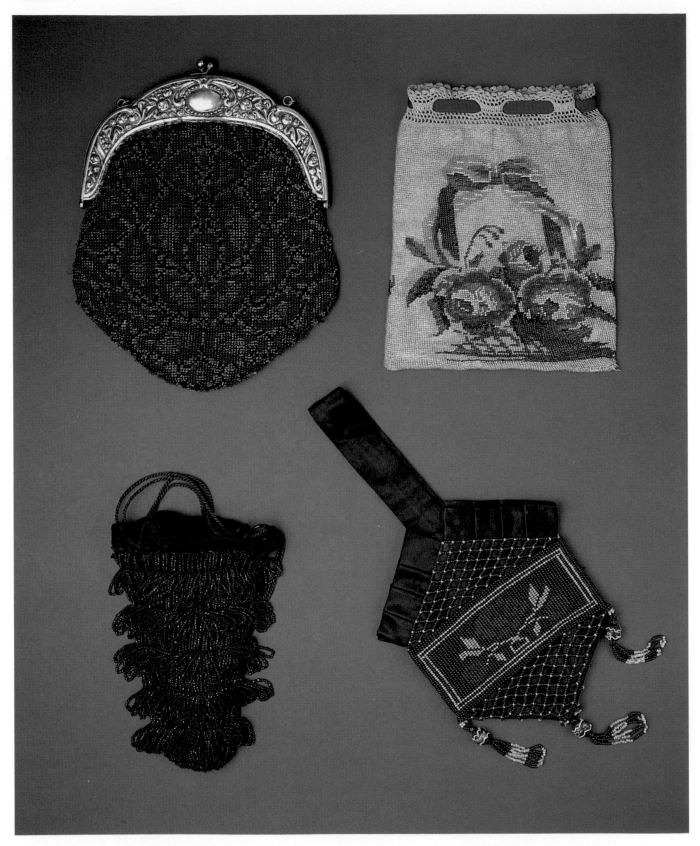

Top Left:
Size - 7½″ x 9½″

Top Right:
Size - 6½″ x 8″

Bottom Left:
Size - 4¾″ x 7¼″

Bottom Right:
Size - 6¼″ x 10″

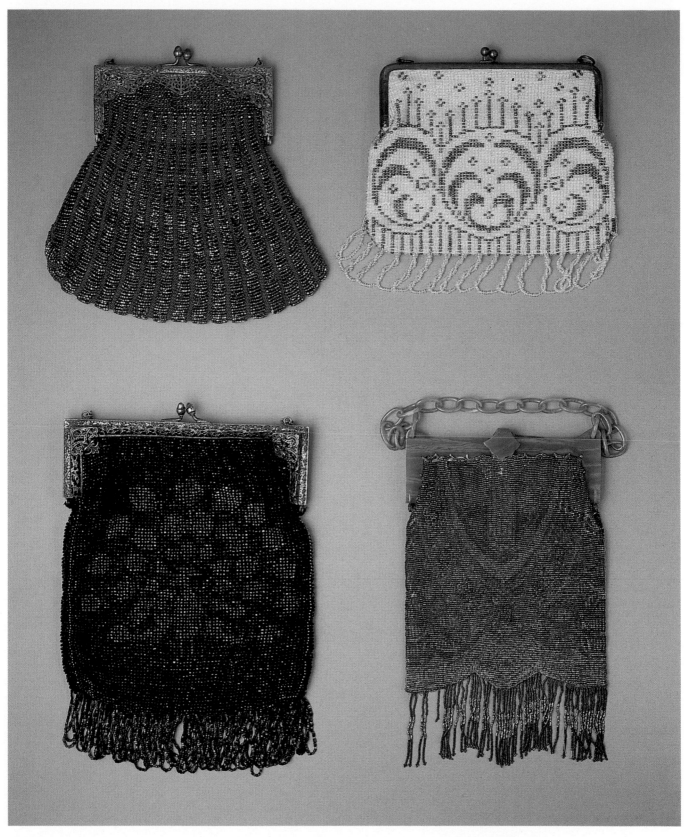

Top Left:
Size - 8″ x 7¾″

Top Right:
Size - 7″ x 7¼″

Bottom Left:
Size - 7¼″ x 10½″

Bottom Right:
Size - 5¾″ x 9½″

Beaded

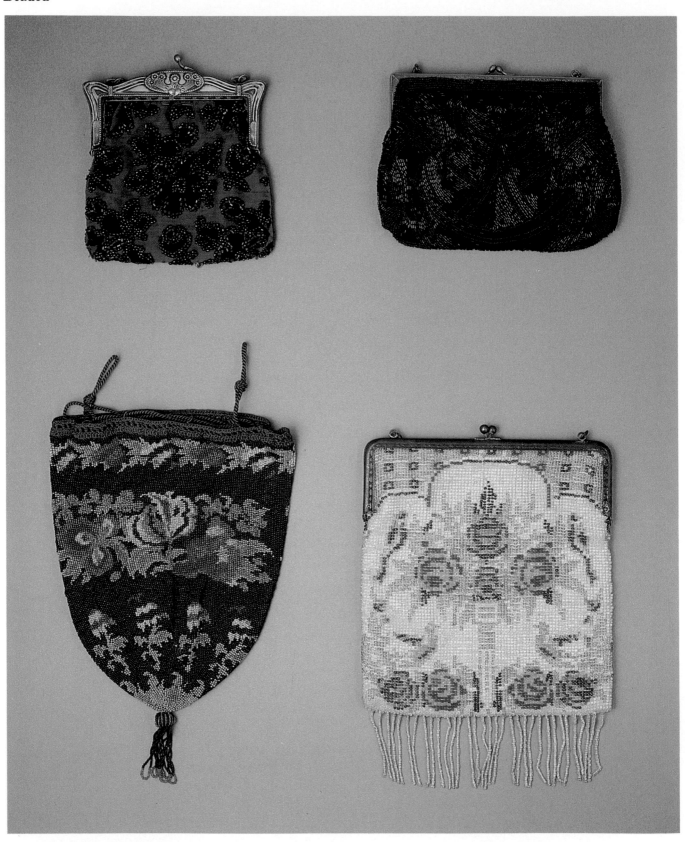

Top Left:
Size - 5¼″ x 6″

Bottom Left:
Maker - Germany
Size - 7″ x 10¾″

Top Right:
Maker - France
Size - 7″ x 5¼″

Bottom Right:
Maker - Germany
Size - 7″ x 10¼″

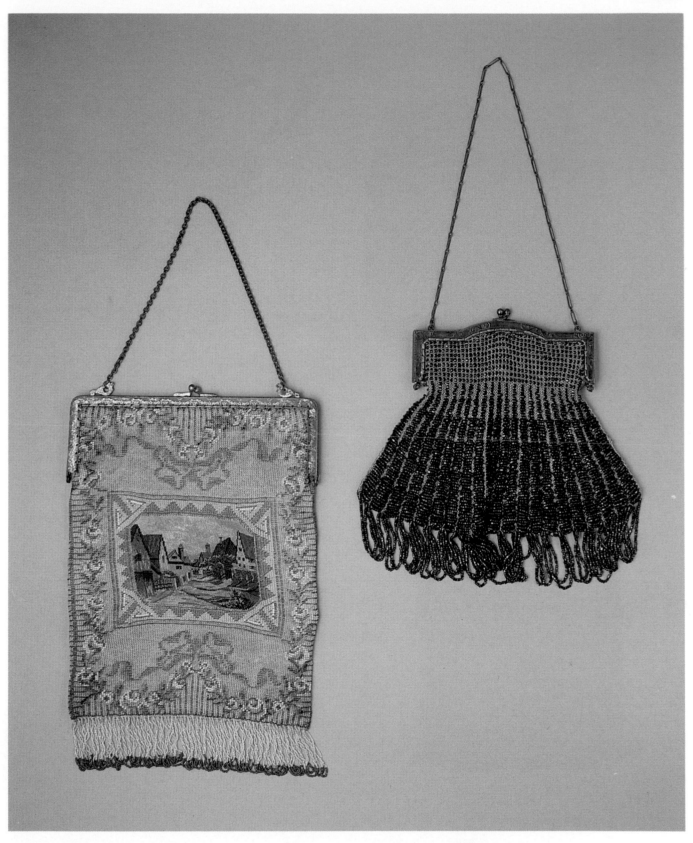

Left:
Size - 7″ x 11″

Right:
Size - 8¾″ x 8″

Beaded

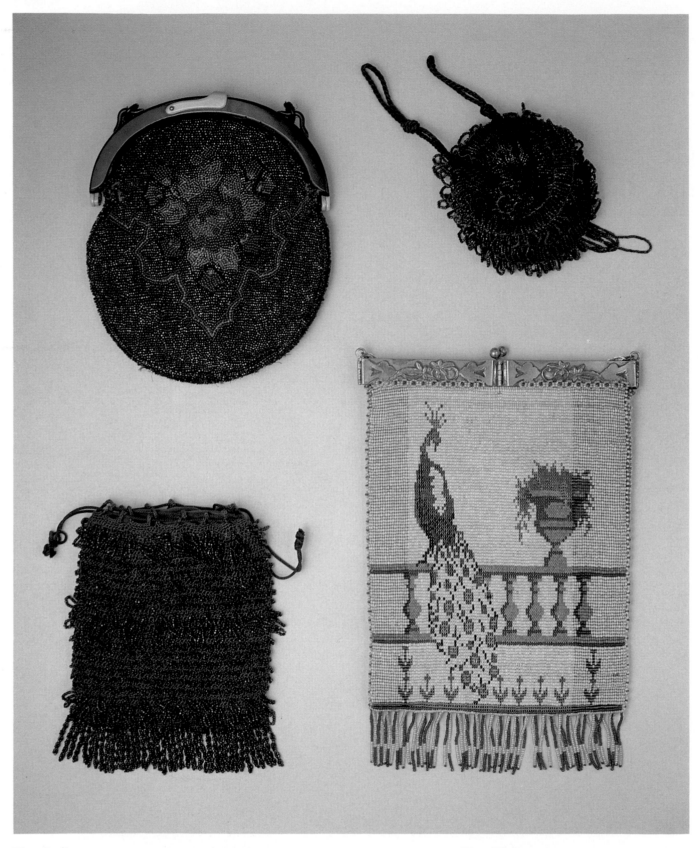

Top Left:
Size - 7″ x 8″

Top Right:
Size - 4¼″ x 7½″

Bottom Left:
Size - 6″ x 7¾″

Bottom Right:
Size - 8″ x 12″

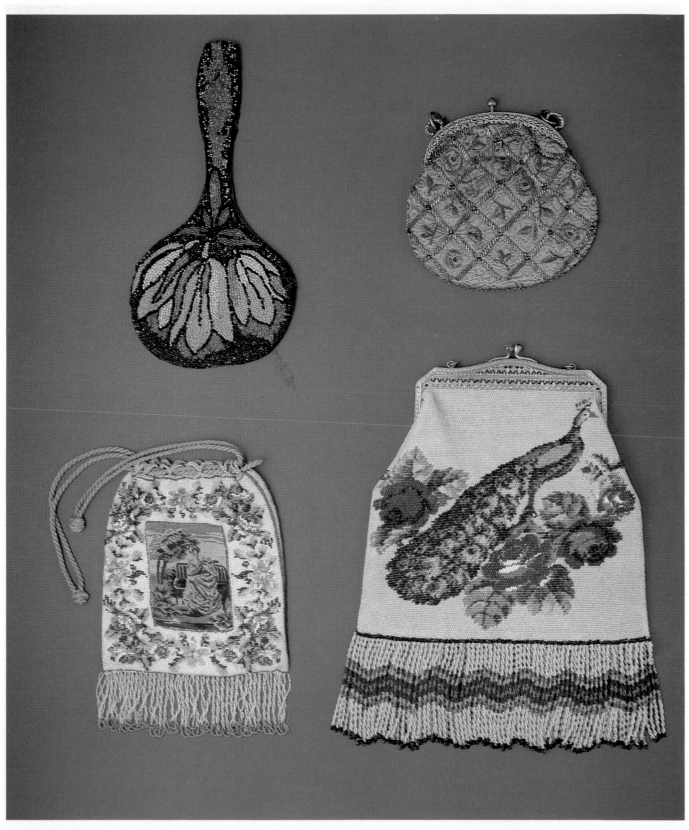

Top Left:
Size - 4½″ x 9¼″

Top Right:
Size - 5¼″ x 5½″

Bottom Left:
Size - 5¼″ x 7¾″

Bottom Right:
Size - 9½″ x 11½″

Beaded

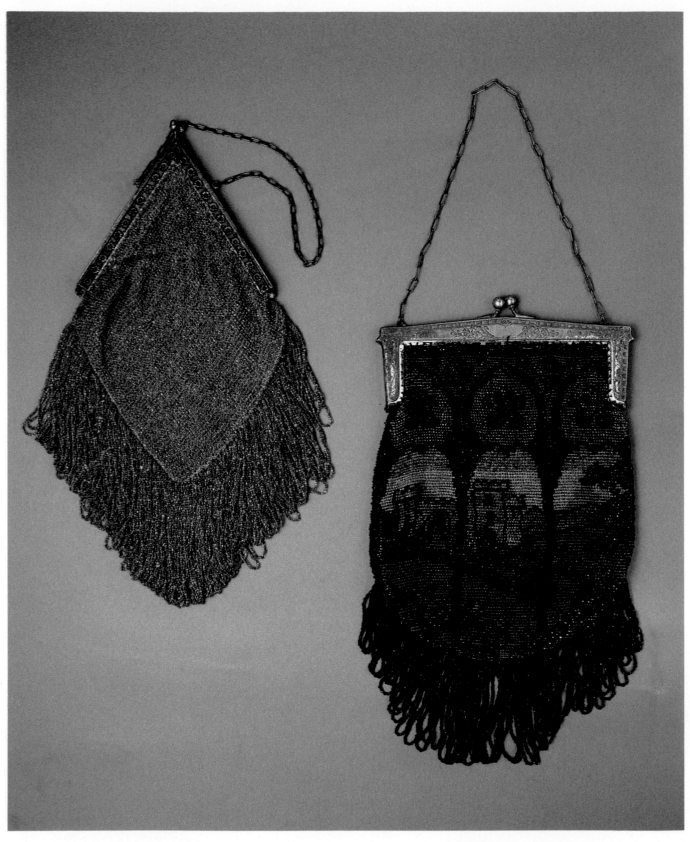

Left:
Size - 7½" x 13½"

Right:
Size - 7½" x 13½"
Style - Silver Plated

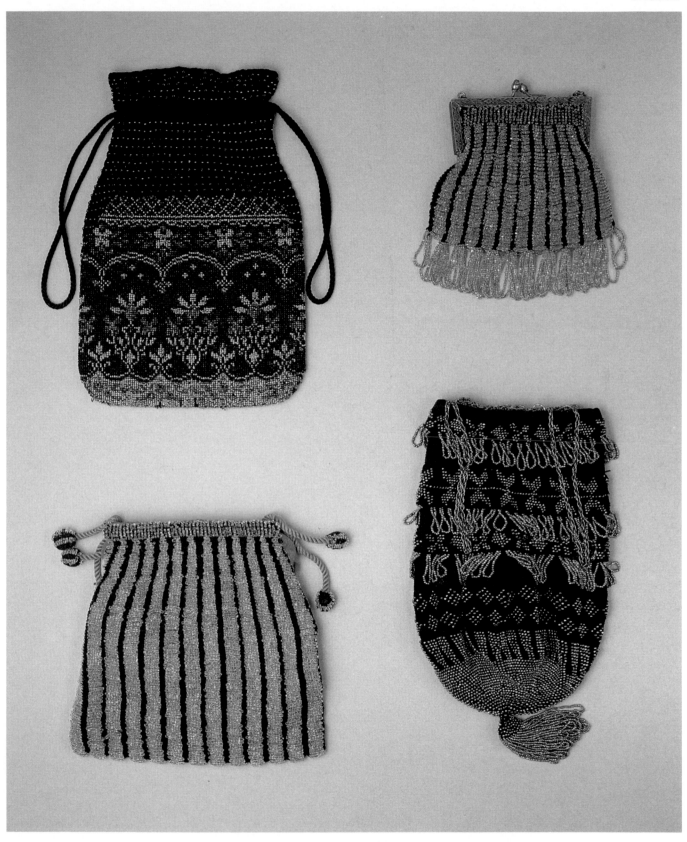

Top Left:
Size - 6½″ x 9¾″

Top Right:
Size - 5¼″ x 6¼″

Bottom Left:
Size - 7¼″ x 7″

Bottom Right:
Size - 5½″ x 11½″

Beaded

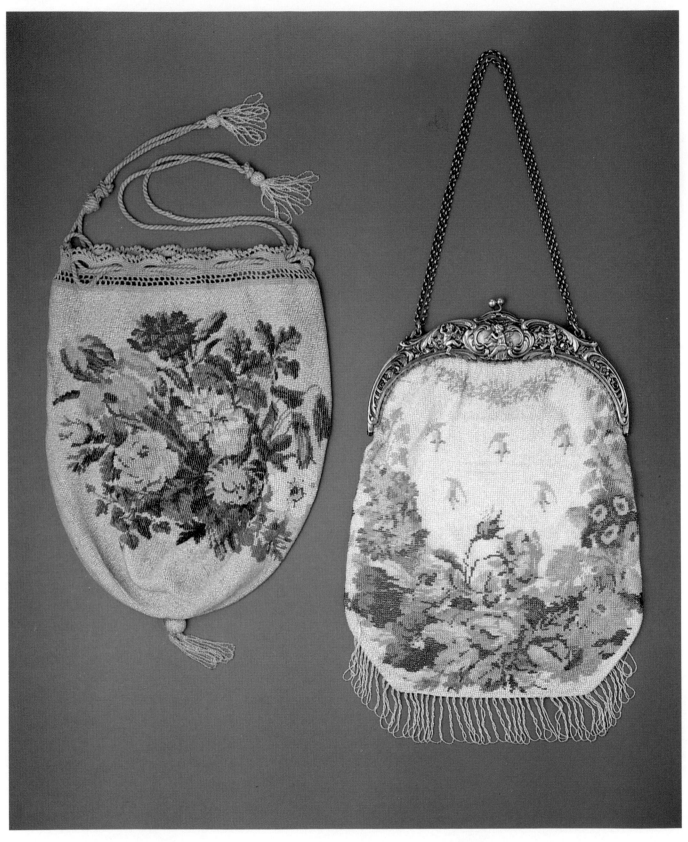

Left:
Size - 9″ x 12″

Right:
Size - 8½″ x 13″
Style - Sterling

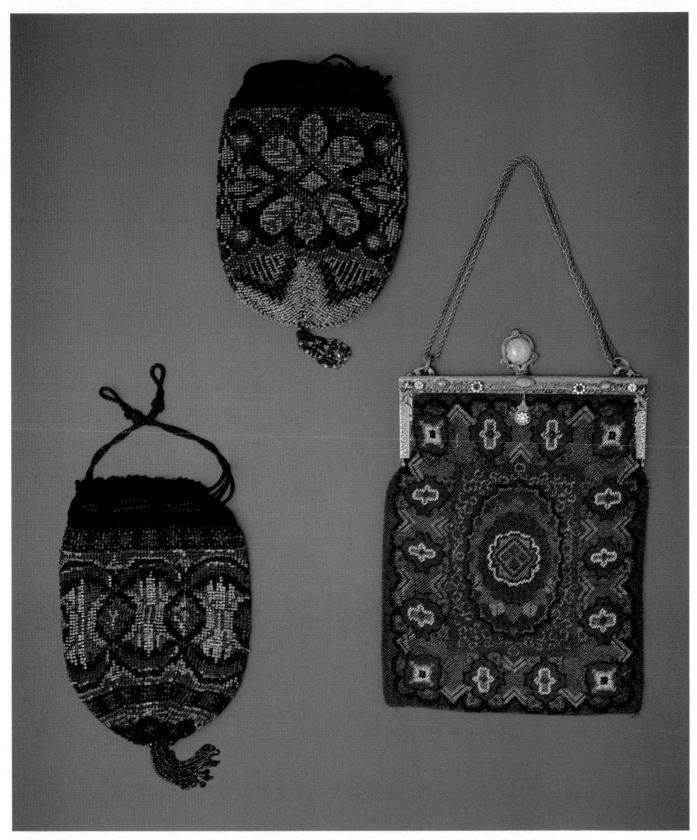

Bottom Left:
Size - 5½″ x 9½″

Top Center:
Size - 5½″ x 9¼″

Bottom Right:
Size - 7½″ x 11″

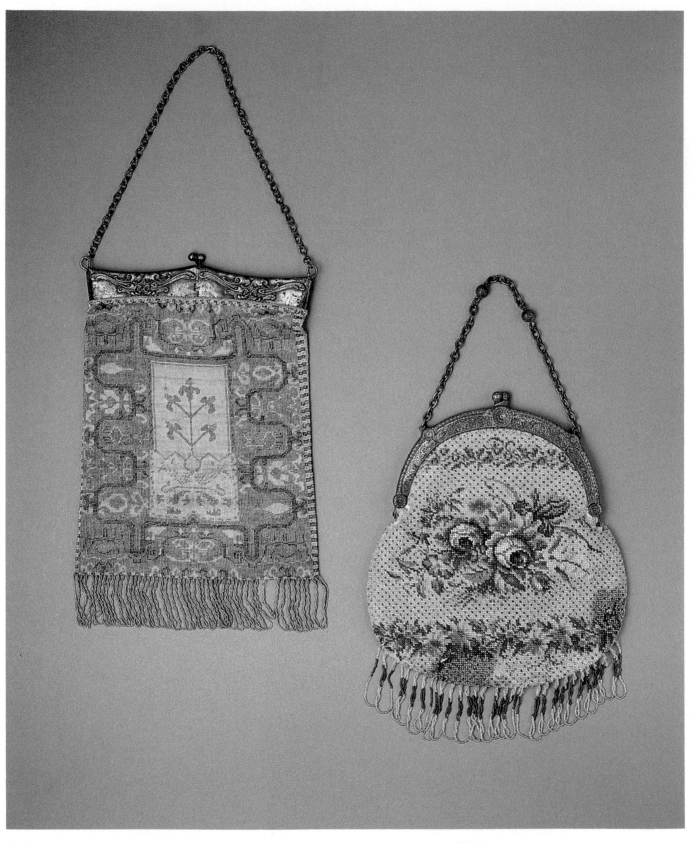

Left:
Size - 6¾″ x 10¾″

Right:
Size - 7½″ x 10″

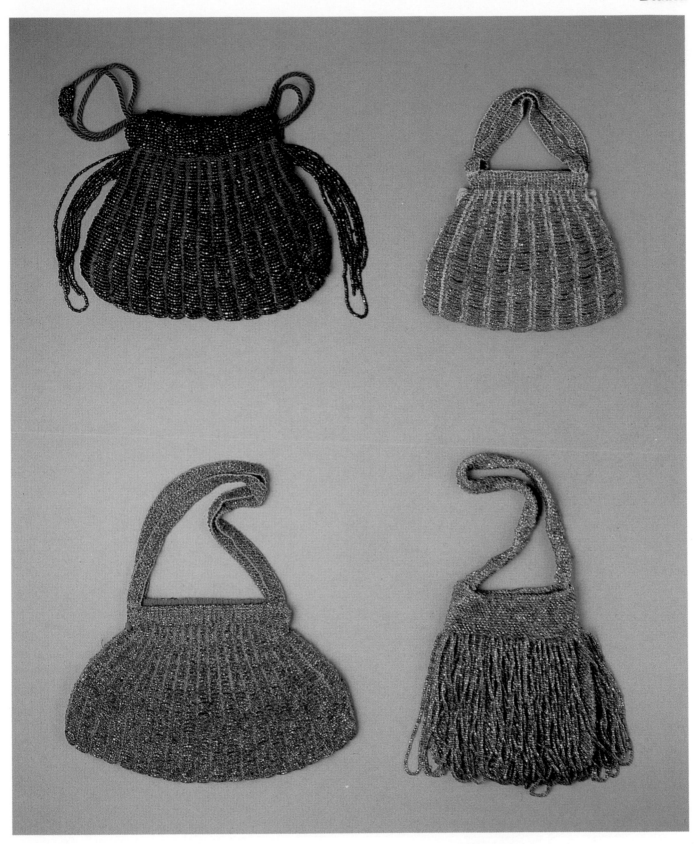

Top Left:
Size - 7½″ x 5¾″

Bottom Left:
Size - 8¼″ x 5¼″

Top Right:
Size - 5¾″ x 4½″

Bottom Right:
Size - 4¾″ x 5¾″

Beaded

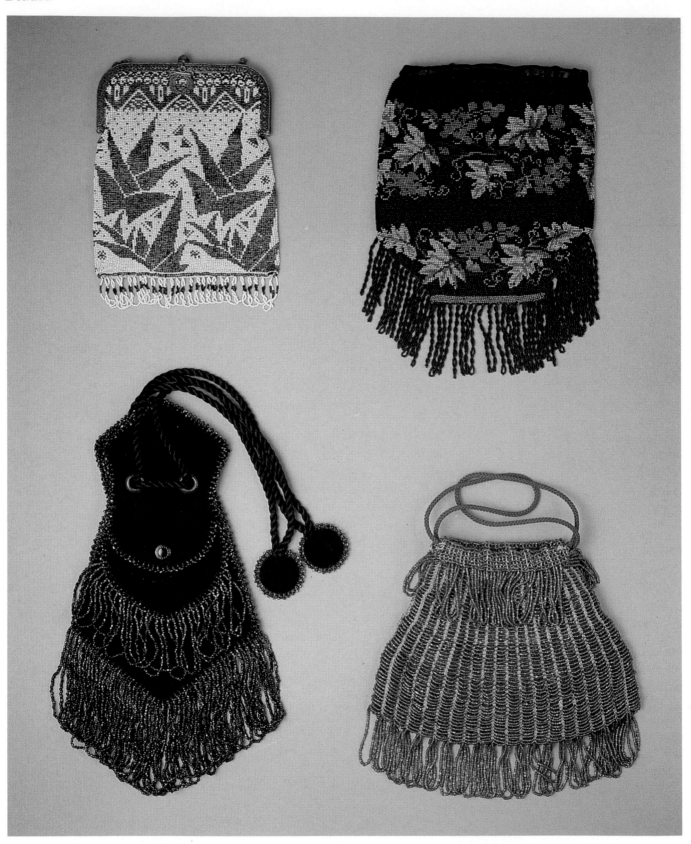

Top Left:
Size - 5¼" x 7"

Bottom Left:
Size - 6¾" x 11½"

Top Right:
Size - 6¼" x 8¾"

Bottom Right:
Size - 7¾" x 7½"

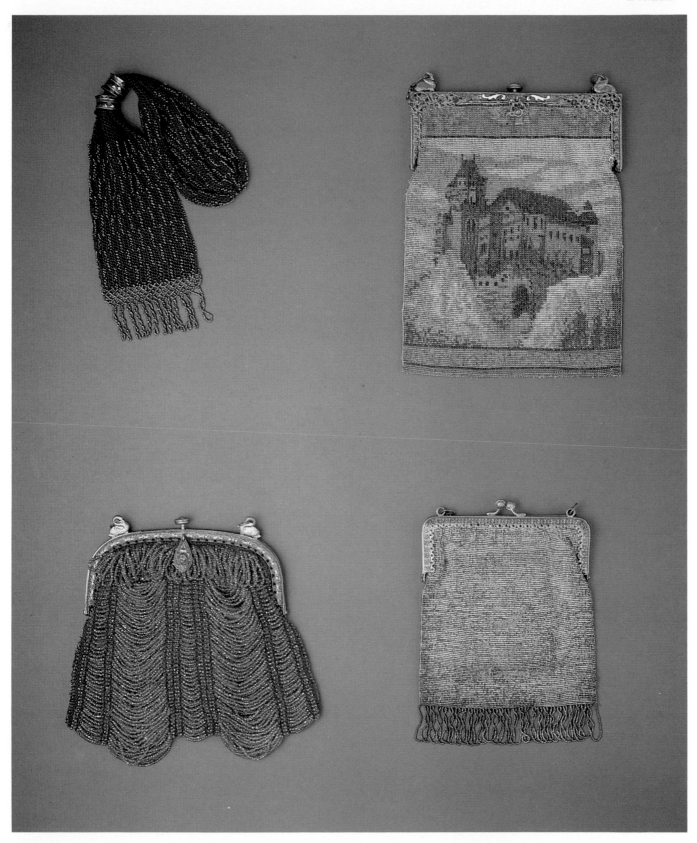

Top Left:
Size - 5″ x 6¼″

Top Right:
Size - 6″ x 8¼″

Bottom Left:
Size - 7″ x 7½″

Bottom Right:
Size - 5″ x 7″

Beaded

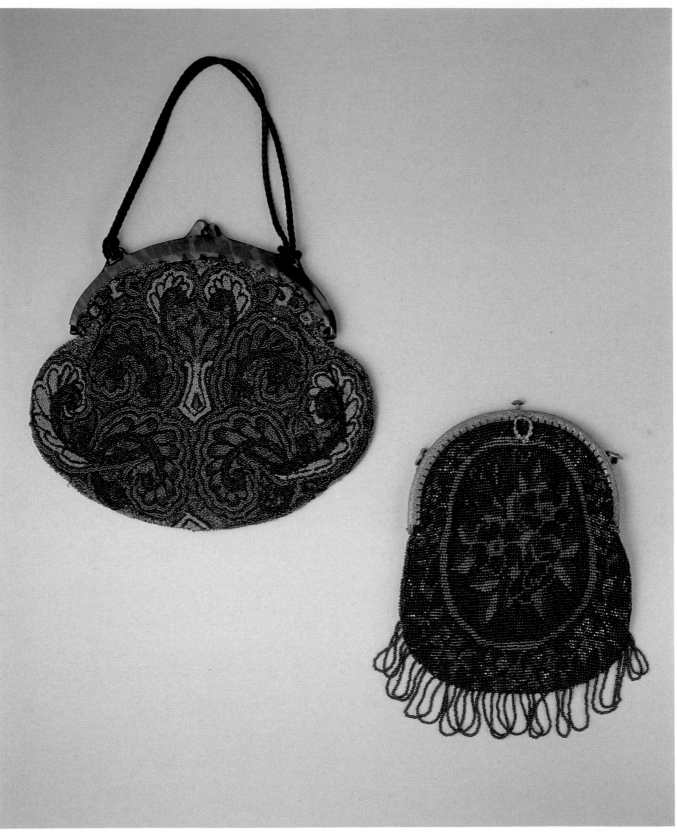

Left:
Size - 10″ x 8¾″

Right:
Size - 6¾″ x 9½″

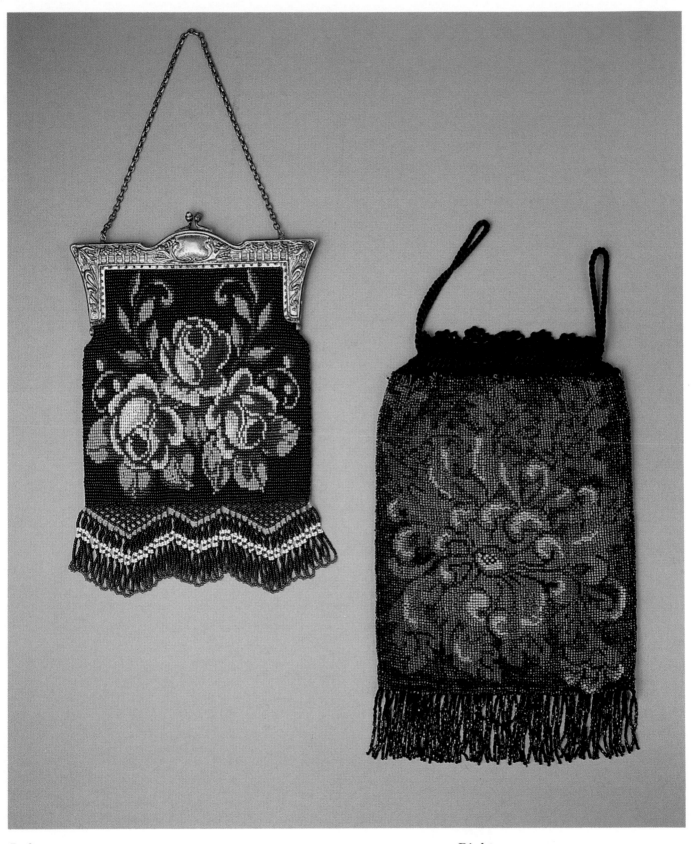

Left:
Size - 7″ x 11″

Right:
Size - 7¼″ x 12¼″

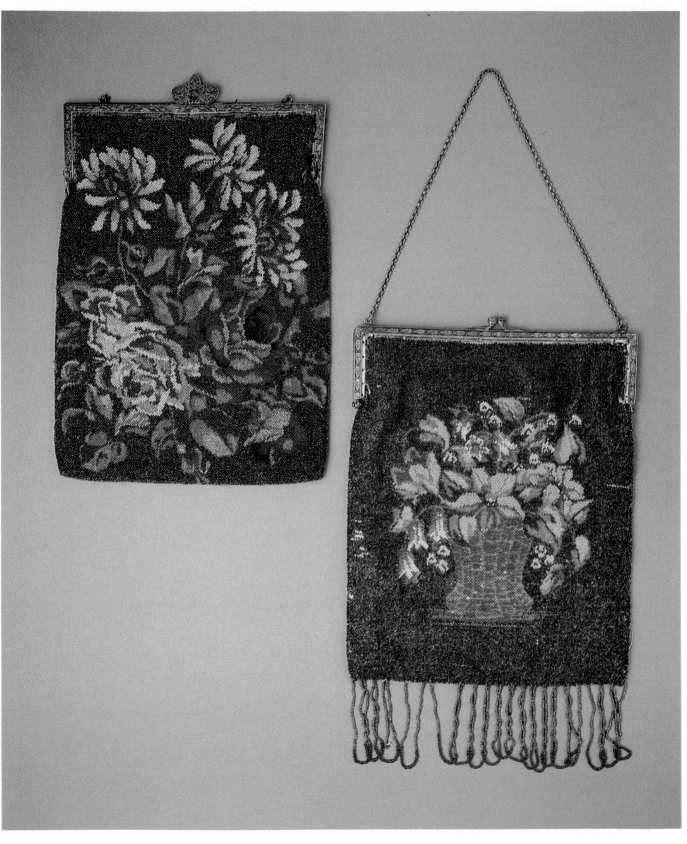

Left:
Size - 7¾″ x 11¾″

Right:
Size - 8″ x 13″

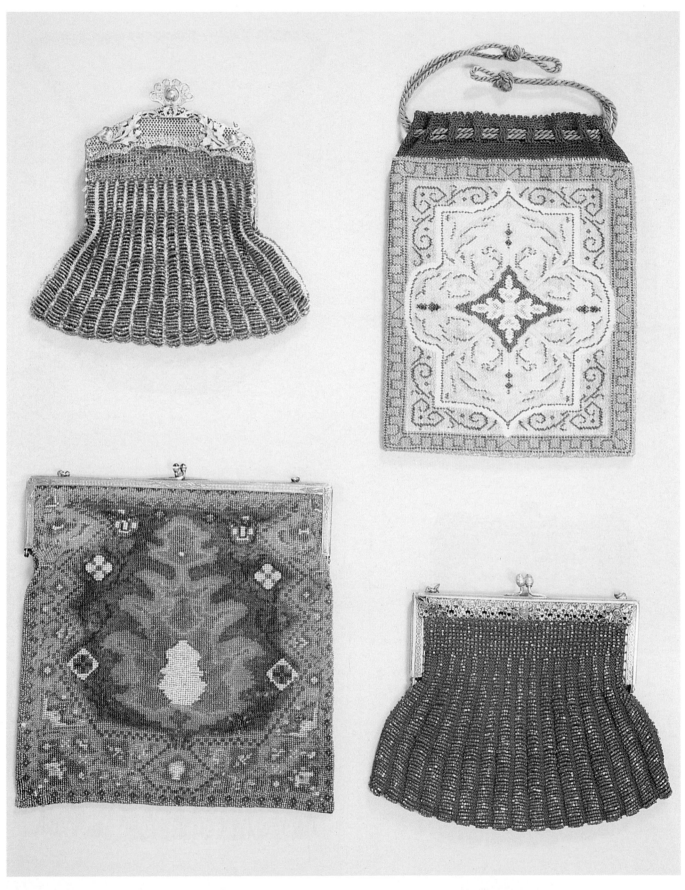

Top Left:
Size - 7½″ x 7¼″

Top Right:
Size - 6¾″ x 9¾″

Bottom Left:
Size - 8½″ x 9¼″
Style - Sterling Silver

Bottom Right:
Size - 8″ x 6¾″

Beaded

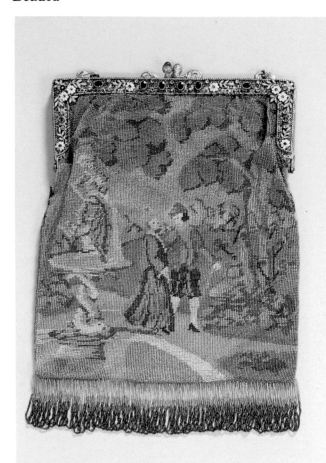

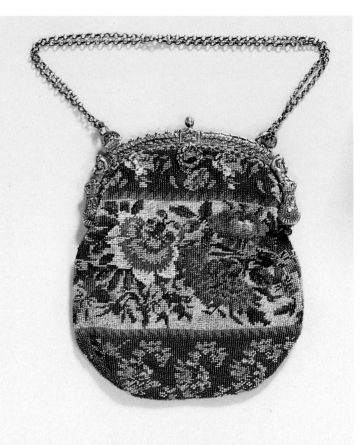

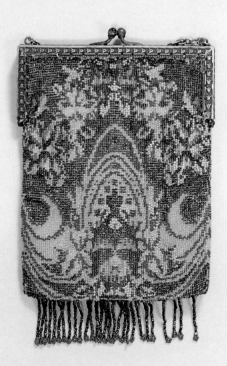

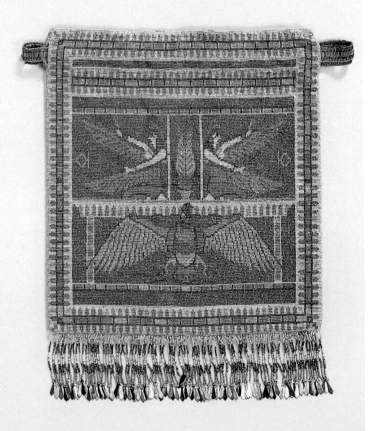

Top Left:
Size - 7½″ x 10¾″
Style - Jeweled Frame:
Carnelian and Moonstone

Bottom Left:
Size - 5½″ x 9″

Top Right:
Size - 6¼″ x 8¼″
Style - 900 Silver

Bottom Right:
Maker - France
Size - 7¾″ x 10¼″

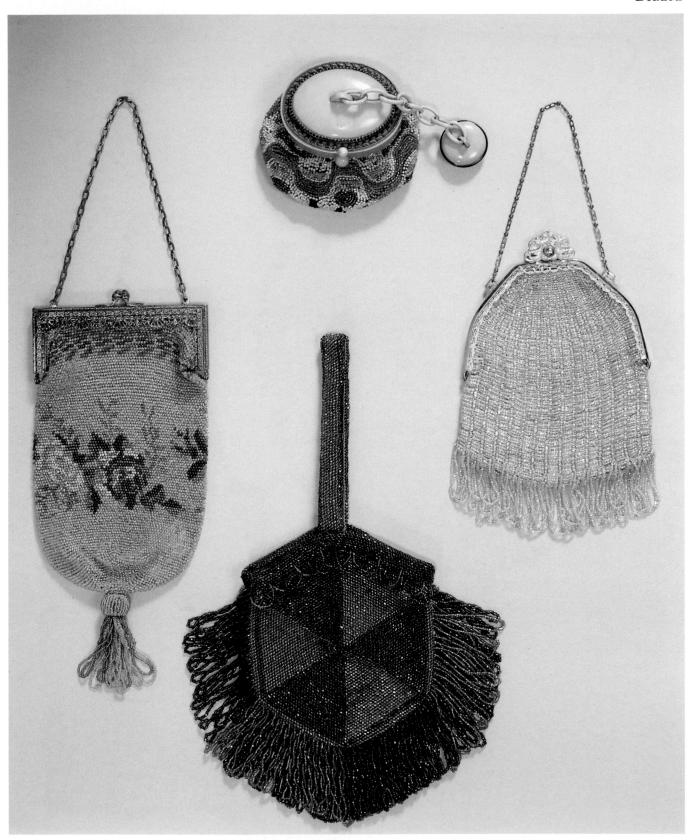

Left:
Size - 5″ x 11¾″

Top Center:
Size - 4¼″ x 9″

Right:
Size - 6″ x 8½″

Bottom Center:
Size - 14½″ x 6½″

Beaded

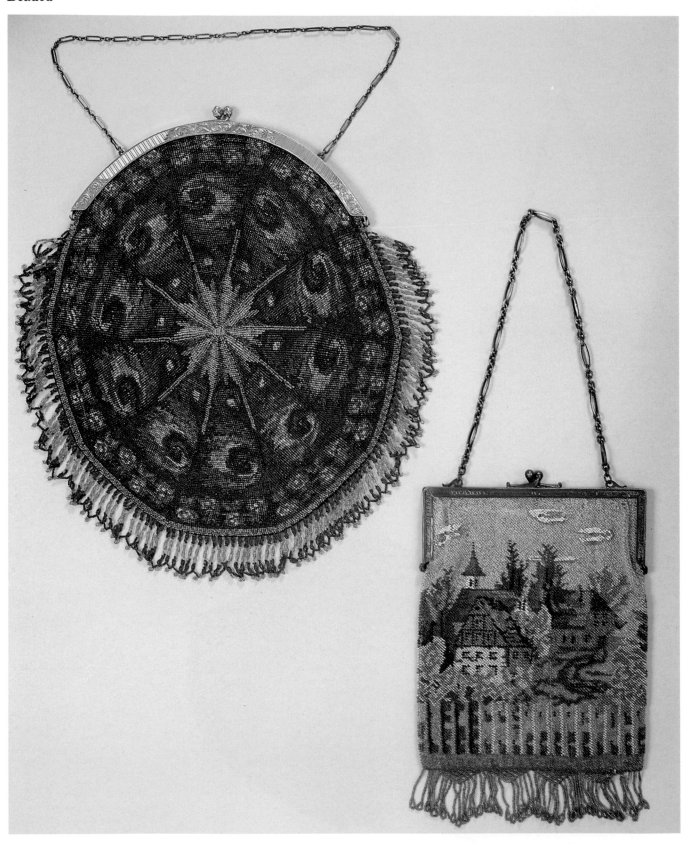

Left:
Size - 11″ x 13¾″
Style - Sterling Frame

Right:
Maker - Germany
Size - 6½″ x 10″

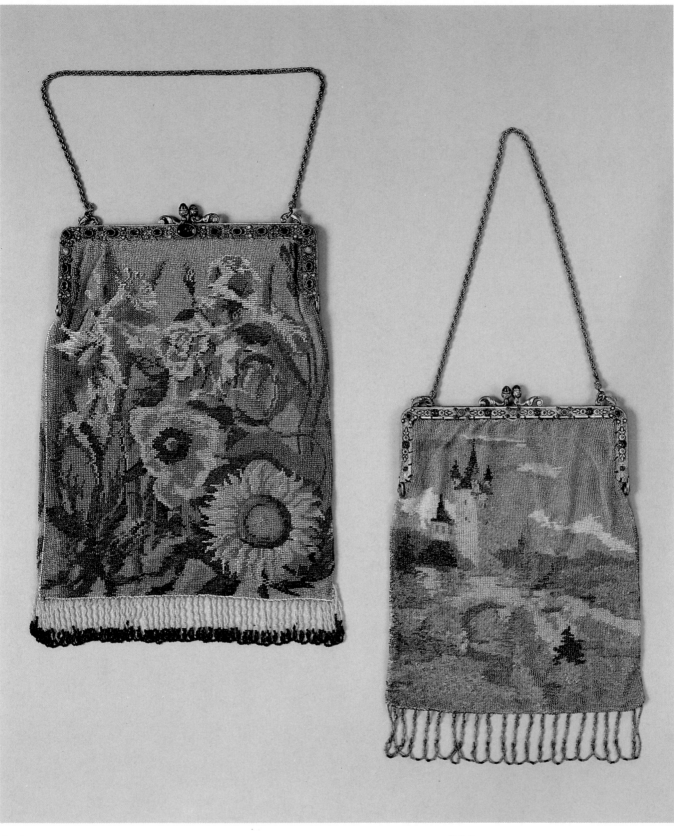

Left:
Size - 8½″ x 12¾″

Right:
Size - 7″ x 10¾″

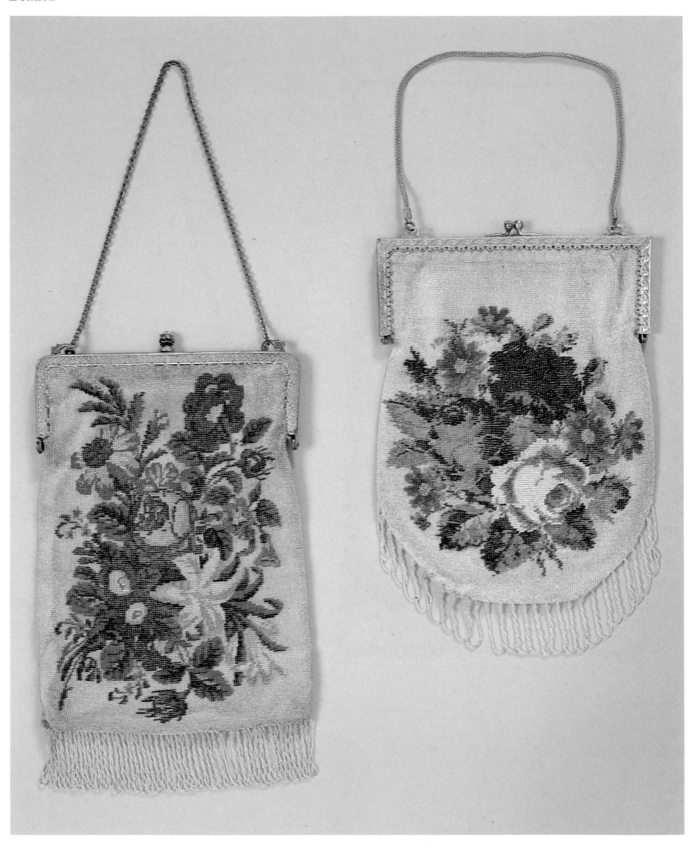

Left:
Size - 7″ x 12¼″

Right:
Size - 7″ x 11½″

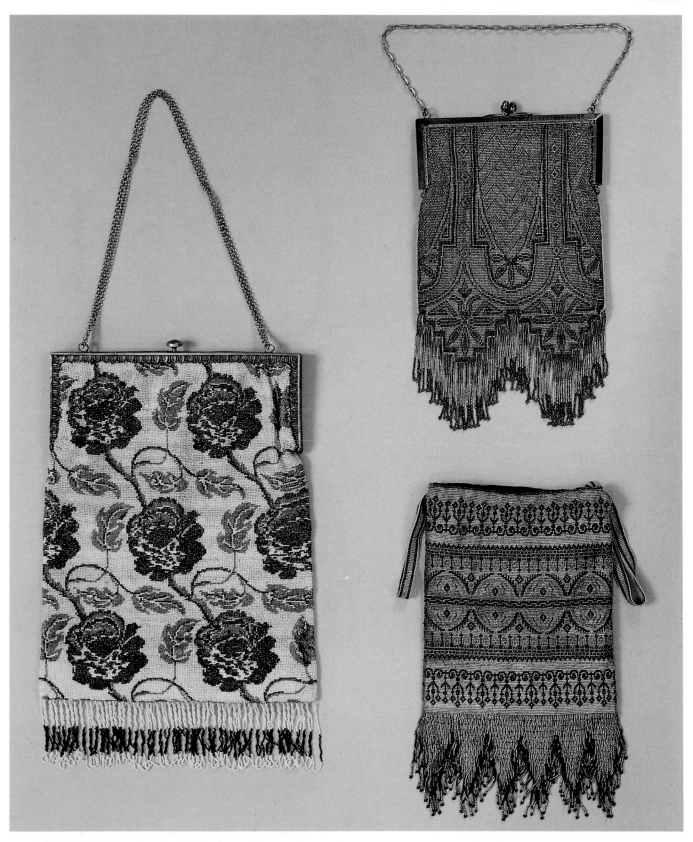

Left:
Maker - France
Size - 8″ x 12¼″

Top Right:
Size - 5¼″ x 9½″

Bottom Right:
Size - 5½″ x 9¼″

Beaded

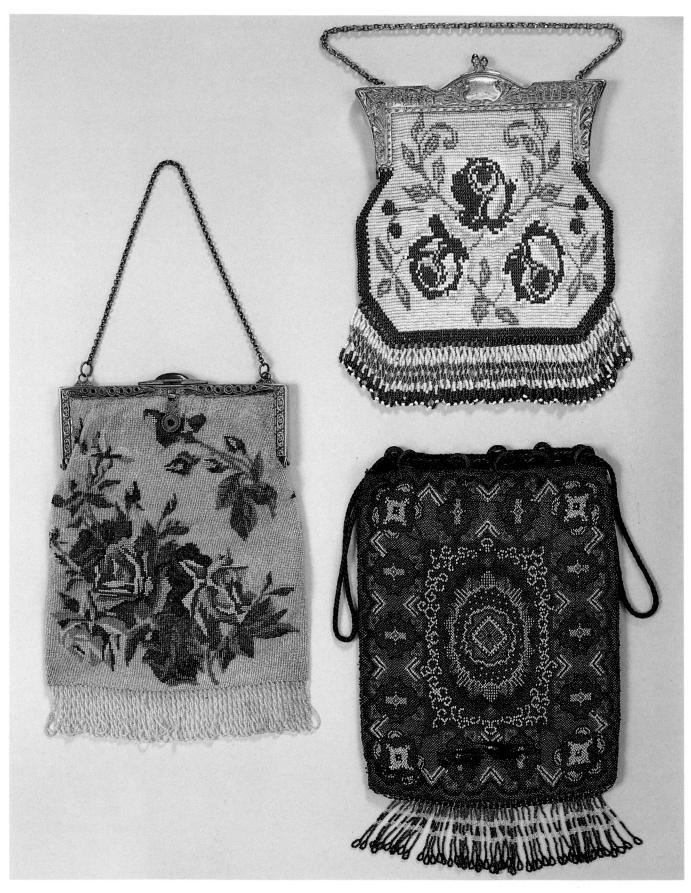

Left:
Size - 7½" x 10½"

Top Right:
Size - 7¼" x 10"

Bottom Right:
Size - 7¼" x 12"

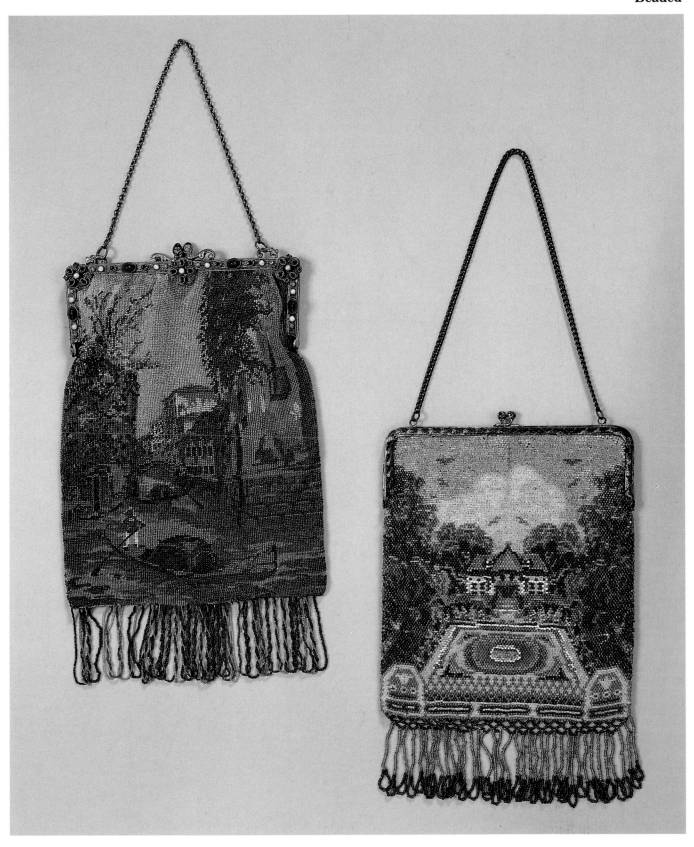

Left:
Size - 7½" x 12¼"

Right:
Size - 7" x 11¼"
 Price established takes into account historical value.
 Information: From the estate of Mr. & Mrs. Higenbottom - President of the First World's
Fair (Columbian Expo 1892-1893). The design on this bag was their home.

Beaded

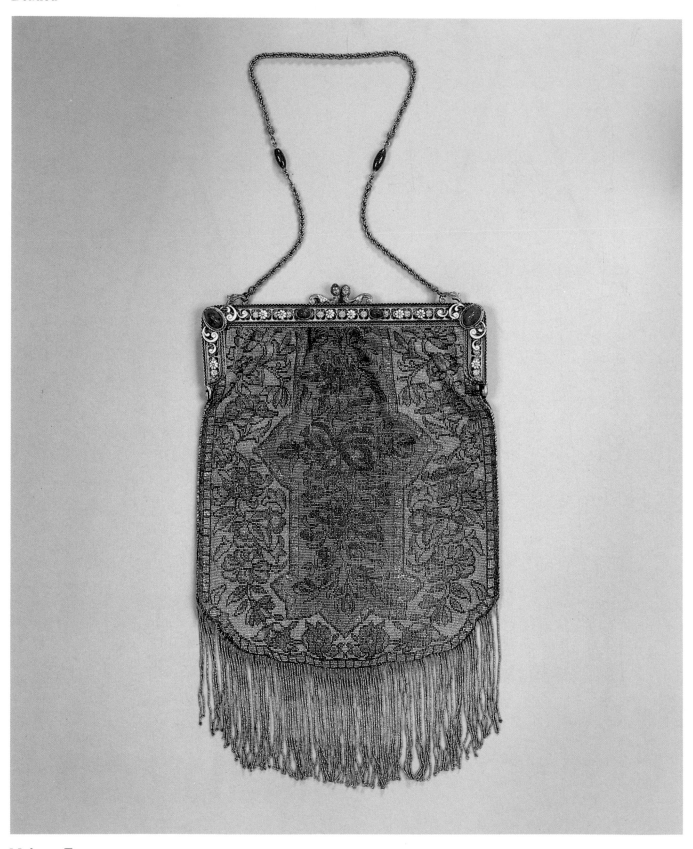

Maker - France
Size - 8½″ x 14″

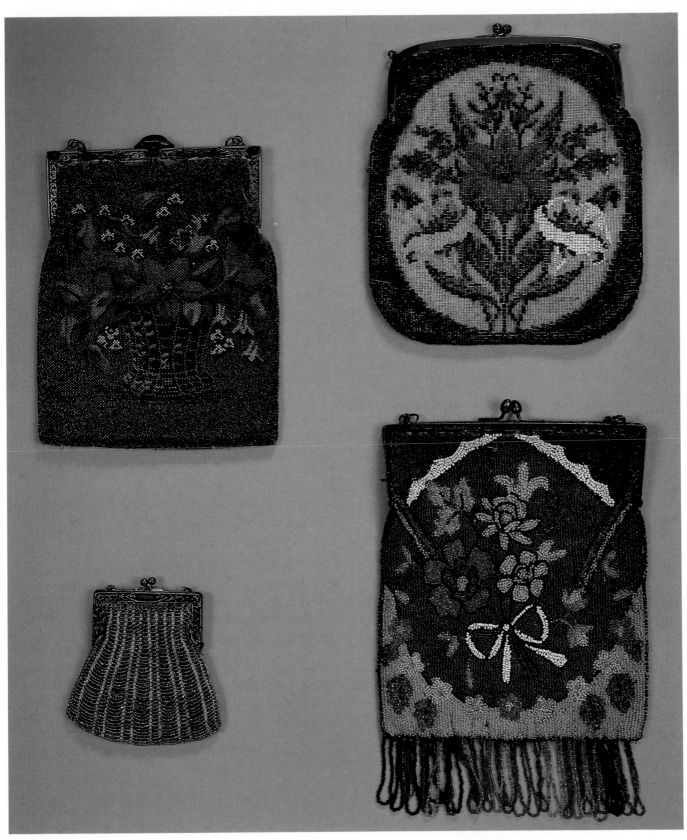

Top Left:
Size - 6¾″ x 8½″

Bottom Left:
Size - 4¼″ x 4¾″

Top Right:
Size - 7½″ x 9″

Bottom Right:
Size - 7½″ x 11½″

Beaded

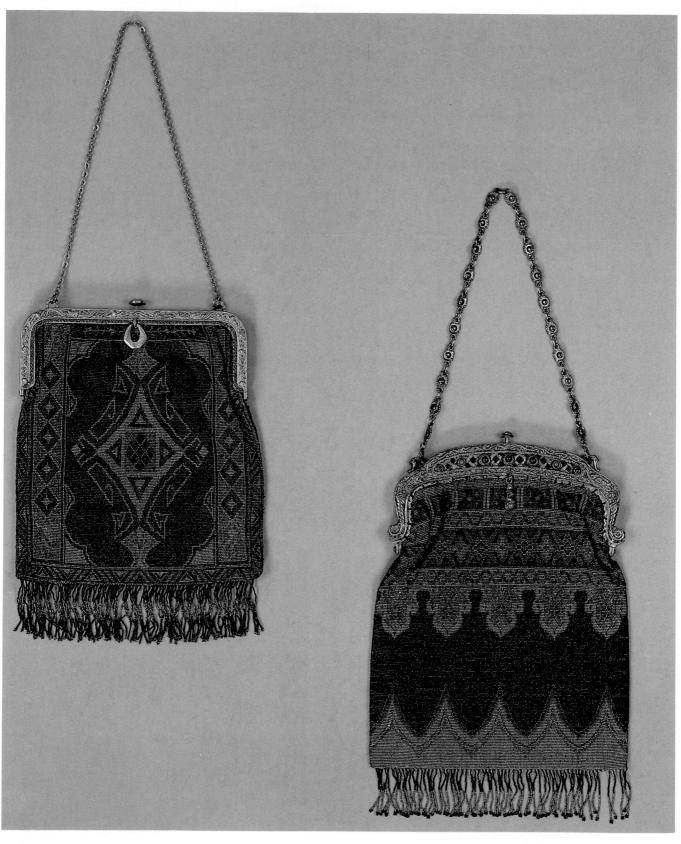

Left:
Maker - France
Size - 7″ x 9¾″

Right:
Size - 7½″ x 11″

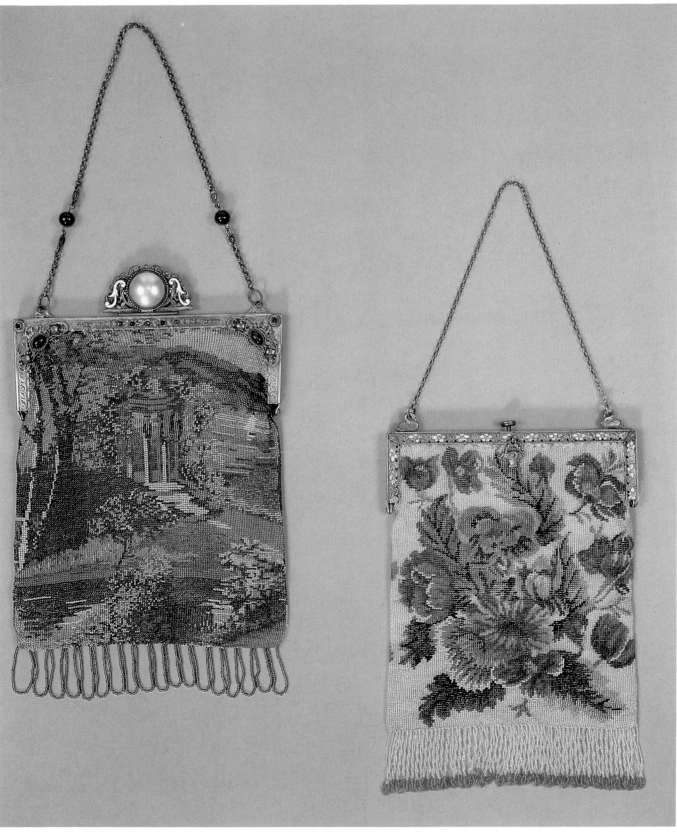

Left:
Size - 7½″ x 12″

Right:
Size - 7¼″ x 10½″

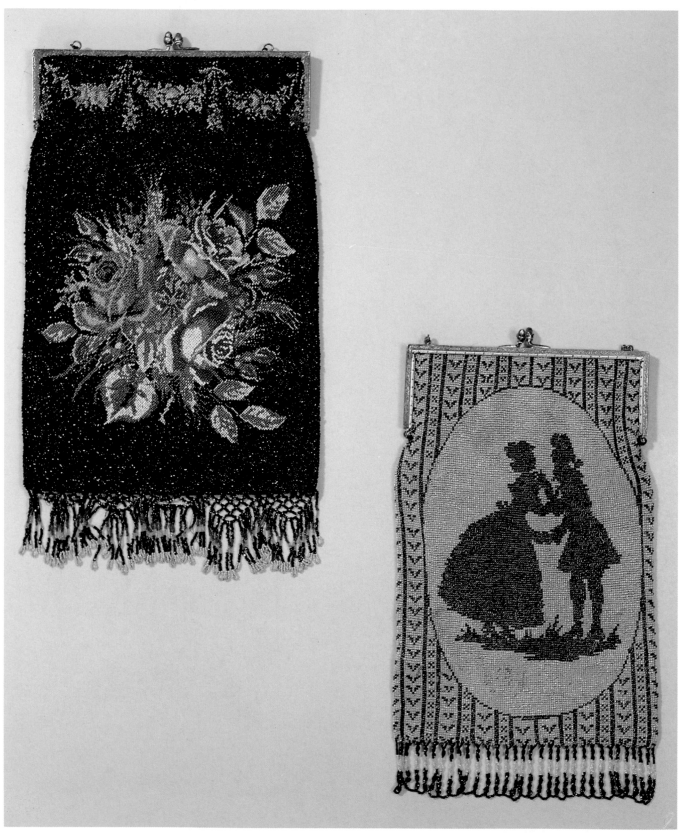

Left:
Size - 8″ x 15″

Right:
Size - 7″ x 12½″

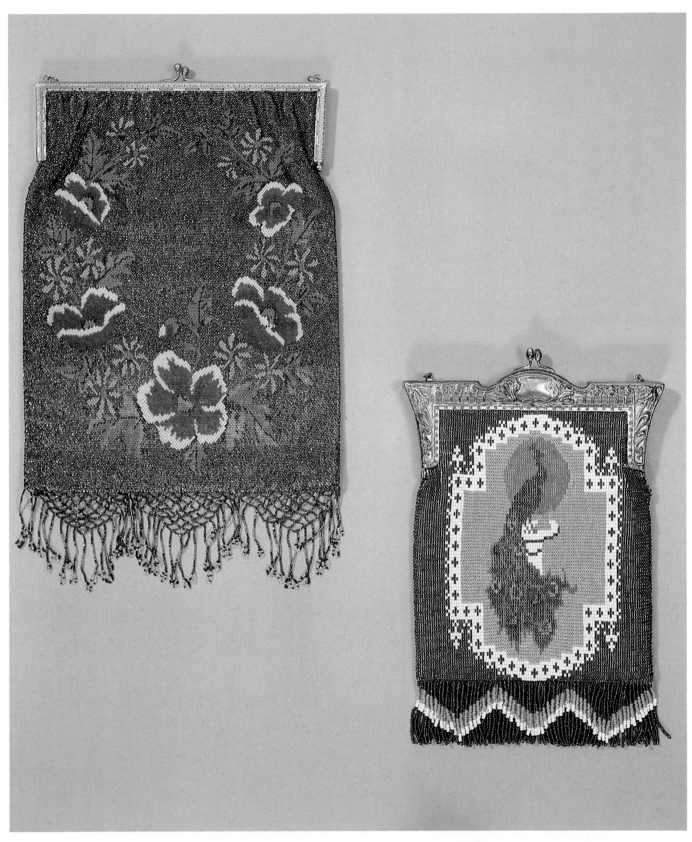

Left:
Size - 8½″ x 14½″

Right:
Size - 7″ x 10¾″

Beaded

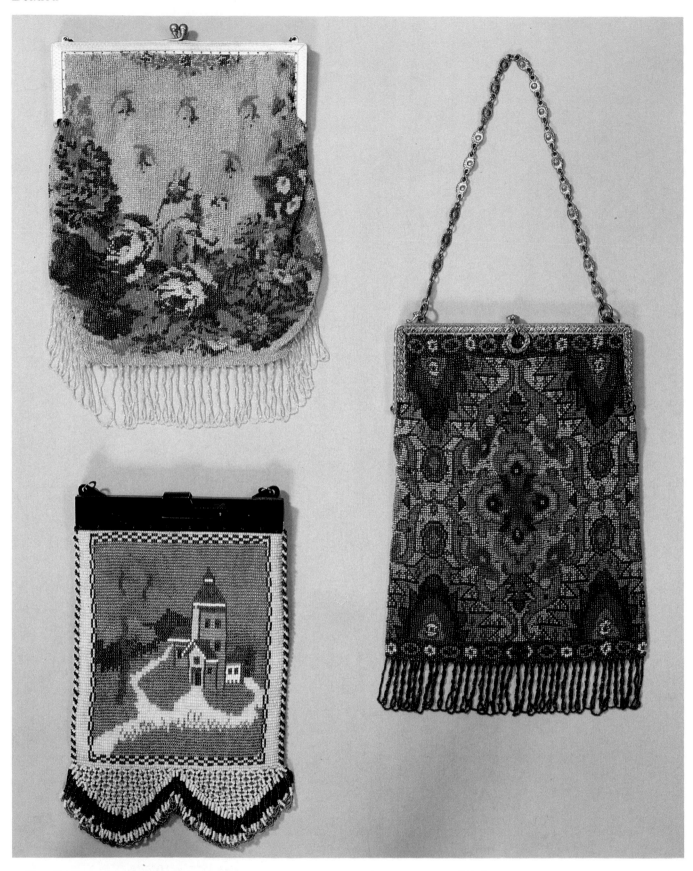

Top Left:
Size - 11″ x 8″

Bottom Left:
Size - 10¼″ x 6″

Right:
Size - 11¼″ x 7½″

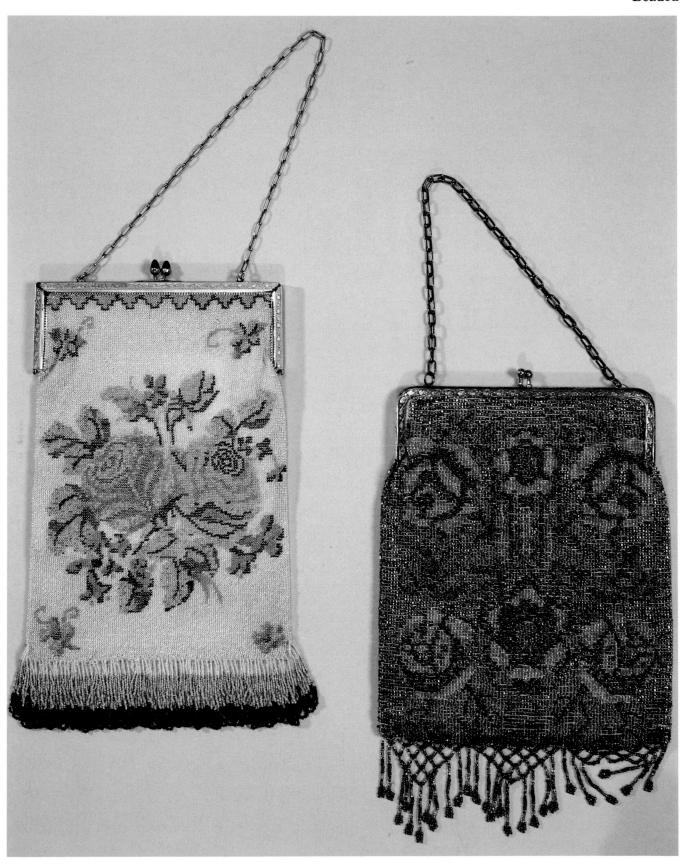

Left:
Size - 6¾″ x 11½″
Style - German Silver

Right:
Size - 7″ x 11″

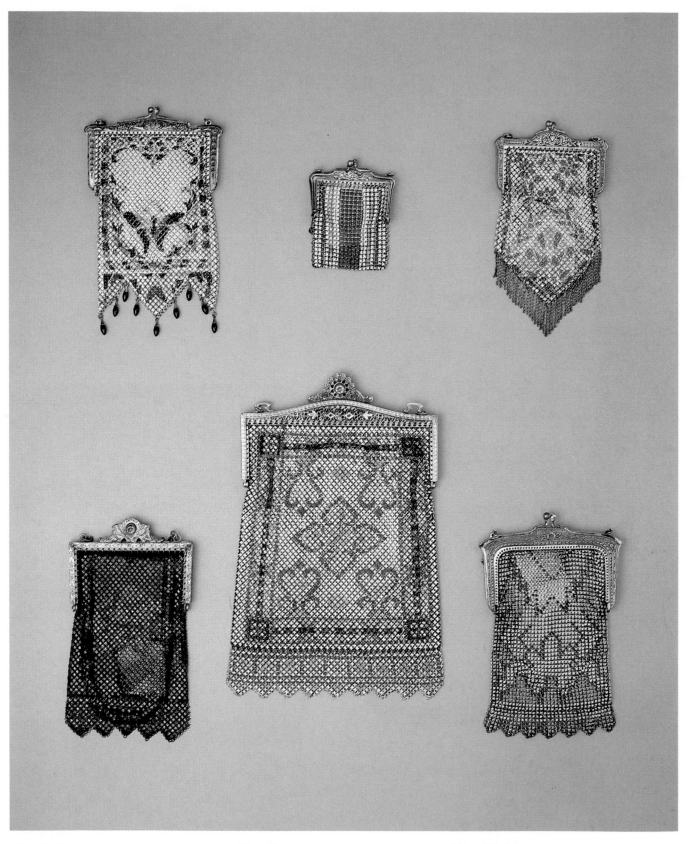

Top Left:
Maker - Mandalian
Size - 4″ x 6¾″

Top Center:
Maker - Whiting & Davis
Size - 2½″ x 3″

Top Right:
Maker - Mandalian
Size - 3¼″ x 6½″

Bottom Left:
Maker - Mandalian
Size - 3½″ x 6½″

Bottom Center:
Maker - Mandalian
Size - 5½″ x 9¼″

Bottom Right:
Maker - Whiting & Davis
Size - 4¼″ x 6¾″
Style - Bead-lite

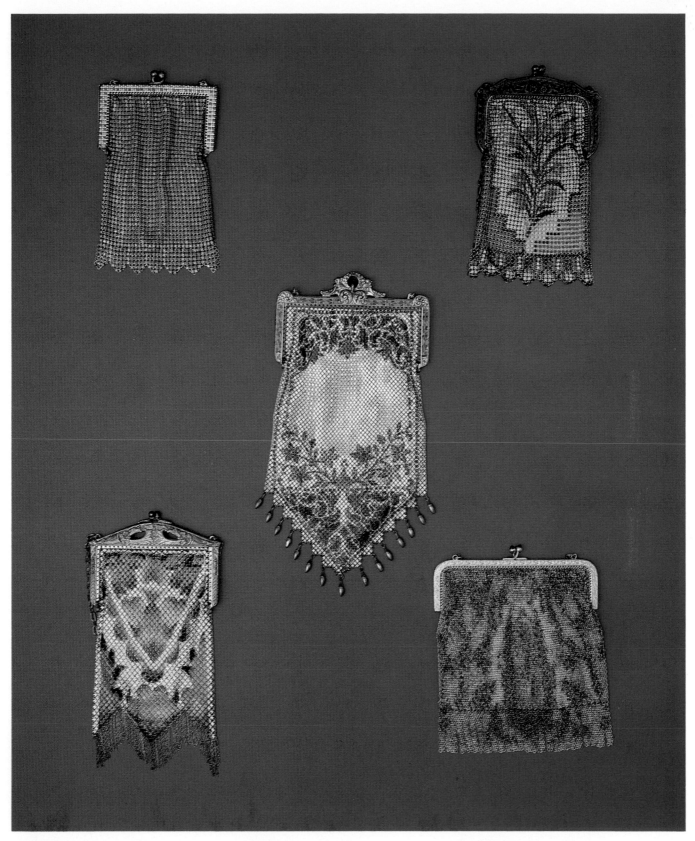

Top Left:
Maker - Whiting & Davis
Size - 3¼" x 5¾"

Center:
Maker - Mandalian
Size - 4½" x 9"

Top Right:
Maker - Whiting & Davis
Size - 3½" x 6¼"

Bottom Left:
Maker - Mandalian
Size - 3¾" x 7½"

Bottom Right:
Maker - Germany
Size - 4¾" x 6"

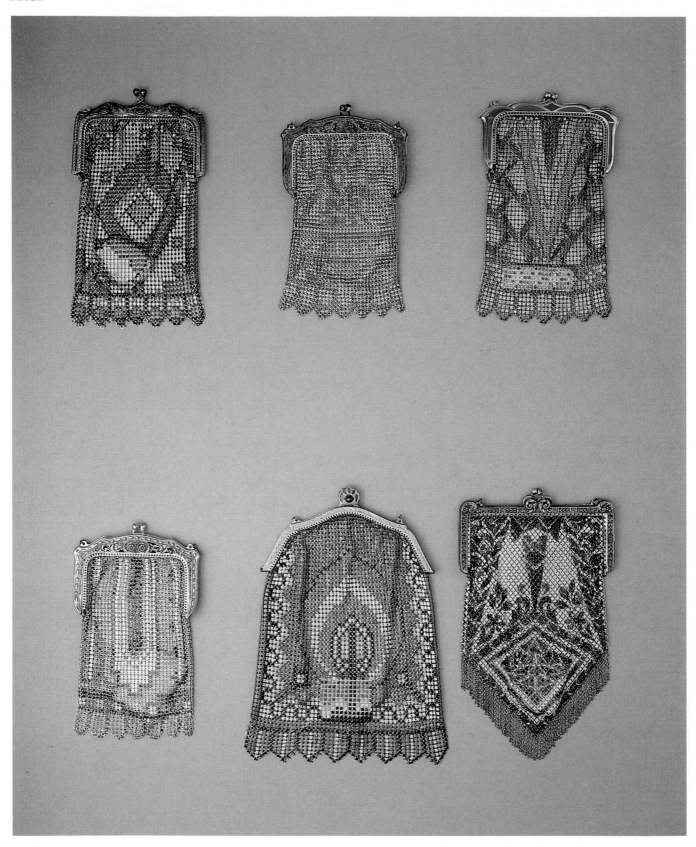

Top Left:
Maker - Whiting & Davis
Size - 3¾″ x 6¾″
Style - Jeweled Framed

Bottom Left:
Maker - Whiting & Davis
Size - 3½″ x 6½″

Top Center:
Maker - Whiting & Davis
Size - 3½″ x 6″

Bottom Center:
Maker - Whiting & Davis
Size - 5″ x 8¼″

Top Right:
Maker - Whiting & Davis
Size - 4″ x 6¾″

Bottom Right:
Maker - Mandalian
Size - 4½″ x 8″

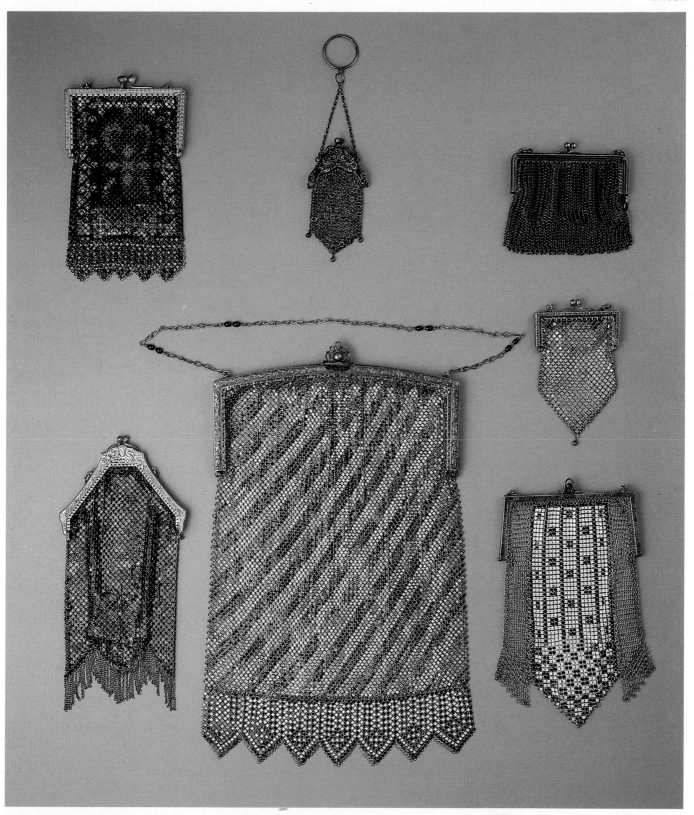

Top Left:
Maker - Mandalian
Size - 3½″ x 6″

Bottom Left:
Maker - Mandalian
Size - 3⅓″ x 7¾″

Top Center:
Size - 1¾″ x 3¼″

Bottom Center:
Maker - Whiting & Davis
Size - 7″ x 12″

Top Right:
Size - 3¼″ x 3″
Style - Gun-metal

Center Right:
Size - 1¼″ x 3¾″
Style - Gun-metal

Bottom Right:
Maker - Whiting & Davis
Size - 4″ x 7¼″

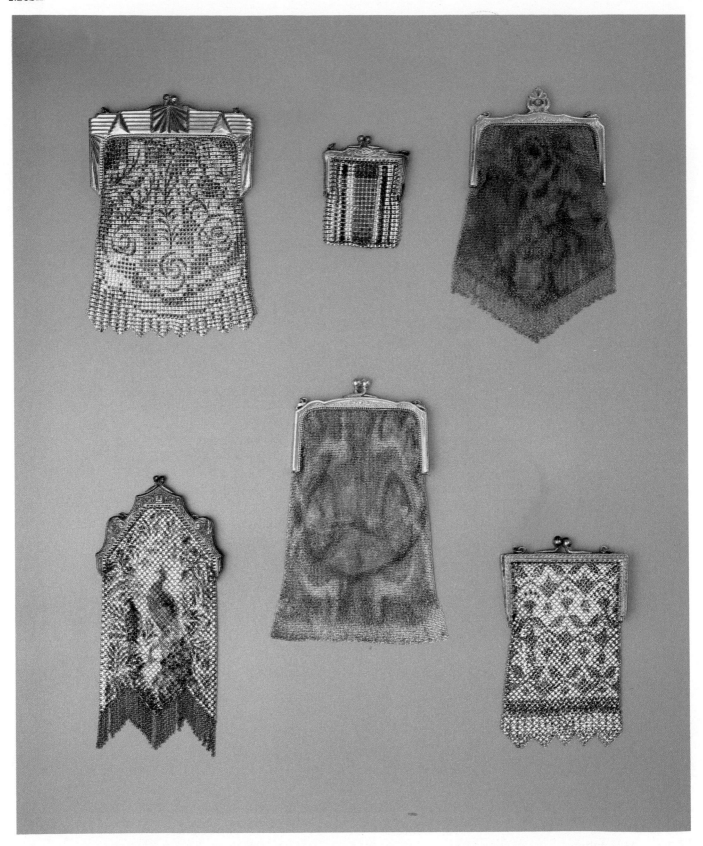

Top Left:
Maker - Whiting & Davis
Size - 4¾″ x 7″

Top Center:
Maker - Whiting & Davis
Size - 2¼″ x 3¼″

Top Right:
Maker - Whiting & Davis
Size - 4″ x 7½″

Bottom Left:
Maker - Mandalian
Size - 3¾″ x 7¾″

Bottom Center:
Maker - Whiting & Davis
Size - 3¾″ x 7¾″

Bottom Right:
Maker - Mandalian
Size - 3½″ x 6¼″

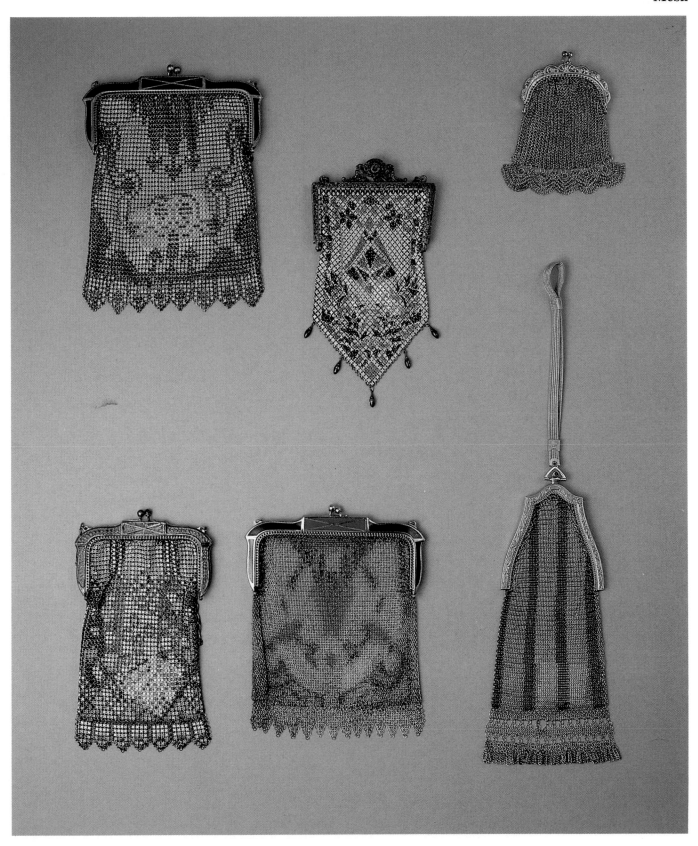

Top Left:
Maker - Whiting & Davis
Size - 5″ x 7¼″

Bottom Left:
Maker - Whiting & Davis
Size - 4″ x 7″

Top Center:
Maker - Mandalian
Size - 3½″ x 7″

Bottom Center:
Maker - Whiting & Davis
Size - 5″ x 6¾″

Top Right:
Size - 2½″ x 4″

Bottom Right:
Maker - Whiting & Davis
Size - 3″ x 8½″

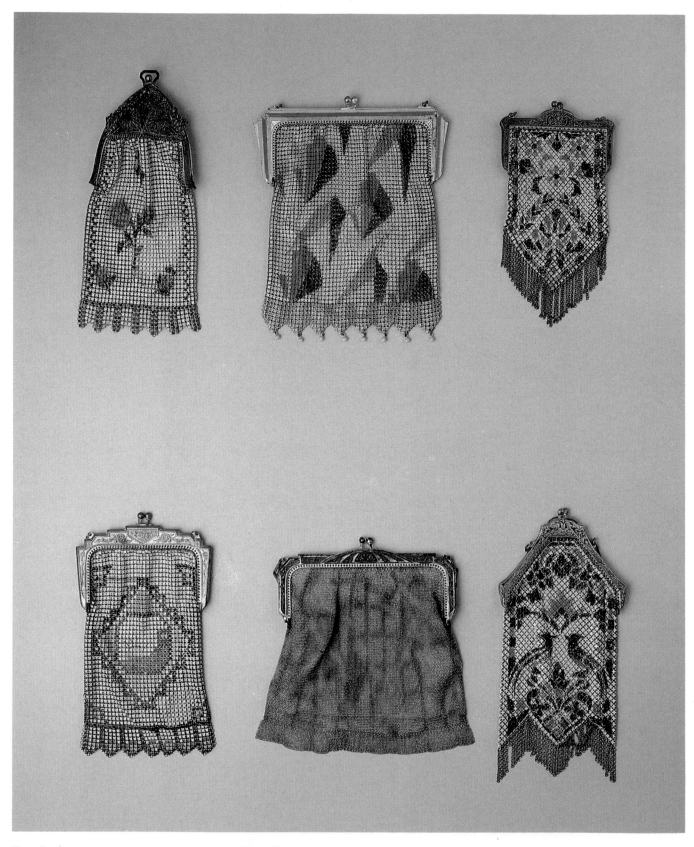

Top Left:
Maker - Whiting & Davis
Size - 3″ x 7½″
Style - "El Sah"

Bottom Left:
Maker - Whiting & Davis
Size - 3¾″ x 7″

Top Center:
Maker - Whiting & Davis
Size - 5½″ x 7¼″

Bottom Center:
Maker - Whiting & Davis
Size - 5″ x 6¼″

Top Right:
Maker - Mandalian
Size - 3¼″ x 6½″

Bottom Right:
Maker - Mandalian
Size - 3¾″ x 8″

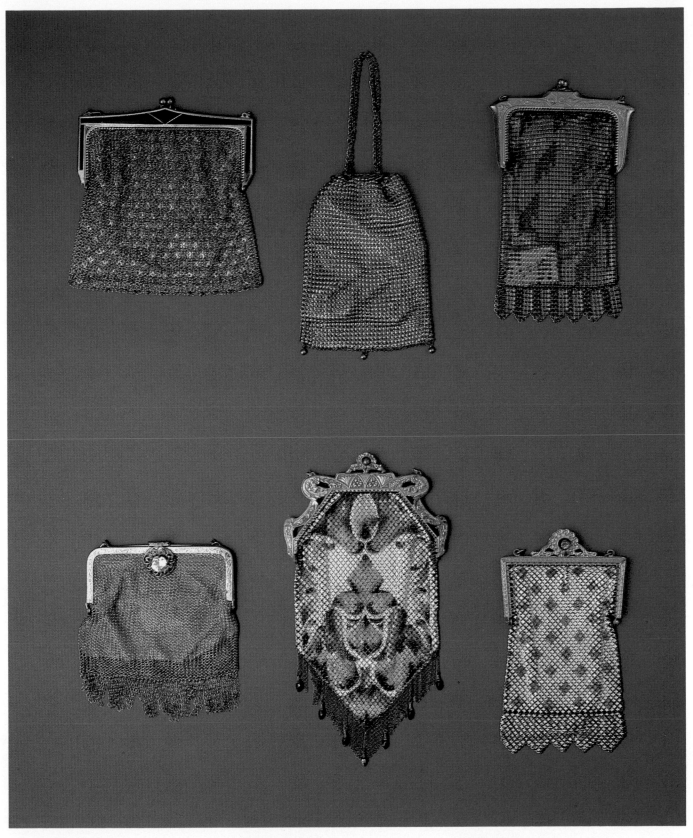

Top Left:
Maker - Whiting & Davis
Size - 5″ x 5¾″

Bottom Left:
Maker - Germany
Size - 4″ x 5¼″

Top Center:
Maker - Whiting & Davis
Size - 3½″ x 5″
Style - Bead-lite

Bottom Center:
Maker - Mandalian
Size - 4¾″ x 9″

Top Right:
Maker - Whiting & Davis
Size - 4″ x 7″

Bottom Right:
Maker - Mandalian
Size - 3½″ x 6½″

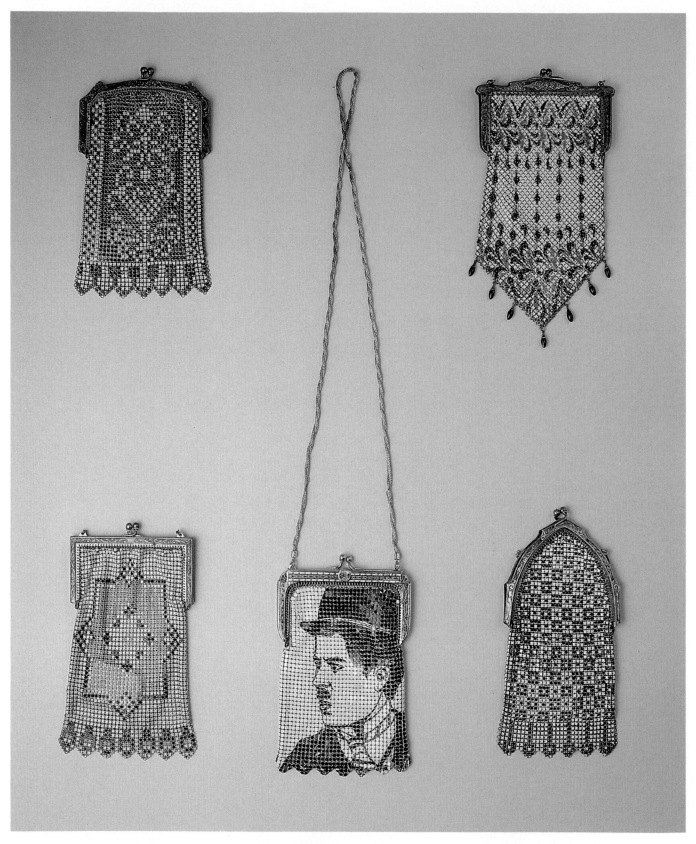

Top Left:
Maker - Whiting & Davis
Size - 3¾″ x 6½″

Bottom Left:
Maker - Whiting & Davis
Size - 3½″ x 7″

Bottom Center:
Maker - Whiting & Davis
Size - 3¾″ x 6¼″
This was part of a series produced for a short time in the late 1960's. Four movie stars were featured — Charlie Chaplin, Clark Gable and possibly Carol Lombard and Mona Sheara.

Top Right:
Maker - Mandalian
Size - 4″ x 8″

Bottom Right:
Maker - Whiting & Davis
Size - 3¼″ x 7¼″

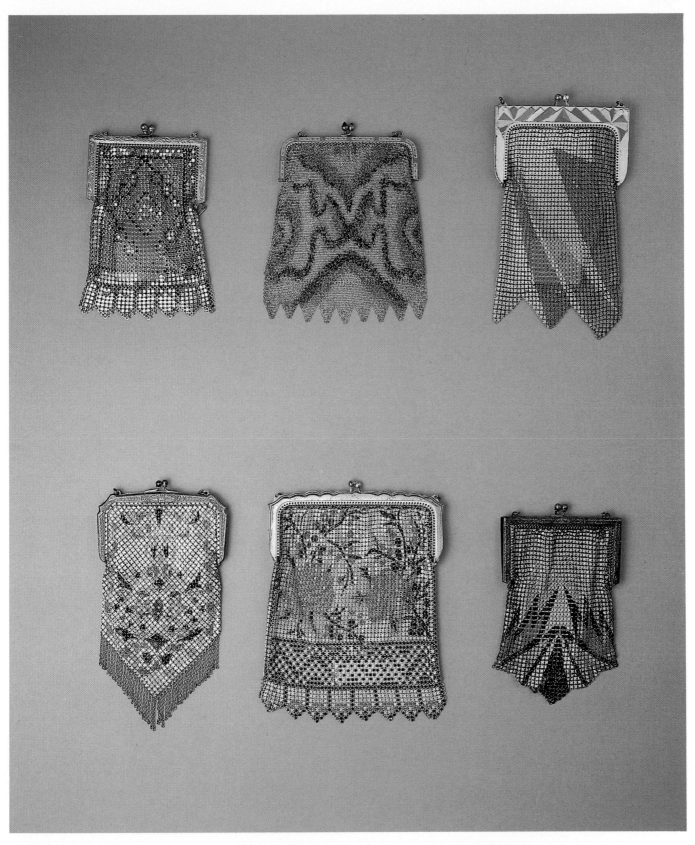

Top Left:
Maker - Whiting & Davis
Size - 3¼″ x 5¼″

Top Center:
Maker - Germany
Size - 4″ x 5¾″

Top Right:
Maker - Whiting & Davis
Size - 3¾″ x 6¾″

Bottom Left:
Maker - Mandalian
Size - 3½″ x 7¼″

Bottom Center:
Maker - Whiting & Davis
Size - 5″ x 7″

Bottom Right:
Maker - Whiting & Davis
Size - 3¾″ x 5¾″

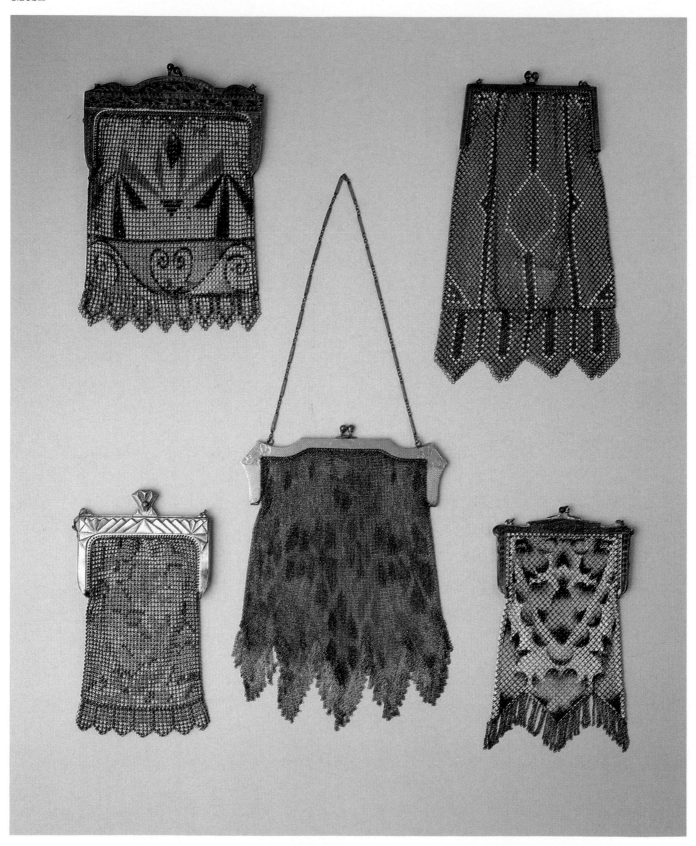

Top Left:
Maker - Whiting & Davis
Size - 5¼″ x 7½″

Bottom Left:
Maker - Whiting & Davis
Size - 3¾″ x 7¼″

Bottom Center:
Maker - Whiting & Davis
Size - 6½″ x 8¾″

Top Right:
Maker - Whiting & Davis
Size - 5″ x 9″

Bottom Right:
Maker - Mandalian
Size - 4″ x 7¼″

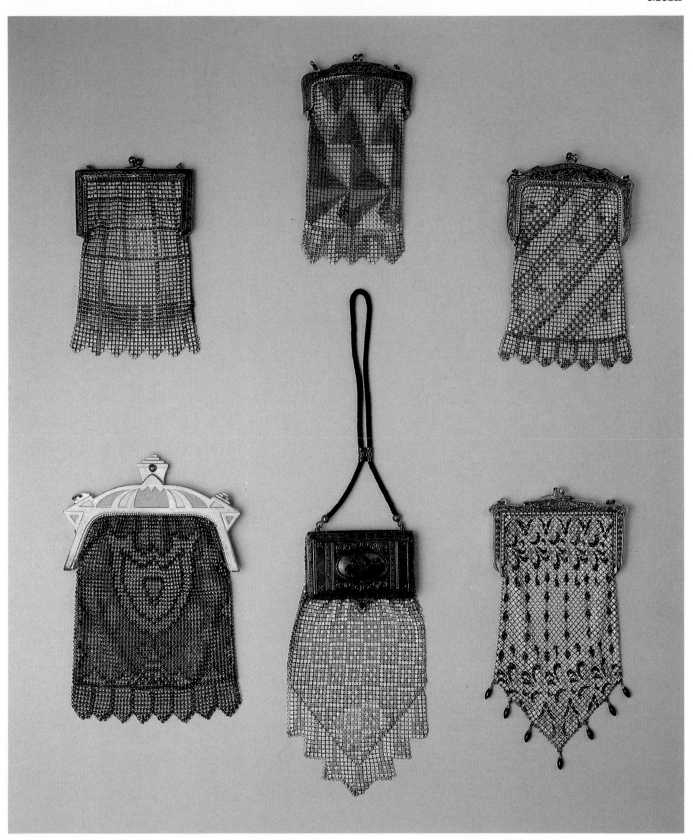

Top Left:
Maker - Whiting & Davis
Size - 3½″ x 5½″

Top Center:
Maker - Whiting & Davis
Size - 3¼″ x 6″

Top Right:
Maker - Whiting & Davis
Size - 3½″ x 6¼″

Bottom Left:
Maker - Whiting & Davis
Size - 5″ x 7¾″
Style - Bead-lite

Bottom Center:
Maker - Whiting & Davis
Size - 4″ x 7½″

Bottom Right:
Maker - Mandalian
Size - 4″ x 8″

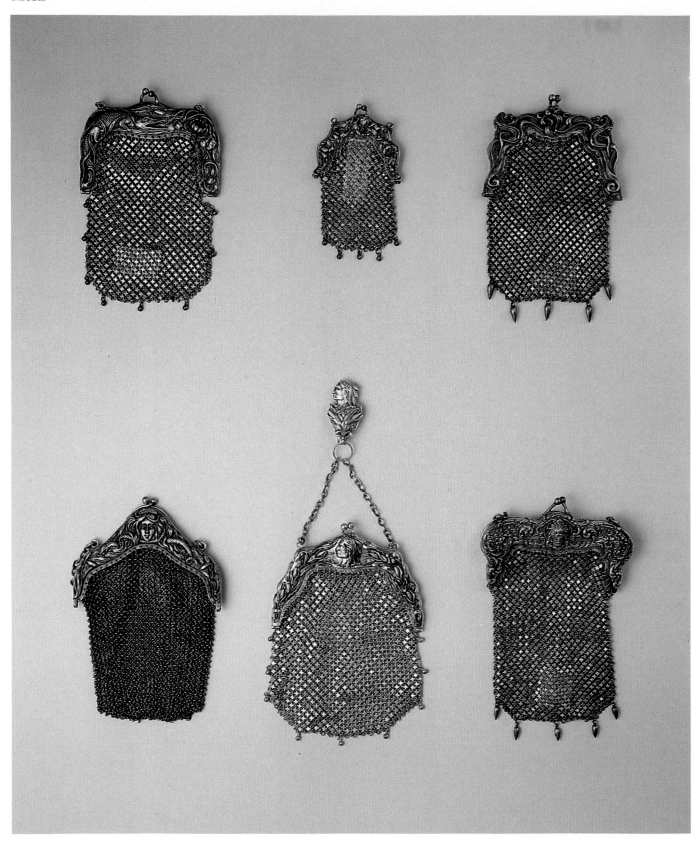

Top Left:
Maker - Whiting & Davis
Size - 3¾″ x 6¼″
Style - Sterling

Bottom Left:
Size - 4¼″ x 6¼″
Style - Sterling

Top Center:
Size - 2¾″ x 4¼″
Style - Sterling

Bottom Center:
Maker - Whiting & Davis
Size - 4¼″ x 6¼″
Style - Sterling

Top Right:
Size - 4″ x 6½″
Style - Sterling

Bottom Right:
Size - 4½″ x 7″
Style - Sterling

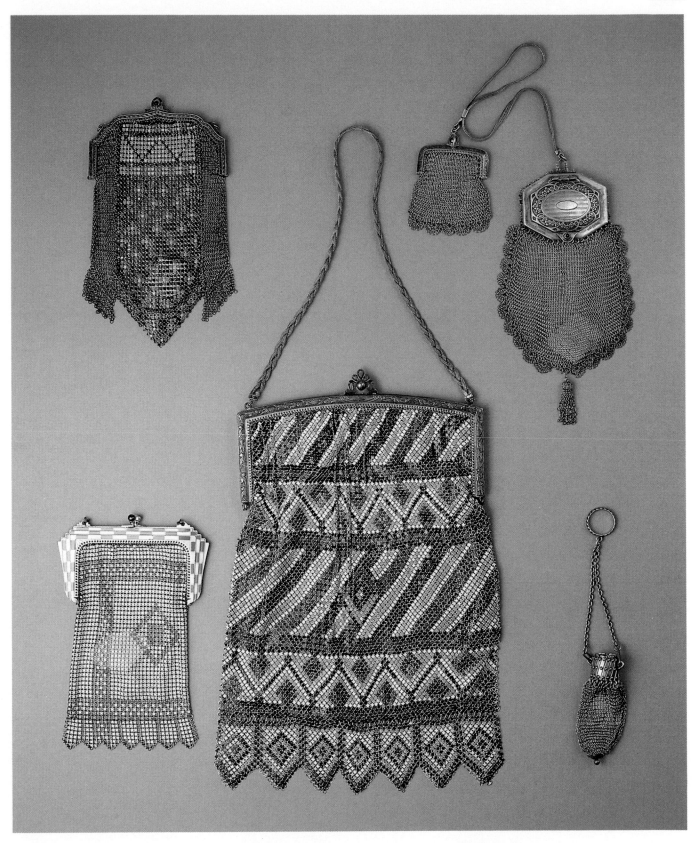

Top Left:
Maker - Whiting & Davis
Size - 4″ x 7″

Bottom Left:
Maker - Whiting & Davis
Size - 4½″ x 6¾″

Bottom Center:
Maker - Whiting & Davis
Size - 9¼″ x 12″

Top Right:
Maker - Whiting & Davis
Size - 3½″ x 7½″

Bottom Right:
Maker - Whiting & Davis
Size - 1½″ x 3½″

Mesh

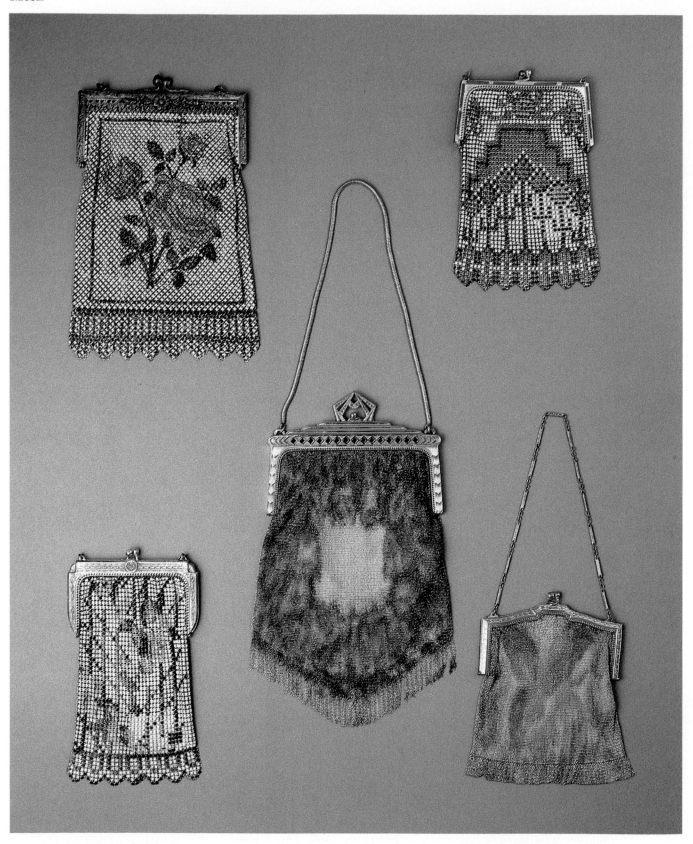

Top Left:
Maker - Mandalian
Size - 5″ x 8¼″

Center:
Maker - Whiting & Davis
Size - 5″ x 9½″

Top Right:
Maker - Whiting & Davis
Size - 4″ x 6½″

Bottom Left:
Maker - Whiting & Davis
Size - 3¾″ x 7″

Bottom Right:
Maker - Whiting & Davis
Size - 4″ x 5½″

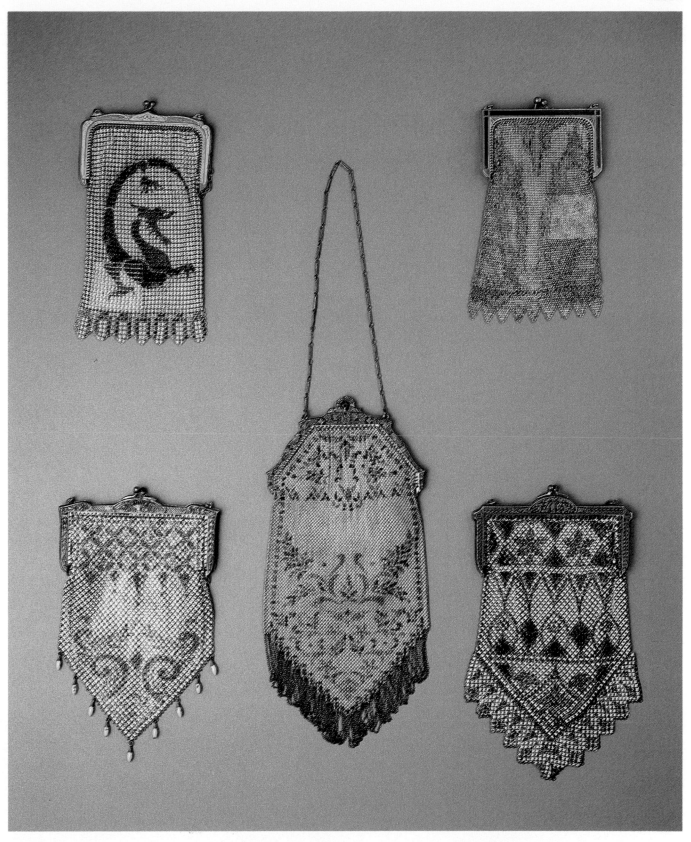

Top Left:
Maker - Whiting & Davis
Size - 3¾″ x 7″

Bottom Left:
Maker - Mandalian
Size - 4½″ x 7¾″

Bottom Center:
Maker - Mandalian
Size - 4½″ x 10″

Top Right:
Maker - Whiting & Davis
Size - 4″ x 6¼″

Bottom Right:
Maker - Mandalian
Size - 4½″ x 8½″

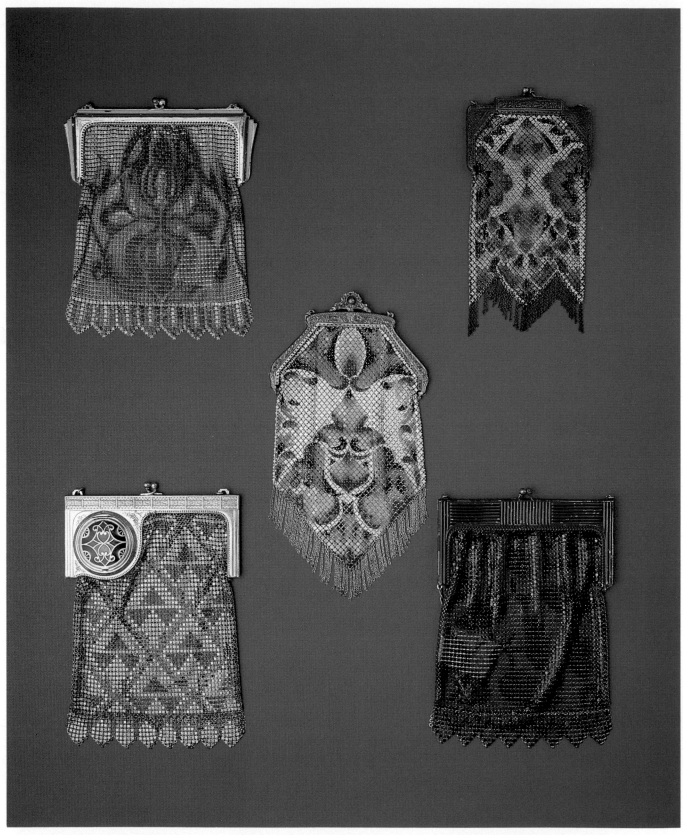

Top Left:
Maker - Whiting & Davis
Size - 5½″ x 6¾″

Bottom Left:
Maker - Whiting & Davis
Size - 5″ x 7¾″

Center:
Maker - Mandalian
Size - 4½″ x 8¾″

Top Right:
Maker - Mandalian
Size - 3½″ x 7″

Bottom Right:
Maker - Whiting & Davis
Size - 5″ x 7¼″

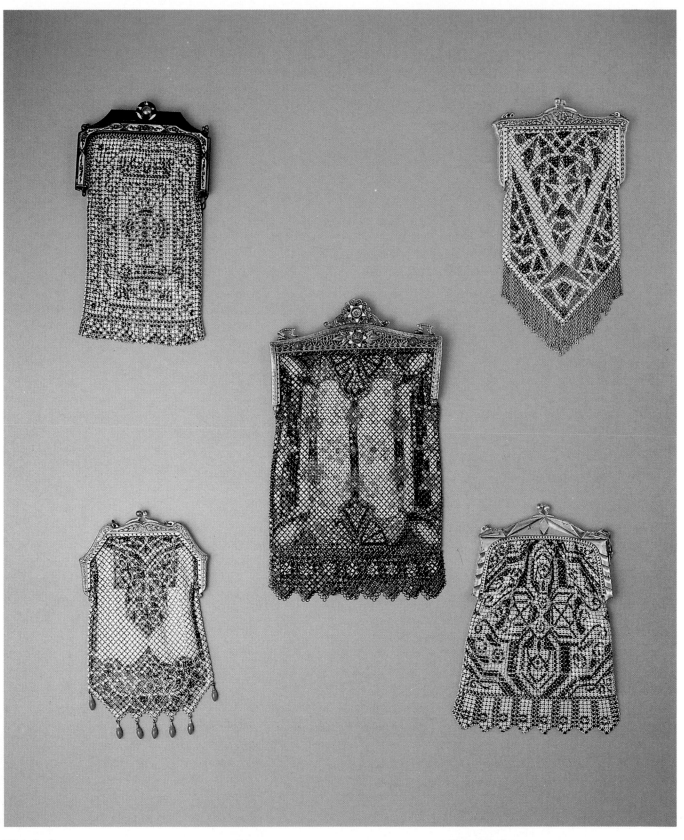

Top Left:
Maker - Whiting & Davis
Size - 3¾″ x 6¾″

Bottom Left:
Maker - Mandalian
Size - 3¾″ x 6¾″

Center:
Maker - Mandalian
Size - 5″ x 8¾″

Top Right:
Maker - Mandalian
Size - 4″ x 7½″

Bottom Right:
Maker - Whiting & Davis
Size - 4½″ x 6¾″

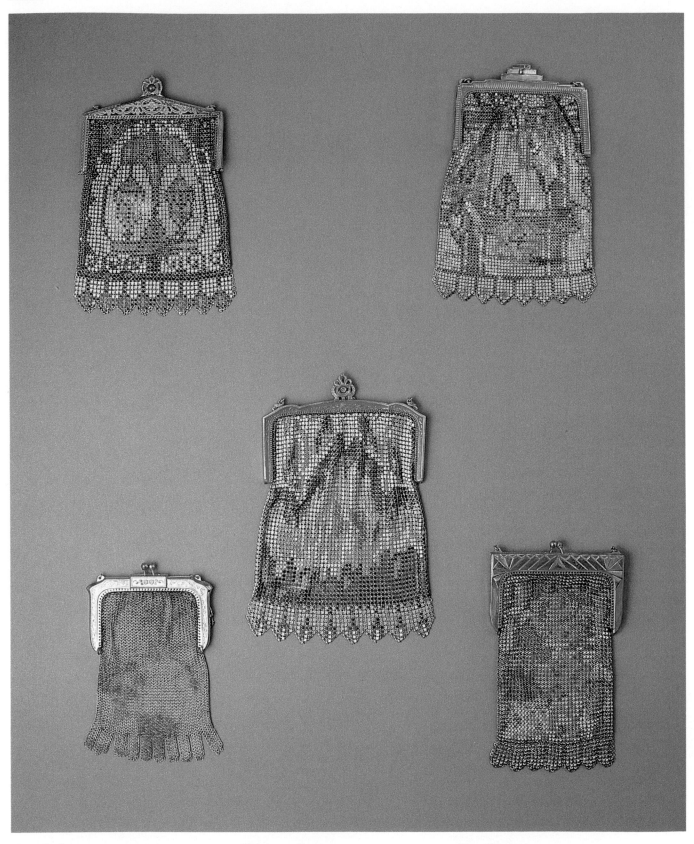

Top Left:
Maker - Whiting & Davis
Size - 4″ x 7″

Bottom Left:
Maker - Whiting & Davis
Size - 3½″ x 6″

Bottom Center:
Maker - Whiting & Davis
Size - 4½″ x 7¾″

Top Right:
Maker - Whiting & Davis
Size - 4″ x 7″

Bottom Right:
Maker - Whiting & Davis
Size - 3¾″ x 6¾″
Style - Bead-lite

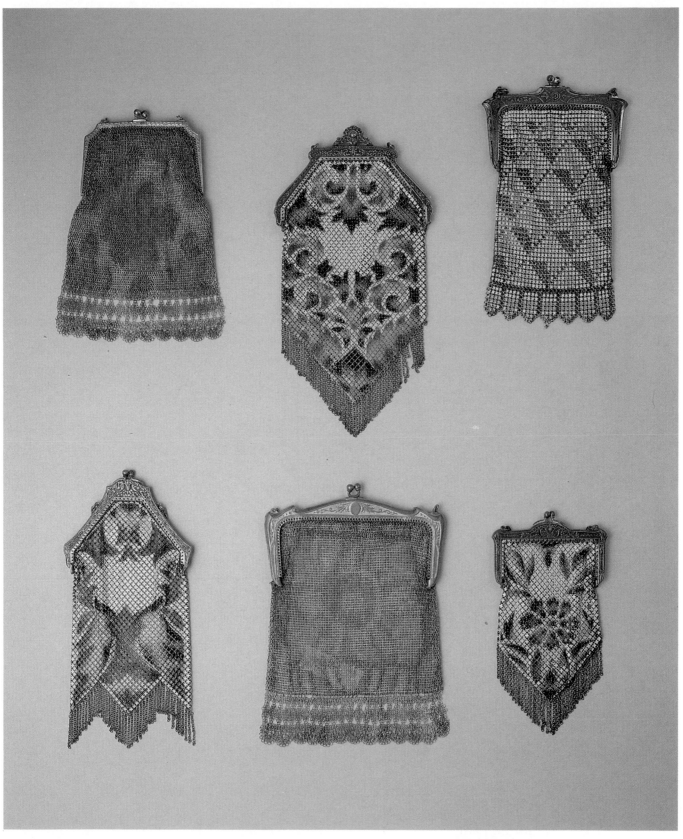

Top Left:
Maker - Whiting & Davis
Size - 4¾" x 6½"

Top Center:
Maker - Mandalian
Size - 4½" x 8¾"

Top Right:
Maker - Whiting & Davis
Size - 4" x 7"

Bottom Left:
Maker - Mandalian
Size - 3½" x 7¾"

Bottom Center:
Maker - Whiting & Davis
Size - 5" x 7½"

Bottom Right:
Maker - Mandalian
Size - 3¼" x 6½"

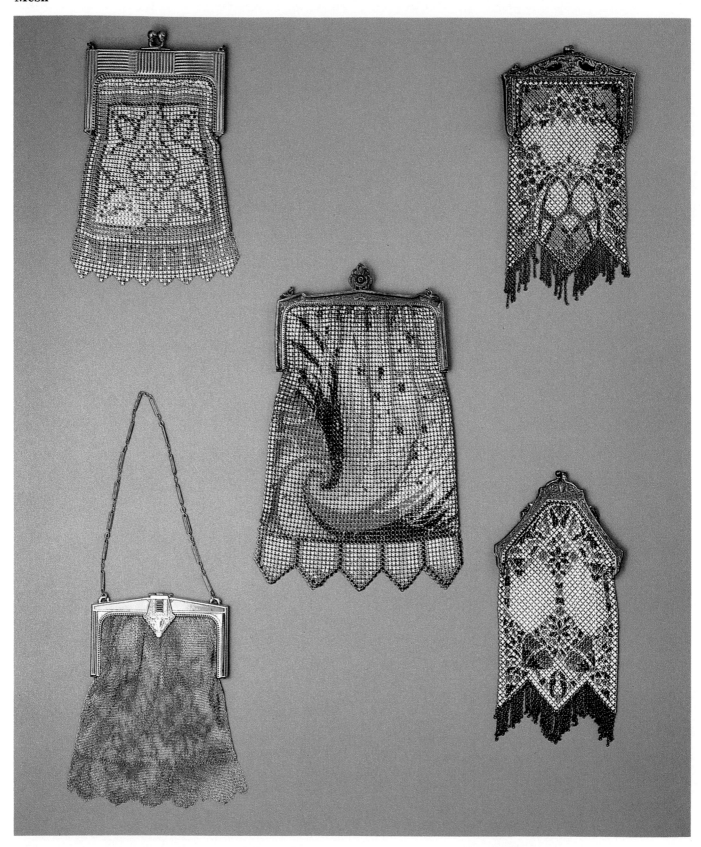

Top Left:
Maker - Whiting & Davis
Size - 4″ x 7¼″

Bottom Left:
Maker - Whiting & Davis
Size - 4″ x 6″

Center:
Maker - Whiting & Davis
Size - 5¾″ x 9¼″

Top Right:
Maker - Mandalian
Size - 3¾″ x 7¼″

Bottom Right:
Maker - Mandalian
Size - 3¾″ x 7¾″

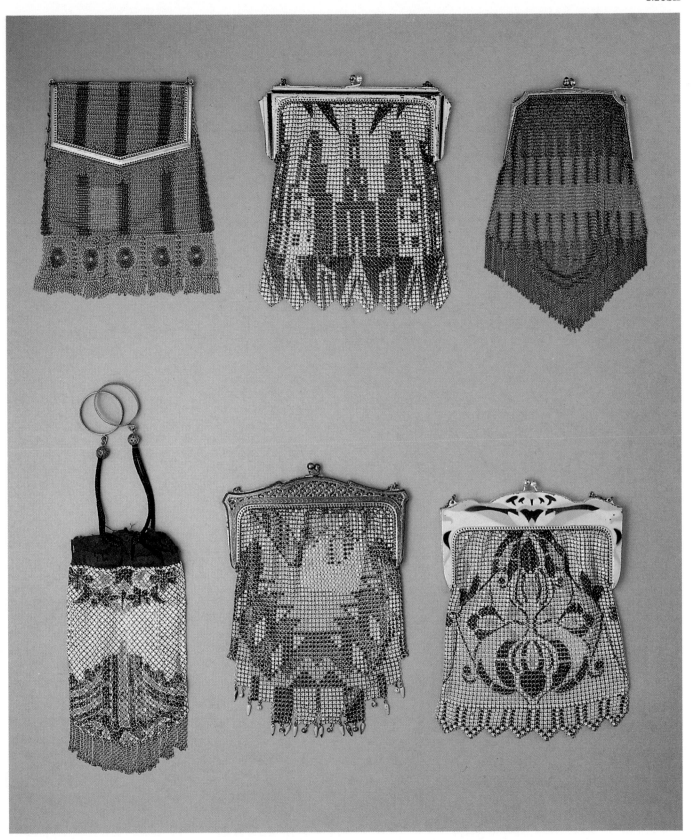

Top Left:
Maker - Whiting & Davis
Size - 5″ x 6″

Bottom Left:
Maker - Whiting & Davis
Size - 3½″ x 7″

Top Center:
Maker - Whiting & Davis
Size - 5½ x 6¾″

Bottom Center:
Maker - Whiting & Davis
Size - 5¼″ x 8″

Top Right:
Maker - Whiting & Davis
Size - 5″ x 7″
Style - Sterling 90%
 14K Gold 10%

Bottom Right:
Maker - Whiting & Davis
Size - 5″ x 7½″

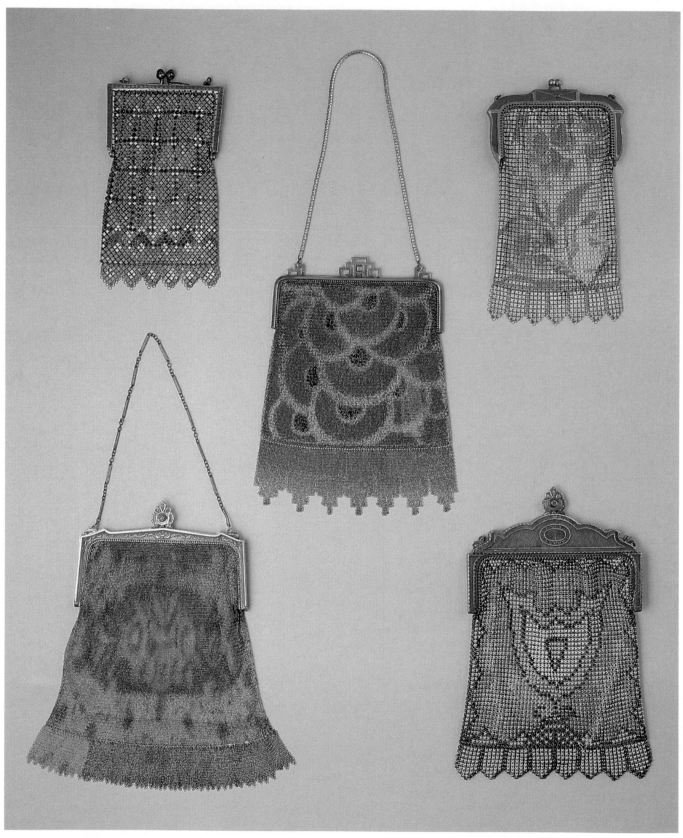

Top Left:
Maker - Mandalian
Size - 3¾" x 6"

Bottom Left:
Maker - Whiting & Davis
Size - 6½" x 8¼"

Center:
Maker - Germany
Size - 5¾" x 7"

Top Right:
Maker - Whiting & Davis
Size - 3¾" x 7"

Bottom Right:
Maker - Whiting & Davis
Size - 5" x 8¾"
Style - Bead-lite

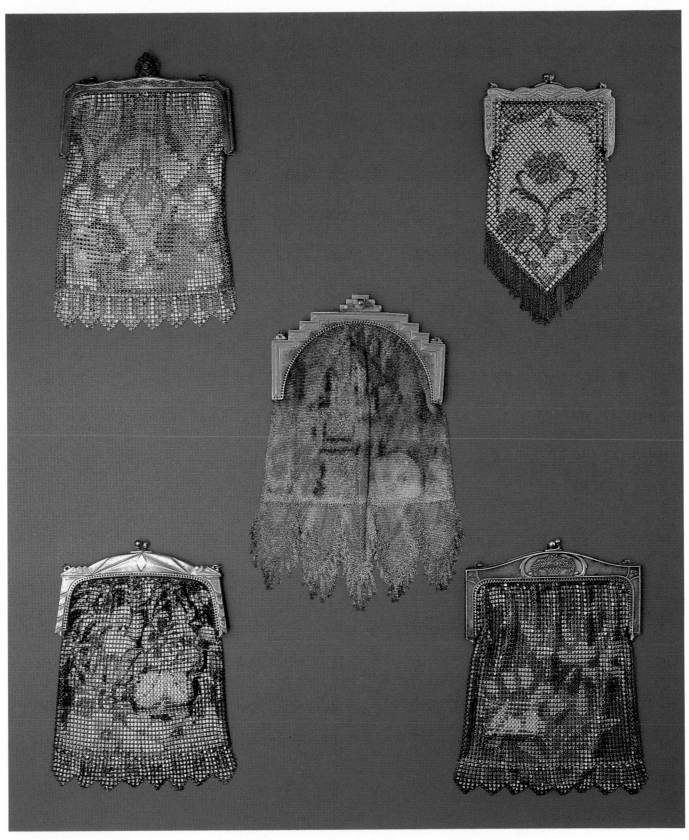

Top Left:
Maker - Whiting & Davis
Size - 5″ x 8″

Bottom Left:
Maker - Whiting & Davis
Size - 5″ x 7½″

Center:
Maker - Whiting & Davis
Size - 6″ x 9″

Top Right:
Maker - Mandalian
Size - 3¾″ x 7½″

Bottom Right:
Maker - Whiting & Davis
Size - 5″ x 7½″

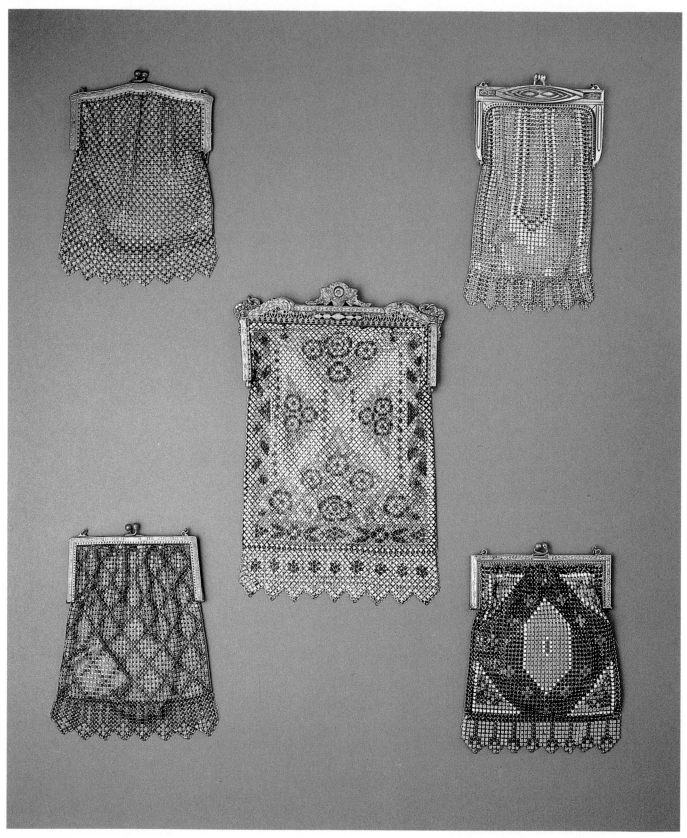

Top Left:
Maker - Whiting & Davis
Size - 4″ x 6¼″

Bottom Left:
Maker - Whiting & Davis
Size - 5″ x 6¼″

Center:
Maker - Mandalian
Size - 6″ x 9″

Top Right:
Maker - Whiting & Davis
Size - 4″ x 6¾″

Bottom Right:
Maker - Whiting & Davis
Size - 4½″ x 6″

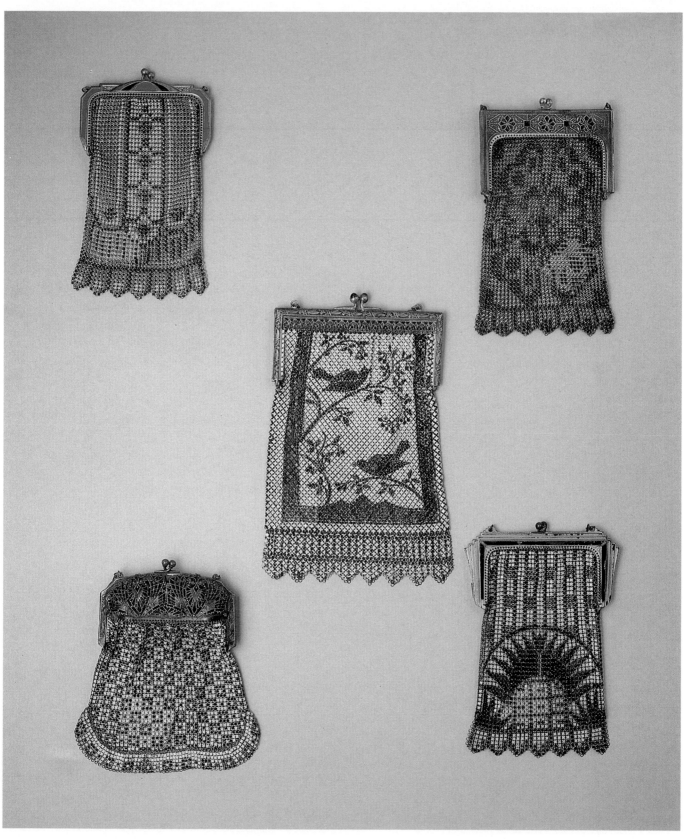

Top Left:
Maker - Whiting & Davis
Size - 3¾″ x 6½″
Style - Bead-lite

Bottom Left:
Maker - Whiting & Davis
Size - 5″ x 6½″
Style - "El Sah"

Center:
Maker - Mandalian
Size - 5″ x 8″

Top Right:
Maker - Whiting & Davis
Size - 3¾″ x 7″
Style - Bead-lite

Bottom Right:
Maker - Whiting & Davis
Size - 4¼″ x 6¾″

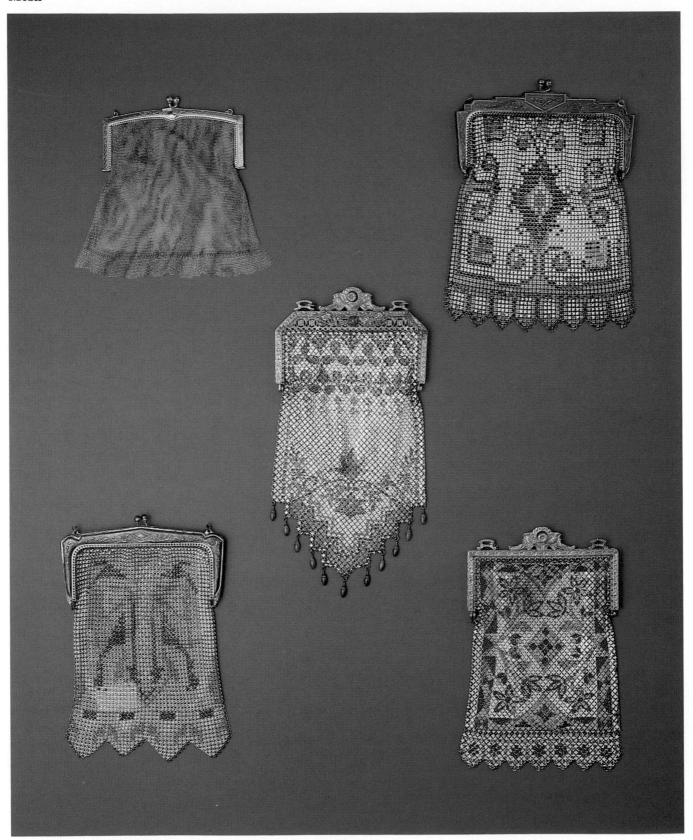

Top Left:
Maker - Whiting & Davis
Size - 4″ x 5½″

Bottom Left:
Maker - Whiting & Davis
Size - 4¾″ x 7¼″
Style - Bead-lite

Bottom Center:
Maker - Mandalian
Size - 4¼″ x 9″

Top Right:
Maker - Whiting & Davis
Size - 5″ x 7¼″

Bottom Right:
Maker - Mandalian
Size - 4¼″ x 7″

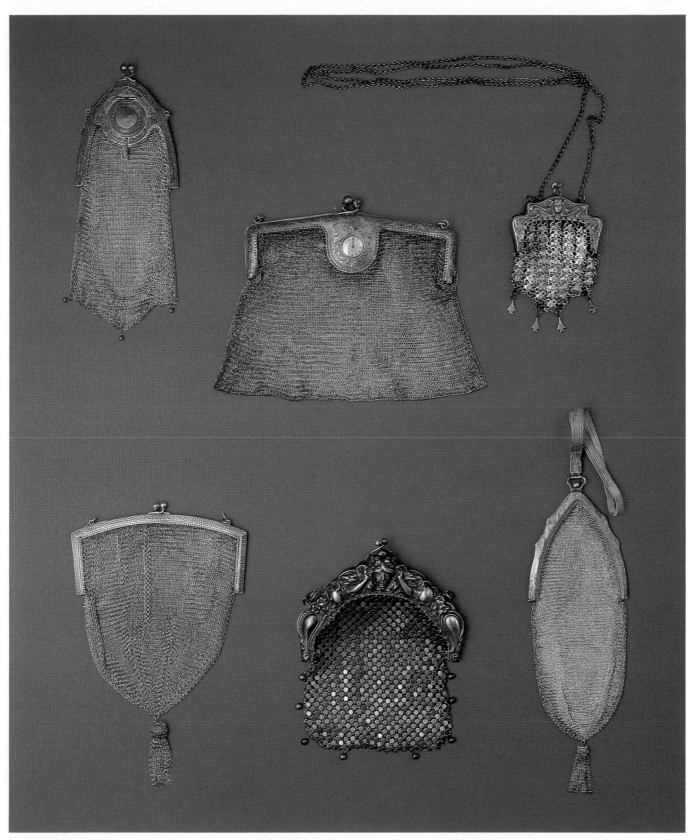

Top Left:
Maker - Whiting & Davis
Size - 3½″ x 8″
Style - "El Sah"

Bottom Left:
Size - 5″ x 8″

Top Center:
Size - 8″ x 6″
Style - German Silver

Bottom Center:
Size - 4¾″ x 6½″
Style - German Silver

Top Right:
Size - 2½″ x 4″

Bottom Right:
Maker - Whiting & Davis
Size - 2¾″ x 9½″

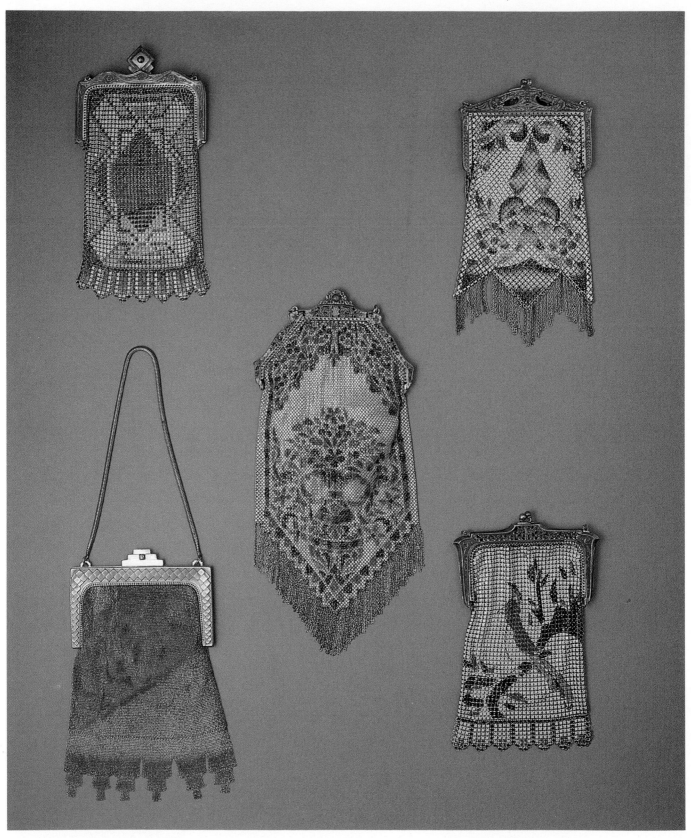

Top Left:
Maker - Whiting & Davis
Size - 3¾" x 7¼"

Bottom Left:
Maker - Whiting & Davis
Size - 4¾" x 7½"

Center:
Maker - Mandalian
Size - 4½" x 10½"

Top Right:
Maker - Mandalian
Size - 3¾" x 7½"

Bottom Right:
Maker - Whiting & Davis
Size - 4" x 7"

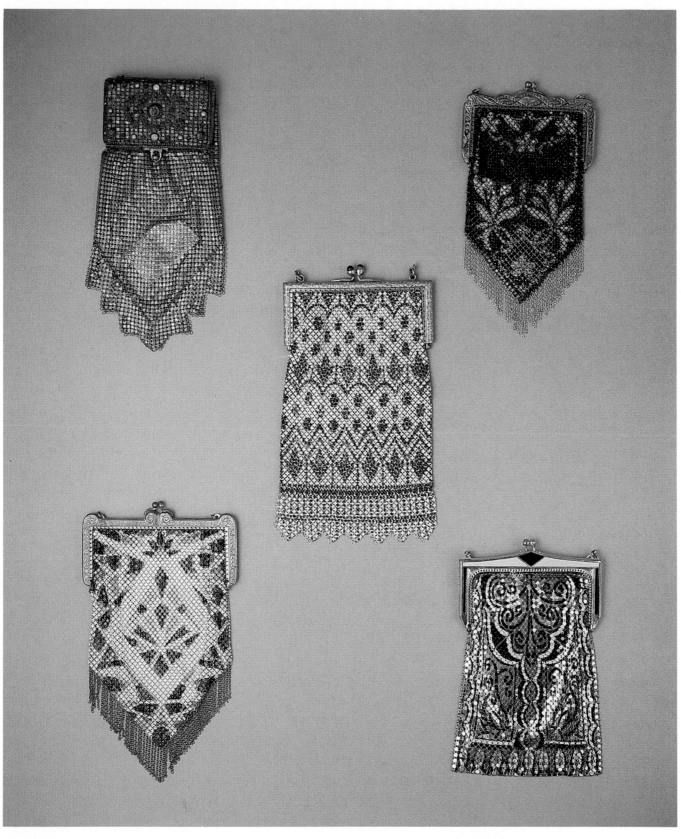

Top Left:
Maker - Whiting & Davis
Size - 4″ x 7¾″

Bottom Left:
Maker - Mandalian
Size - 4¼″ x 8″

Center:
Maker - Mandalian
Size - 4¼″ x 7¾″

Top Right:
Maker - Mandalian
Size - 3¾″ x 7¼″

Bottom Right:
Maker - Whiting & Davis
Size - 4″ x 7″

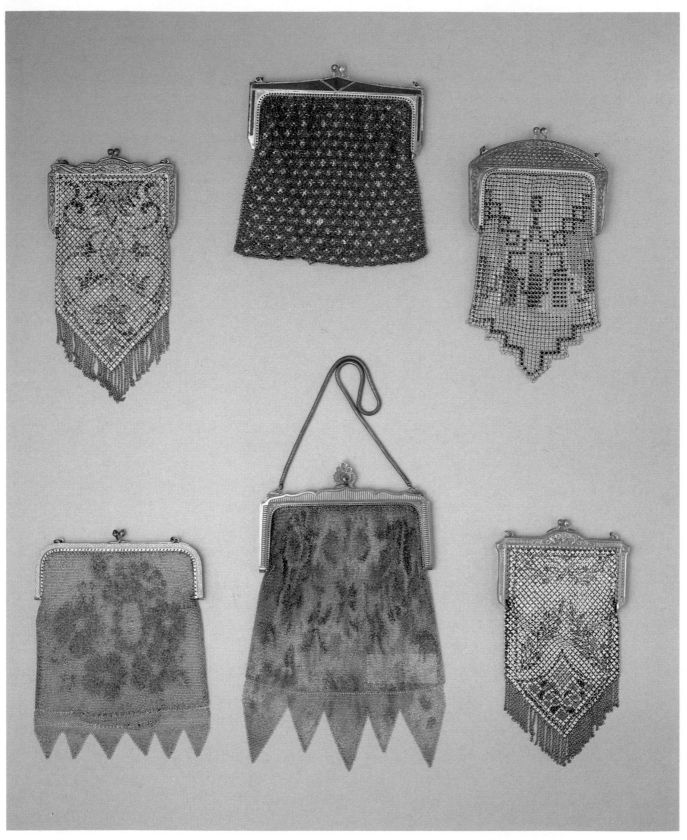

Top Left:
Maker - Mandalian
Size - 3¾″ x 7¼″

Top Center:
Maker - Whiting & Davis
Size - 5½″ x 5¾″

Top Right:
Maker - Whiting & Davis
Size - 4″ x 7¼″

Bottom Left:
Maker - Germany
Size - 5″ x 6¾″

Bottom Center:
Maker - Whiting & Davis
Size - 6″ x 8¾″

Bottom Right:
Maker - Mandalian
Size - 3¾″ x 7¼″

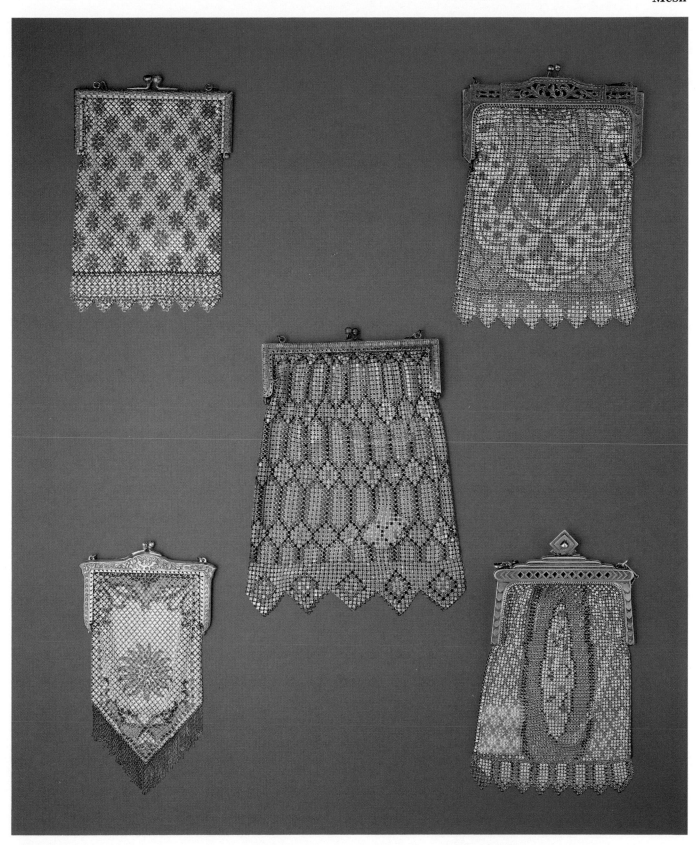

Top Left:
Maker - Mandalian
Size - 4½″ x 6¾″

Bottom Left:
Maker - Mandalian
Size - 4″ x 7½″

Center:
Maker - Whiting & Davis
Size - 6″ x 8½″

Top Right:
Maker - Whiting & Davis
Size - 5¼″ x 7½″

Bottom Right:
Maker - Whiting & Davis
Size - 4½″ x 7¾″

Mesh

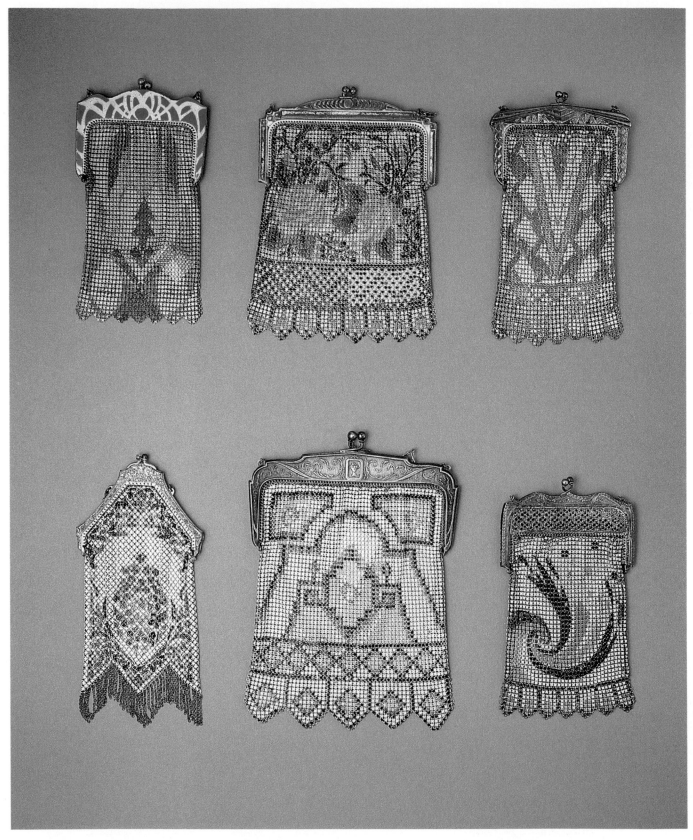

Top Left:
Maker - Whiting & Davis
Size - 3¾″ x 7″

Top Center:
Maker - Whiting & Davis
Size - 5¾″ x 7¼″

Top Right:
Maker - Whiting & Davis
Size - 4″ x 7¼″

Bottom Left:
Maker - Mandalian
Size - 3¾″ x 7¾″

Bottom Center:
Maker - Whiting & Davis
Size - 6″ x 8½″

Bottom Right:
Maker - Whiting & Davis
Size - 3¾″ x 7″

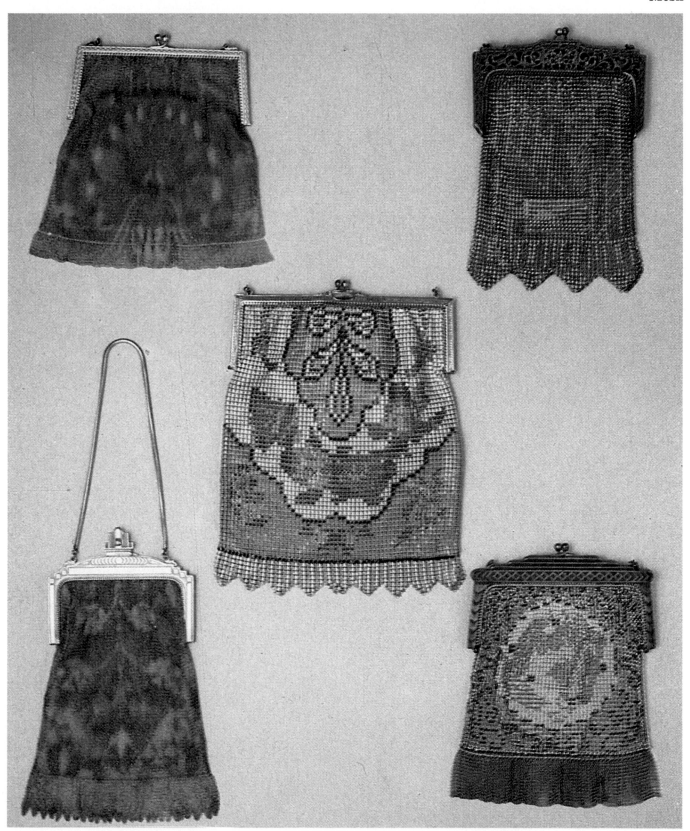

Top Left:
Maker - Whiting & Davis
Size - 6½″ x 6¾″

Bottom Left:
Maker - Whiting & Davis
Size - 5¼″ x 8¼″

Center:
Maker - Whiting & Davis
Size - 7¼″ x 8½″
Style - "El Sah"

Top Right:
Maker - Whiting & Davis
Size - 4¾″ x 7½″
Style - Bead-lite

Bottom Right:
Maker - Whiting & Davis
Size - 6½″ x 7½″
Style - Bead-lite

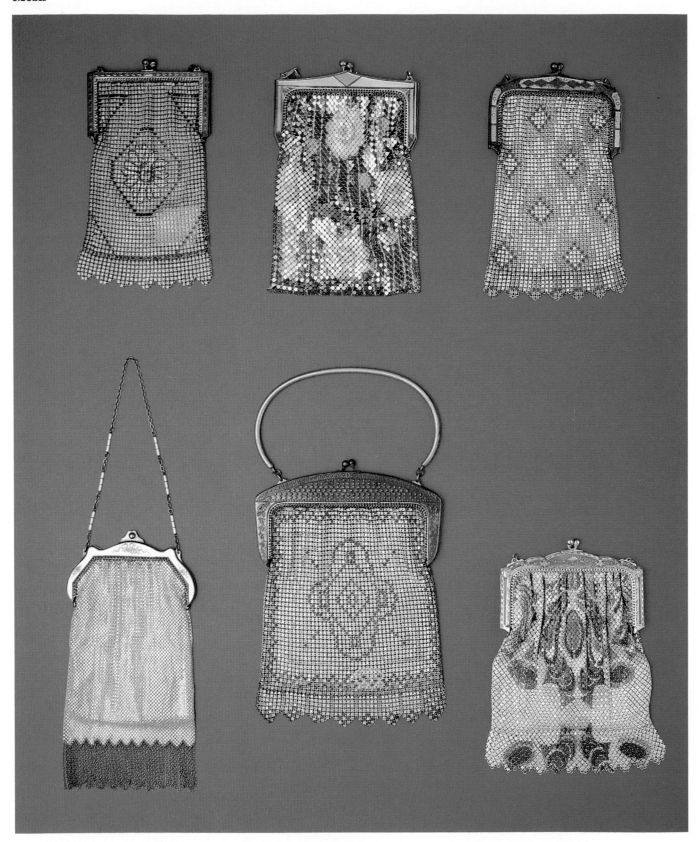

Top Left:
Maker - Whiting & Davis
Size - 4″ x 6½″

Top Center:
Maker - Whiting & Davis
Size - 4½″ x 6¾″

Top Right:
Maker - Whiting & Davis
Size - 3¾″ x 6¾″

Bottom Left:
Maker - Whiting & Davis
Size - 3¾″ x 7½″
Style - Sterling Frame

Bottom Center:
Maker - Whiting & Davis
Size - 5¼″ x 7½″

Bottom Right:
Maker - Whiting & Davis
Size - 5″ x 6¾″

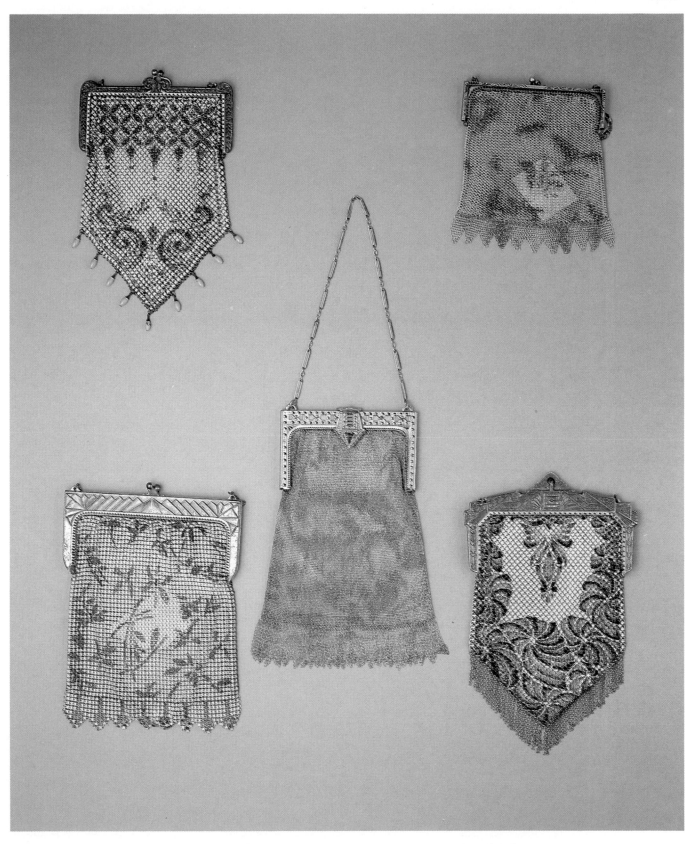

Top Left:
Maker - Mandalian
Size - 4¼″ x 7½″

Bottom Left:
Maker - Whiting & Davis
Size - 5¼″ x 7¼″

Center:
Maker - Whiting & Davis
Size - 5½″ x 7½″

Top Right:
Maker - Whiting & Davis
Size - 4¼″ x 5¼″

Bottom Right:
Maker - Mandalian
Size - 4¾″ x 8¼″

Mesh

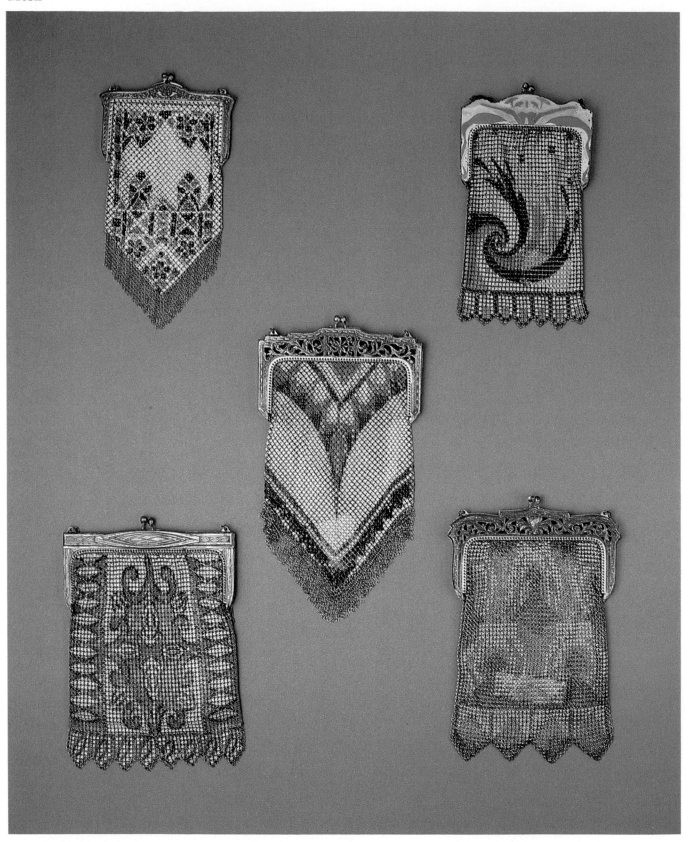

Top Left:
Maker - Mandalian
Size - 4″ x 7¼″

Bottom Left:
Maker - Whiting & Davis
Size - 5½″ x 7¼″

Center:
Maker - Whiting & Davis
Size - 4¾″ x 8½″

Top Right:
Maker - Whiting & Davis
Size - 3¾″ x 7″

Bottom Right:
Maker - Whiting & Davis
Size - 5″ x 7¾″
Style - Bead-lite

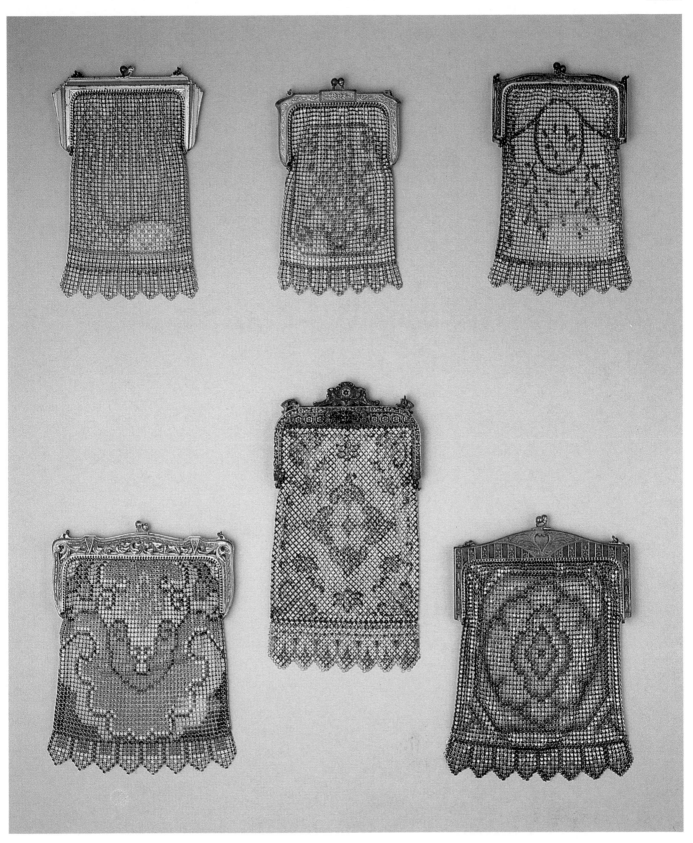

Top Left:
Maker - Whiting & Davis
Size - 4¼″ x 6½″

Top Center:
Maker - Whiting & Davis
Size - 3½″ x 6¼″

Top Right:
Maker - Whiting & Davis
Size - 3¾″ x 6¾″

Bottom Left:
Maker - Whiting & Davis
Size - 5¼″ x 7¼″

Bottom Center:
Maker - Mandalian
Size - 4¾″ x 8¼″

Bottom Right:
Maker - Whiting & Davis
Size - 5″ x 7¾″

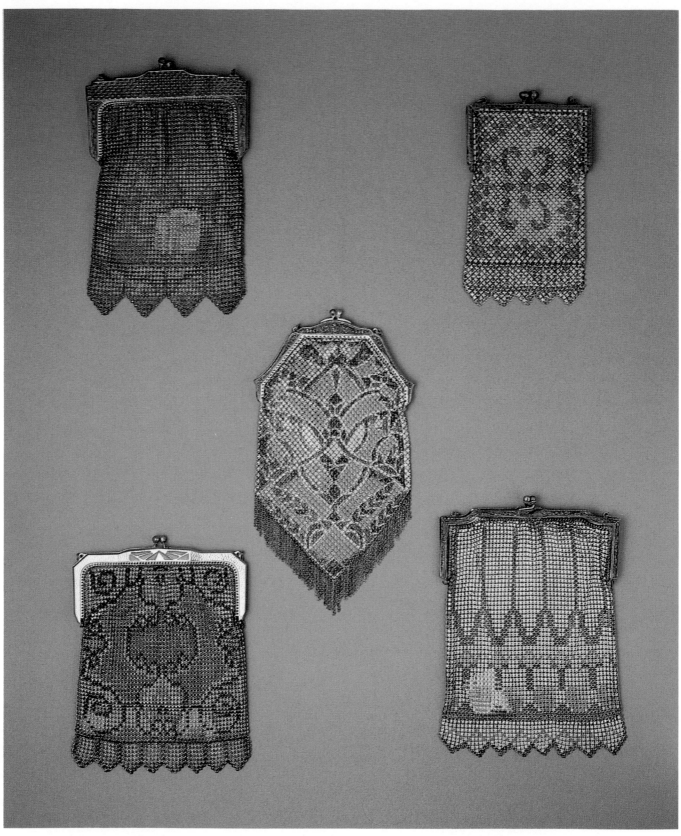

Top Left:
Maker - Whiting & Davis
Size - 4½″ x 7½″

Center:
Maker - Mandalian
Size - 4½″ x 8½″

Top Right:
Maker - Mandalian
Size - 3¾″ x 6¼″

Bottom Left:
Maker - Whiting & Davis
Size - 5″ x 6¾″
Style - Bead-lite

Bottom Right:
Maker - Whiting & Davis
Size - 5″ x 7½″

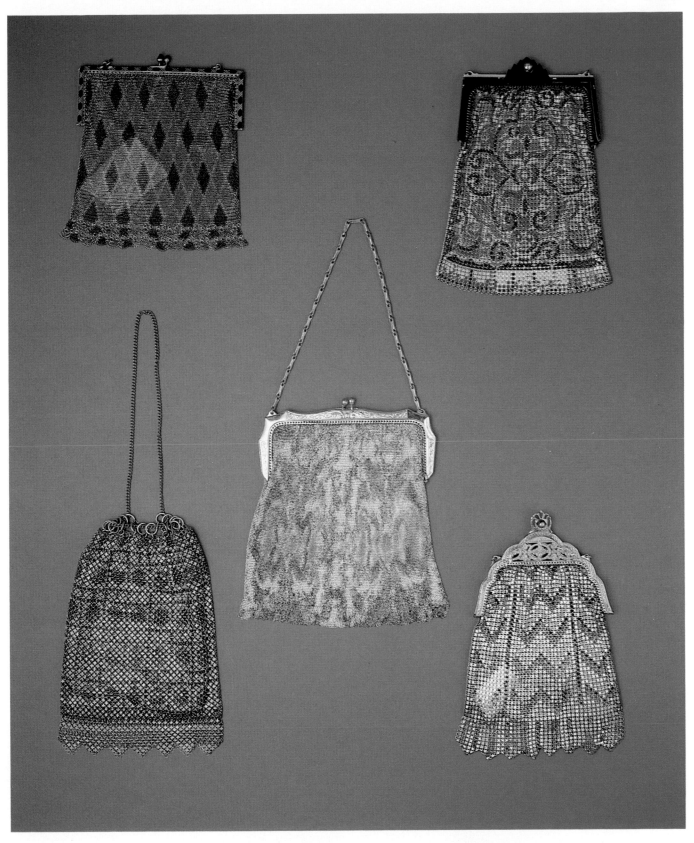

Top Left:
Maker - Germany
Size - 5½″ x 5¼″

Bottom Left:
Maker - Whiting & Davis
Size - 4½″ x 7″

Bottom Center:
Maker - Whiting & Davis
Size - 6¼″ x 6½″

Top Right:
Maker - Whiting & Davis
Size - 4½″ x 7″

Bottom Right:
Maker - Whiting & Davis
Size - 4½″ x 7¼″

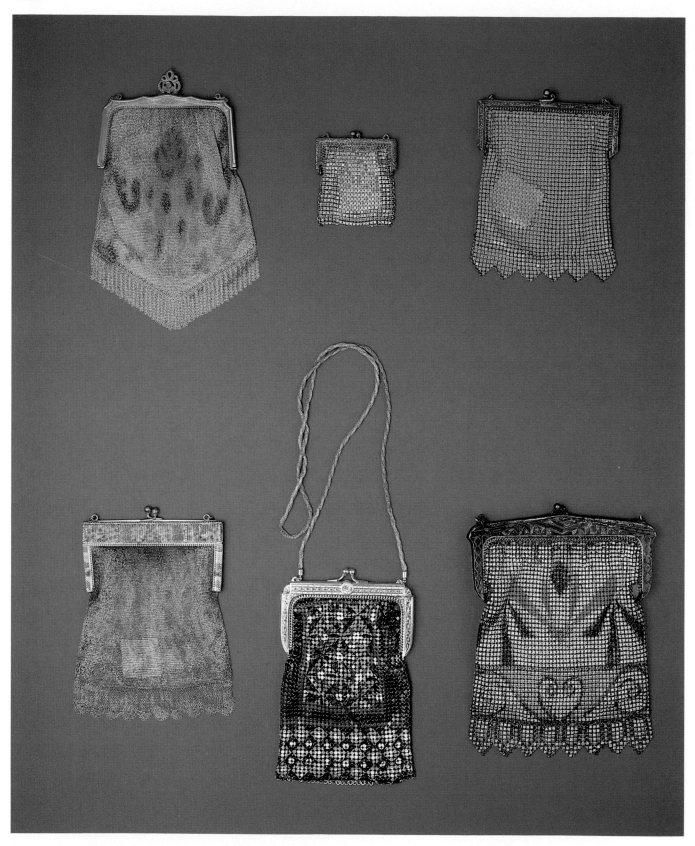

Top Left:
Maker - Whiting & Davis
Size - 5″ x 7½″

Top Center:
Maker - Whiting & Davis
Size - 2¼″ x 3″

Top Right:
Maker - Whiting & Davis
Size - 4″ x 5½″

Bottom Left:
Maker - Whiting & Davis
Size - 4¼″ x 6″

Bottom Center:
Maker - Whiting & Davis
Size - 3¾″ x 6″

Bottom Right:
Maker - Whiting & Davis
Size - 5¼″ x 7¼″

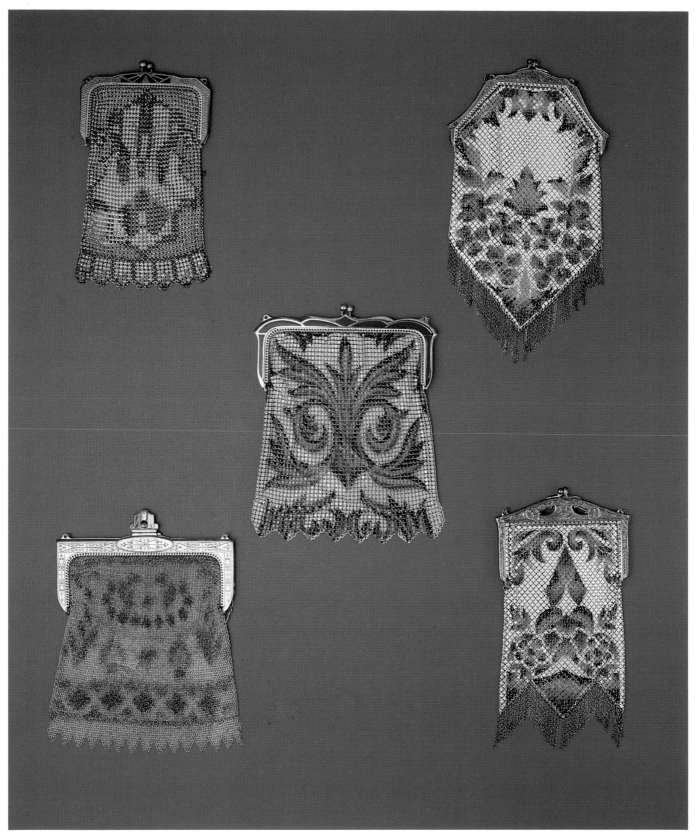

Top Left:
Maker - Whiting & Davis
Size - 3¾″ x 6½″
Style - Bead-lite

Bottom Left:
Maker - Whiting & Davis
Size - 5½″ x 7″

Center:
Maker - Whiting & Davis
Size - 5¼″ x 6¾″

Top Right:
Maker - Mandalian
Size - 4½″ x 8½″

Bottom Right:
Maker - Mandalian
Size - 3¾″ x 7½″

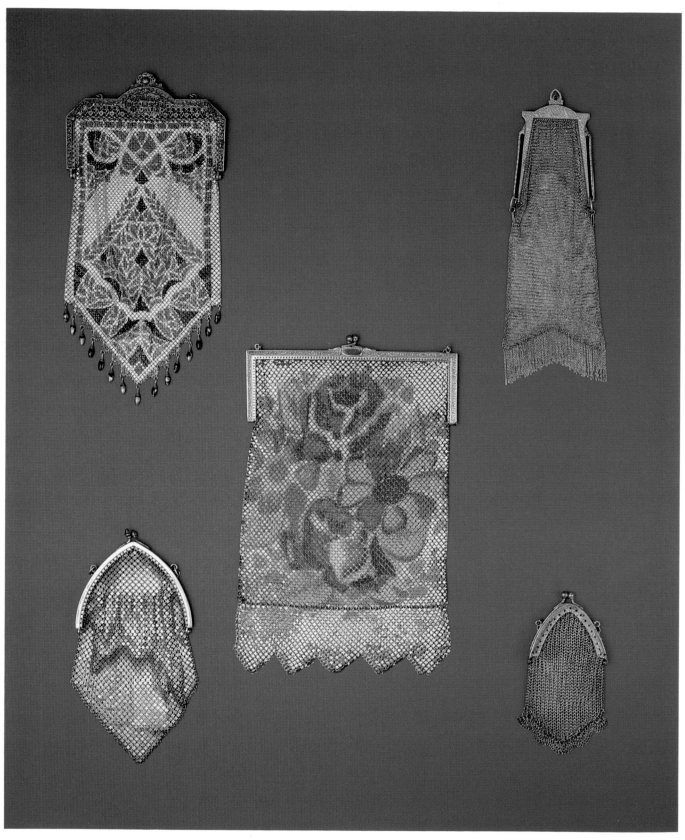

Top Left:
Maker - Mandalian
Size - 4½" x 9½"

Top Center:
Maker - Whiting & Davis
Size - 6" x 9¾"

Top Right:
Maker - Whiting & Davis
Size - 3" x 8½"

Bottom Left:
Size - 3¾" x 6¾"

Bottom Right:
Size - 2½" x 4¾"

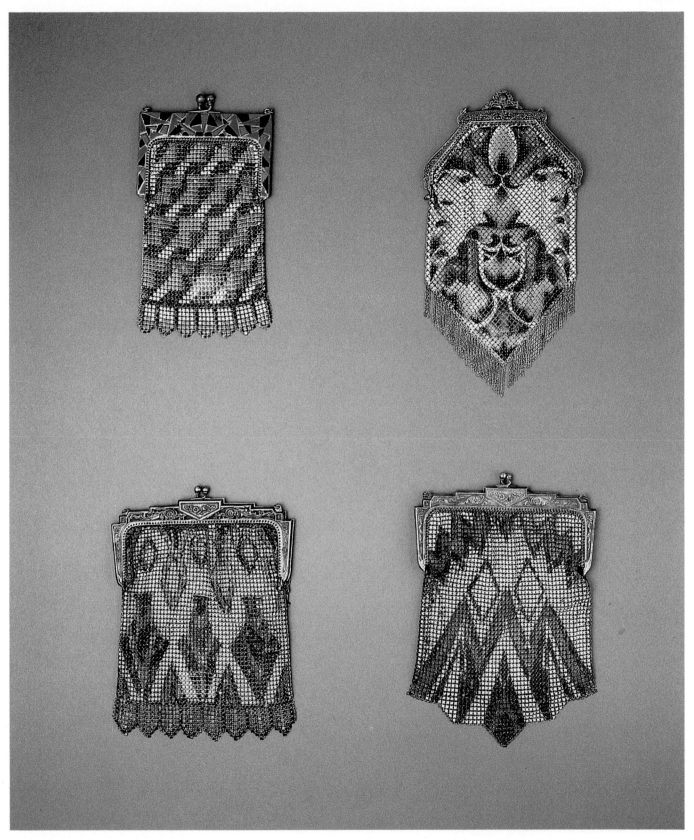

Top Left:
Maker - Whiting & Davis
Size - 3¾" x 7"

Bottom Left:
Maker - Whiting & Davis
Size - 5" x 7¼"

Top Right:
Maker - Mandalian
Size - 4½" x 8¾"

Bottom Right:
Maker - Whiting & Davis
Size - 5¼" x 7¾"

Mesh

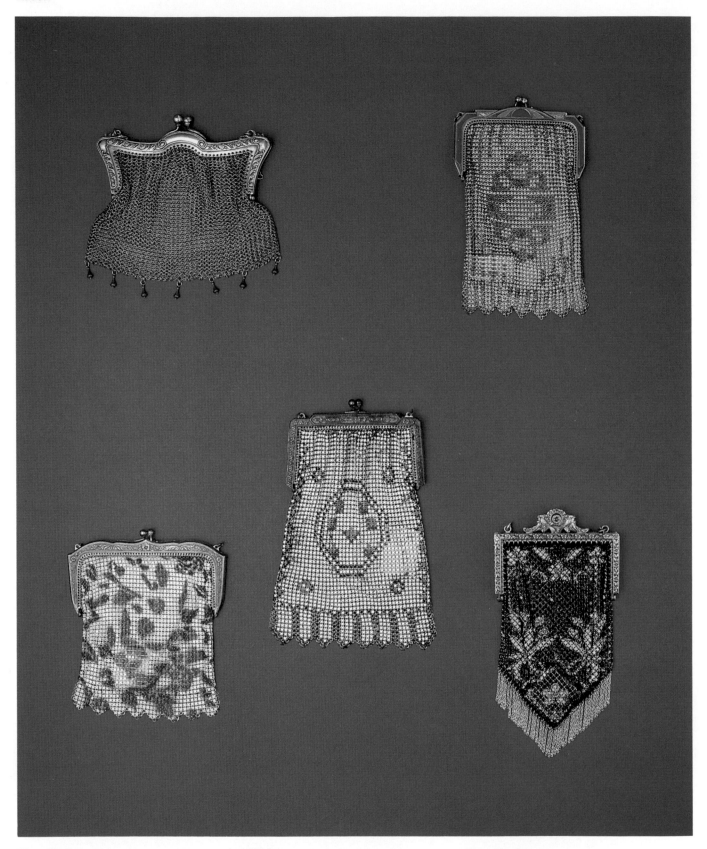

Top Left:
Size - 5¾" x 5¼"
Style - German Silver

Bottom Left:
Maker - Whiting & Davis
Size - 4½" x 5½"

Center:
Maker - Whiting & Davis
Size - 4½" x 7¼"

Top Right:
Maker - Whiting & Davis
Size - 3¾" x 6¼"
Style - Bead-lite

Bottom Right:
Maker - Mandalian
Size - 3½" x 7"

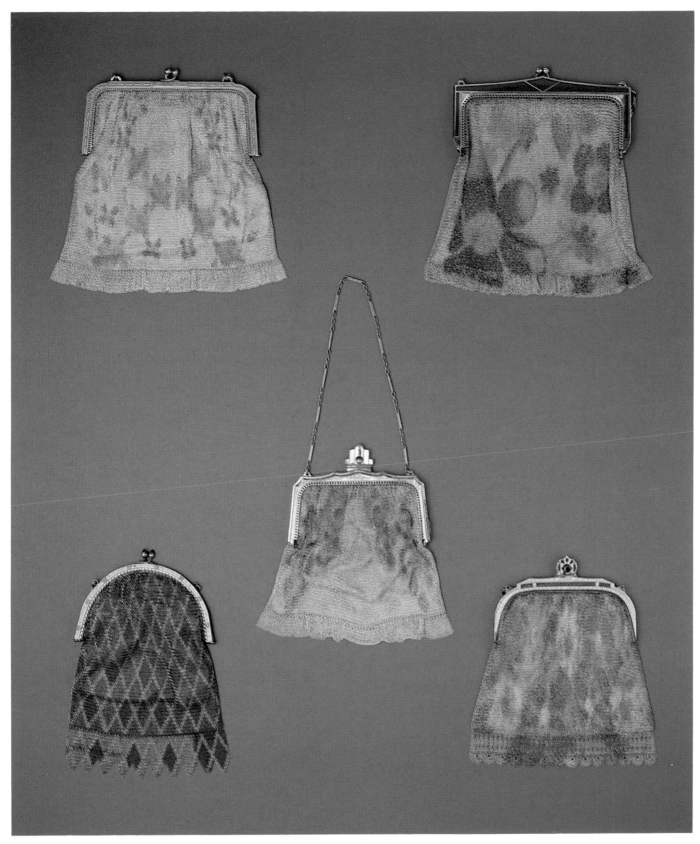

Top Left:
Maker - Whiting & Davis
Size - 6″ x 6¼″

Bottom Left:
Maker - Whiting & Davis
Size - 5½″ x 6″

Center:
Maker - Germany
Size - 4½″ x 6½″

Top Right:
Maker - Whiting & Davis
Size - 6″ x 6½″

Bottom Right:
Maker - Whiting & Davis
Size - 5¼″ x 6″

Mesh

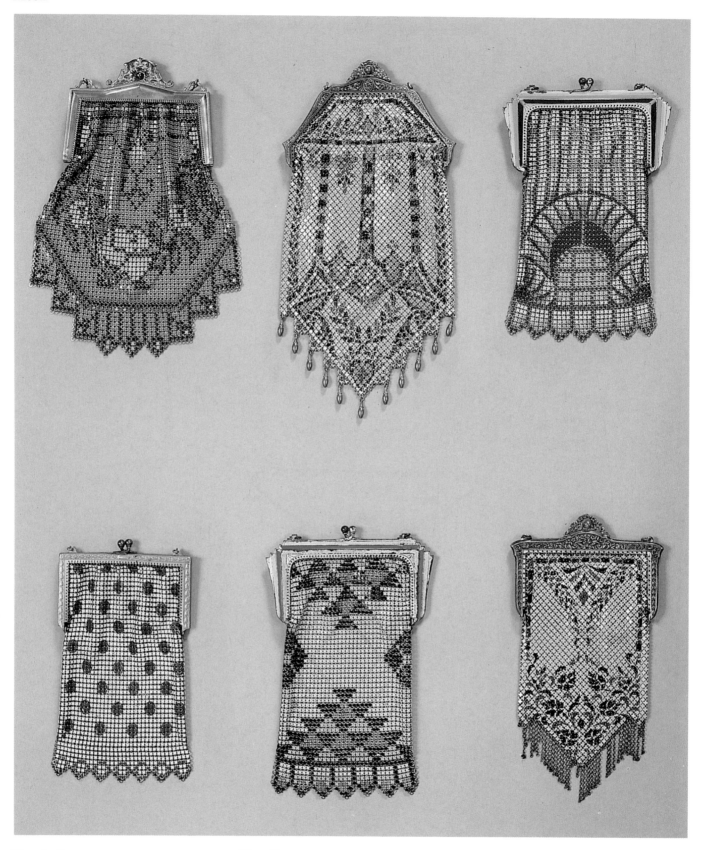

Top Left:
Maker - Whiting & Davis
Size - 6¾″ x 7¾″

Top Center:
Maker - Mandalian
Size - 4½″ x 9¼″

Top Right:
Maker - Whiting & Davis
Size - 4¼″ x 6¾″

Bottom Left:
Maker - Whiting & Davis
Size - 3½″ x 6¼″

Bottom Center:
Maker - Whiting & Davis
Size - 4¼″ x 7″

Bottom Right:
Maker - Mandalian
Size - 4″ x 7¼″

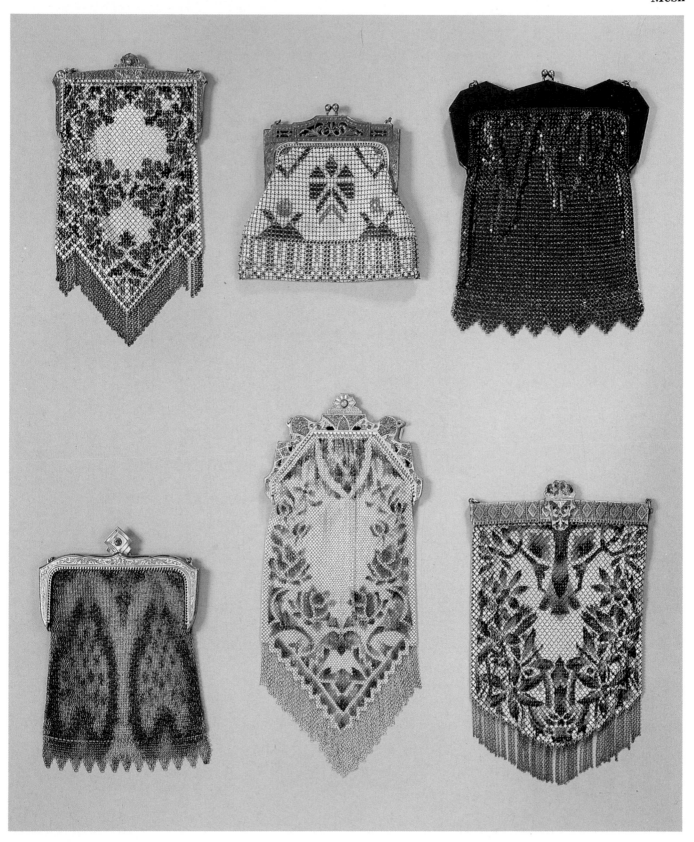

Top Left:
Maker - Mandalian
Size - 4½″ x 8½″

Top Center:
Maker - Whiting & Davis
Size - 5¼″ x 5″

Top Right:
Maker - Whiting & Davis
Size - 5½″ x 7½″

Bottom Left:
Maker - Whiting & Davis
Size - 4¾″ x 7″

Bottom Center:
Maker - Mandalian
Size - 4½″ x 10¾″

Bottom Right:
Maker - Mandalian
Size - 5″ x 8½″

Mesh

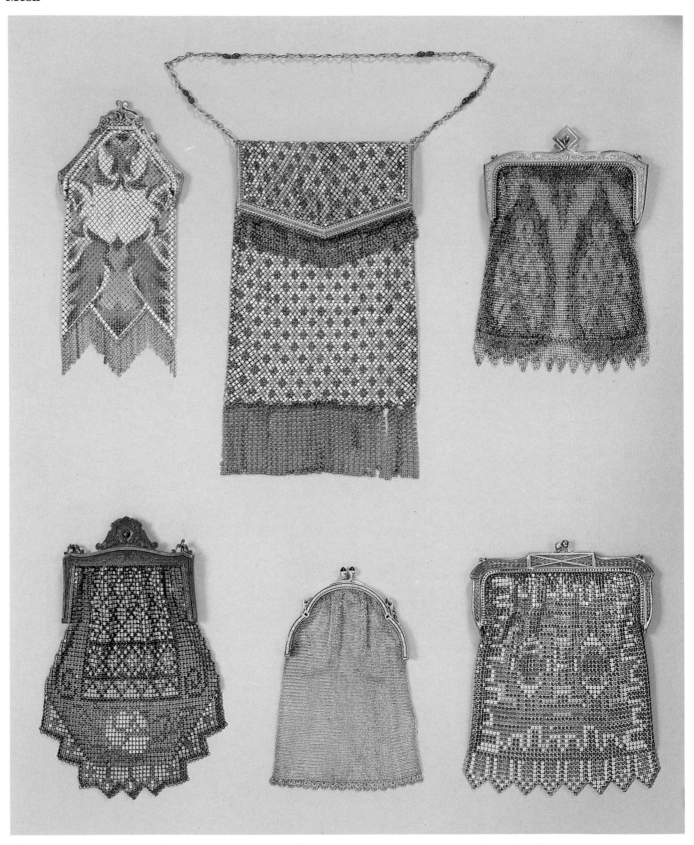

Top Left:
Maker - Mandalian
Size - 3¾" x 8"

Top Center:
Maker - Whiting & Davis
Size - 5½" x 9"

Top Right:
Maker - Whiting & Davis
Size - 5" x 7"

Bottom Left:
Maker - Whiting & Davis
Size - 5¼" x 8"

Bottom Center:
Size - 4½" x 6½"

Bottom Right:
Maker - Whiting & Davis
Size - 5½" x 7"

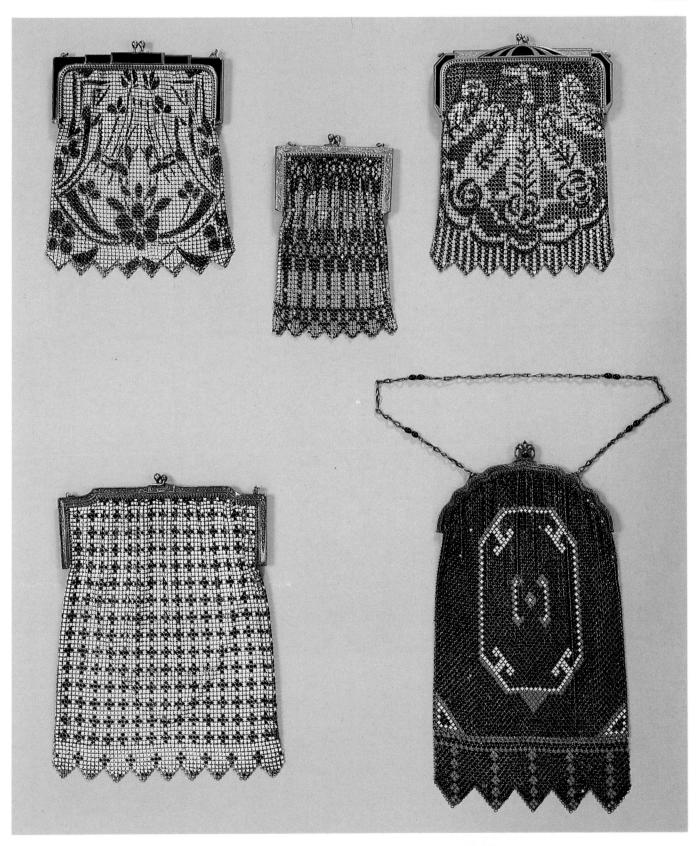

Top Left:
Maker - Whiting & Davis
Size - 5½″ x 6¾″

Bottom Left:
Maker - Whiting & Davis
Size - 7″ x 9″

Center:
Maker - Whiting & Davis
Size - 3¾″ x 5¾″

Top Right:
Maker - Whiting & Davis
Size - 5¼″ x 6¾″

Bottom Right:
Maker - Whiting & Davis
Size - 6¼″ x 10¼″

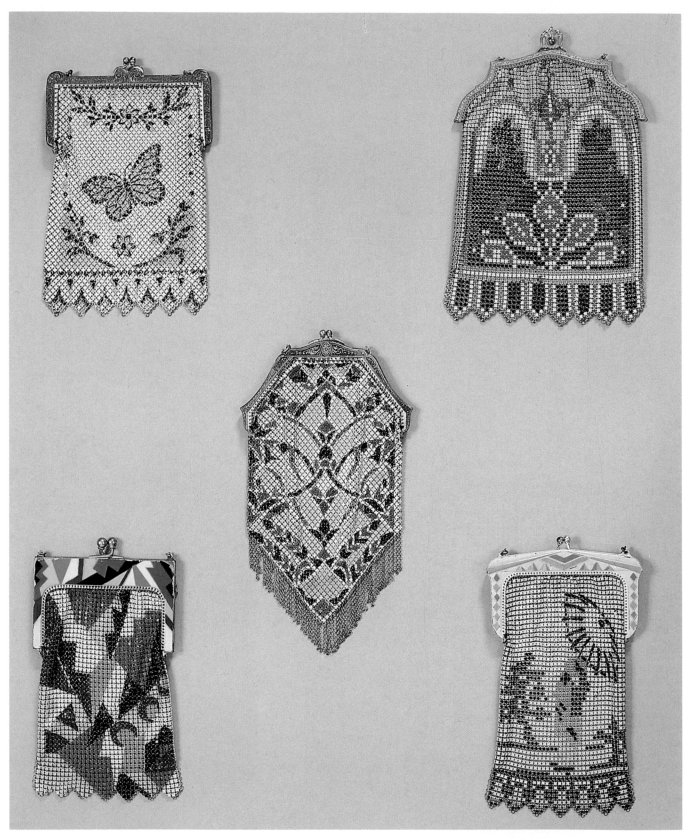

Top Left:
Maker - Mandalian
Size - 4½″ x 7″

Bottom Left:
Maker - Whiting & Davis
Size - 4″ x 7″

Center:
Maker - Mandalian
Size - 4½″ x 8½″

Top Right:
Maker - Whiting & Davis
Size - 5½″ x 7¾″

Bottom Right:
Maker - Whiting & Davis
Size - 4″ x 7″

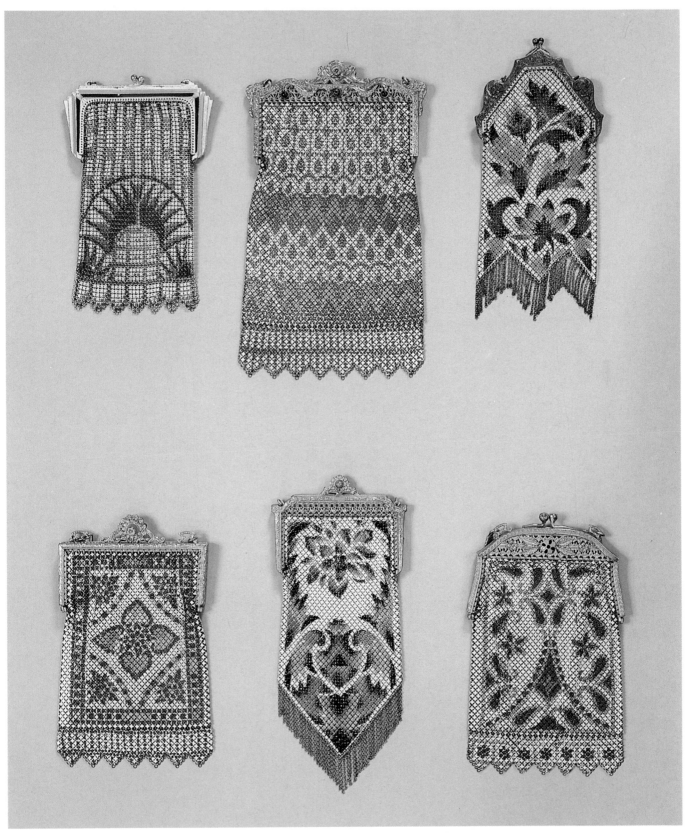

Top Left:
Maker - Whiting & Davis
Size - 4¼″ x 7″

Top Center:
Maker - Mandalian
Size - 5¼″ x 9″

Top Right:
Maker - Mandalian
Size - 3½″ x 8″

Bottom Left:
Maker - Mandalian
Size - 4¾″ x 7″

Bottom Center:
Maker - Mandalian
Size - 4″ x 8¾″

Bottom Right:
Maker - Mandalian
Size - 4½″ x 7¼″

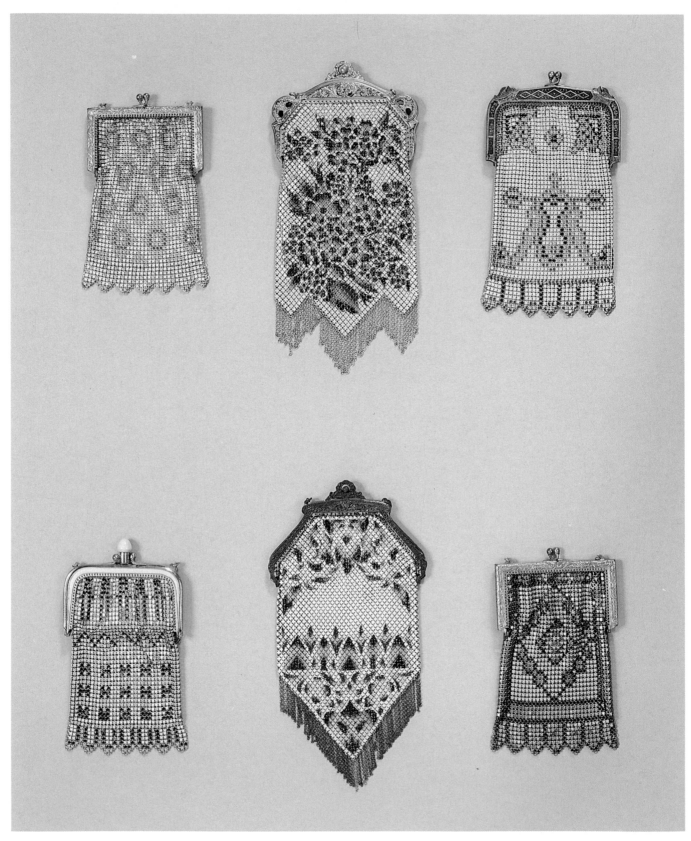

Top Left:
Maker - Whiting & Davis
Size - 3¾" x 6"

Top Center:
Maker - Mandalian
Size - 4¼" x 9"

Top Right:
Maker - Whiting & Davis
Size - 3¾" x 7"

Bottom Left:
Maker - Whiting & Davis
Size - 3½" x 6¼"

Bottom Center:
Maker - Mandalian
Size - 4½" x 8½"

Bottom Right:
Maker - Whiting & Davis
Size - 3½" x 6"

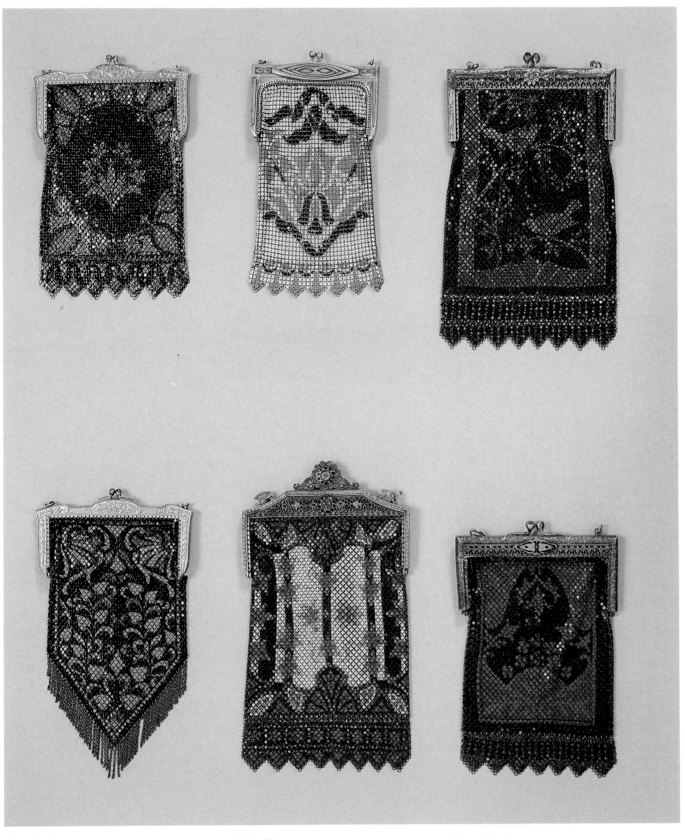

Top Left:
Maker - Mandalian
Size - 4½″ x 8″

Top Center:
Maker - Whiting & Davis
Size - 3¾″ x 7″

Top Right:
Maker - Mandalian
Size - 5″ x 8½″

Bottom Left:
Maker - Mandalian
Size - 4¾″ x 7″

Bottom Center:
Maker - Mandalian
Size - 5″ x 9″

Bottom Right:
Maker - Mandalian
Size - 4½″ x 7¼″

Mesh

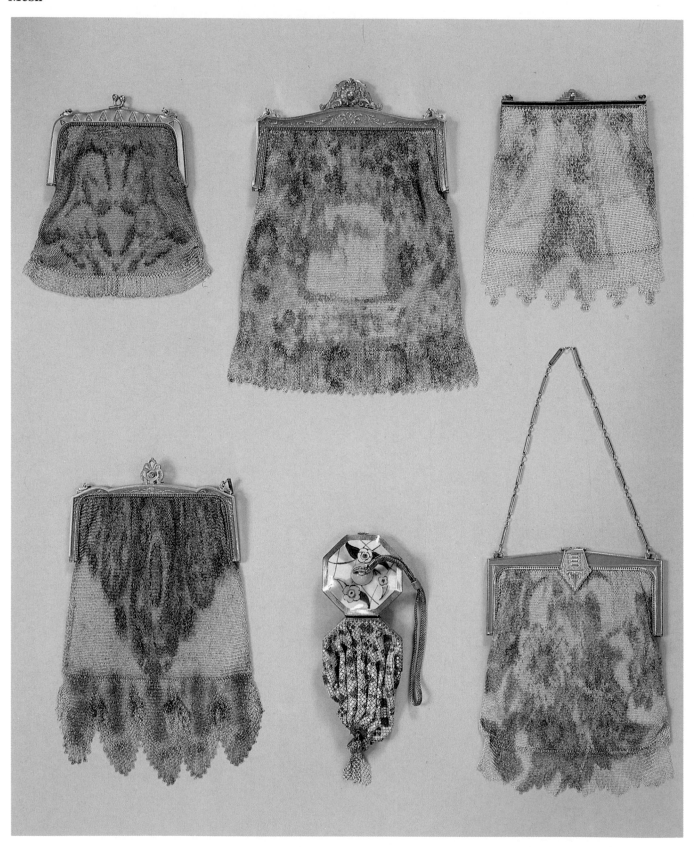

Top Left:
Maker - Whiting & Davis
Size - 5″ x 6″

Top Center:
Maker - Whiting & Davis
Size - 8″ x 9″

Top Right:
Maker - Germany
Size - 5″ x 6¼″

Bottom Left:
Maker - Whiting & Davis
Size - 5½″ x 9¼″

Bottom Center:
Maker - Whiting & Davis
Size - 2½″ x 6¼″
Style - Enameled Sterling Top

Bottom Right:
Maker - Whiting & Davis
Size - 5¾″ x 7″

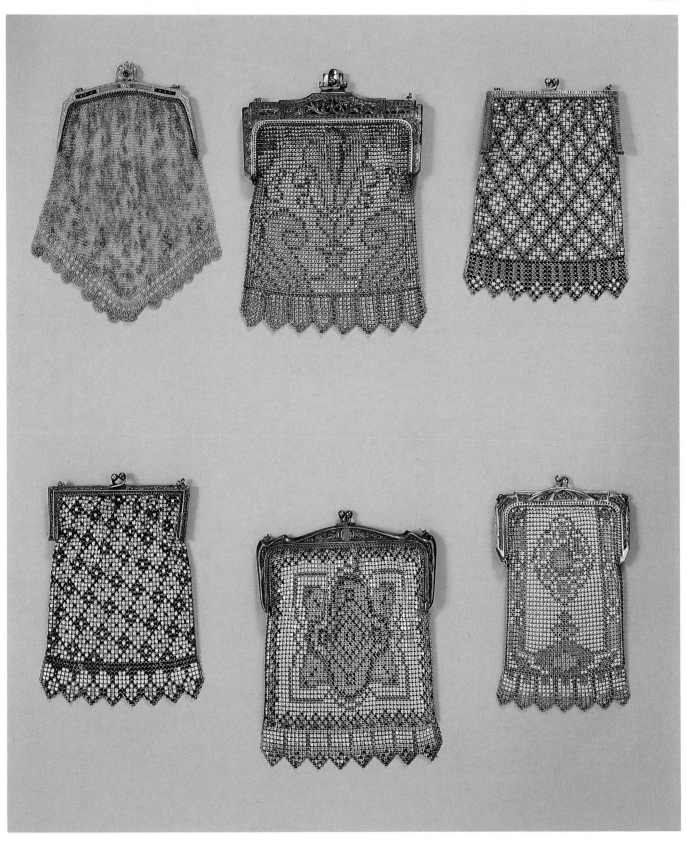

Top Left:
Maker - Whiting & Davis
Size - 5½″ x 7½″

Top Center:
Maker - Whiting & Davis
Size - 5¼″ x 7½″

Top Right:
Maker - Whiting & Davis
Size - 4½″ x 6¼″

Bottom Left:
Maker - Whiting & Davis
Size - 4½″ x 6¾″

Bottom Center:
Maker - Whiting & Davis
Size - 5¼″ x 7¼″

Bottom Right:
Maker - Whiting & Davis
Size - 3¾″ x 6½″

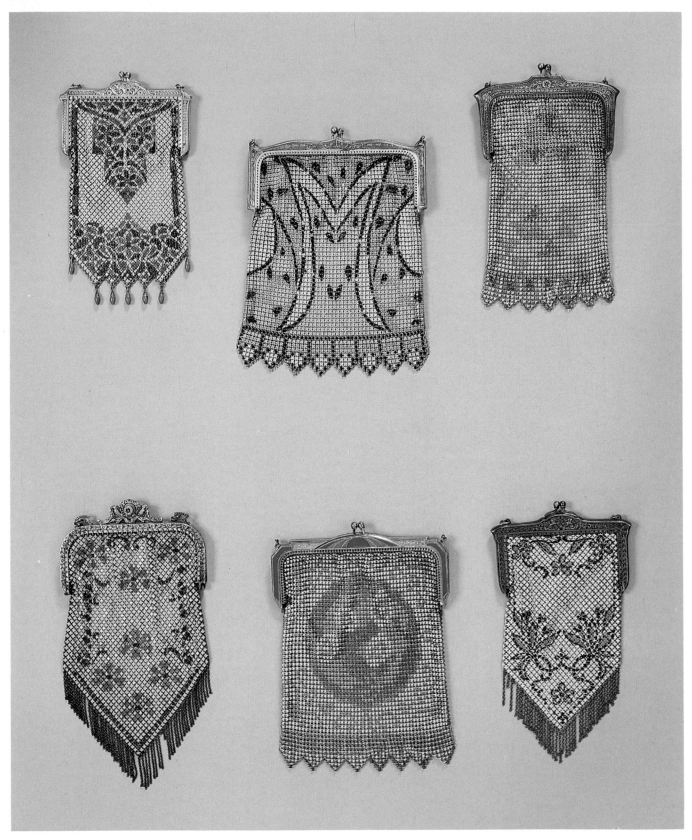

Top Left:
Maker - Mandalian
Size - 3¾″ x 6¾″

Top Center:
Maker - Whiting & Davis
Size - 5½″ x 7″

Top Right:
Maker - Whiting & Davis
Size - 4″ x 7″

Bottom Left:
Maker - Mandalian
Size - 4¼″ x 8″

Bottom Center:
Maker - Whiting & Davis
Size - 5″ x 7″

Bottom Right:
Maker - Mandalian
Size - 3¾″ x 7″

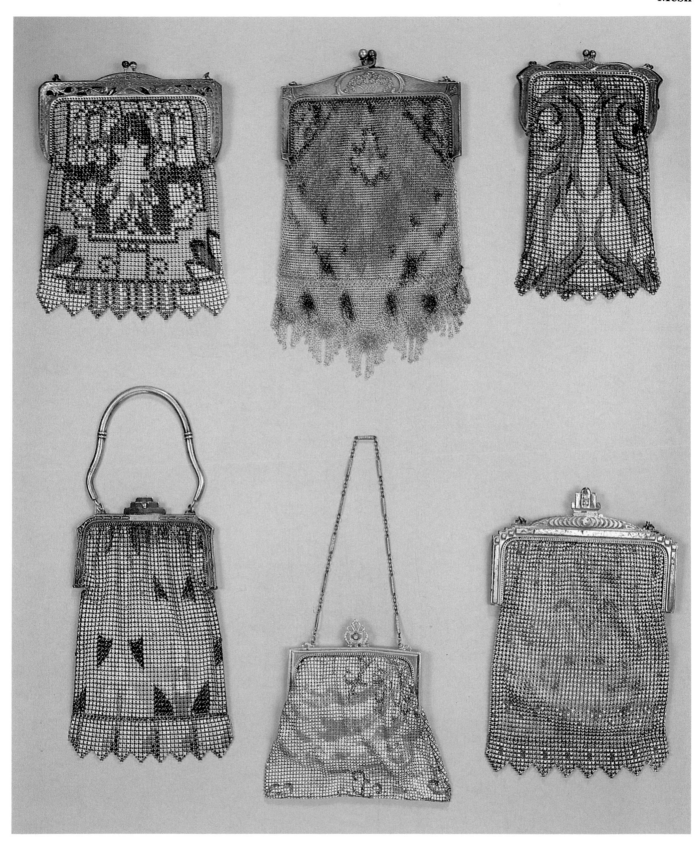

Top Left:
Maker - Whiting & Davis
Size - 5¼″ x 7″

Top Center:
Maker - Whiting & Davis
Size - 5¼″ x 9″

Top Right:
Maker - Whiting & Davis
Size - 4″ x 6¾″

Bottom Left:
Maker - Whiting & Davis
Size - 4¾″ x 7¼″

Bottom Center:
Maker - Whiting & Davis
Size - 5¼″ x 5″

Bottom Right:
Maker - Whiting & Davis
Size - 5″ x 7¾″

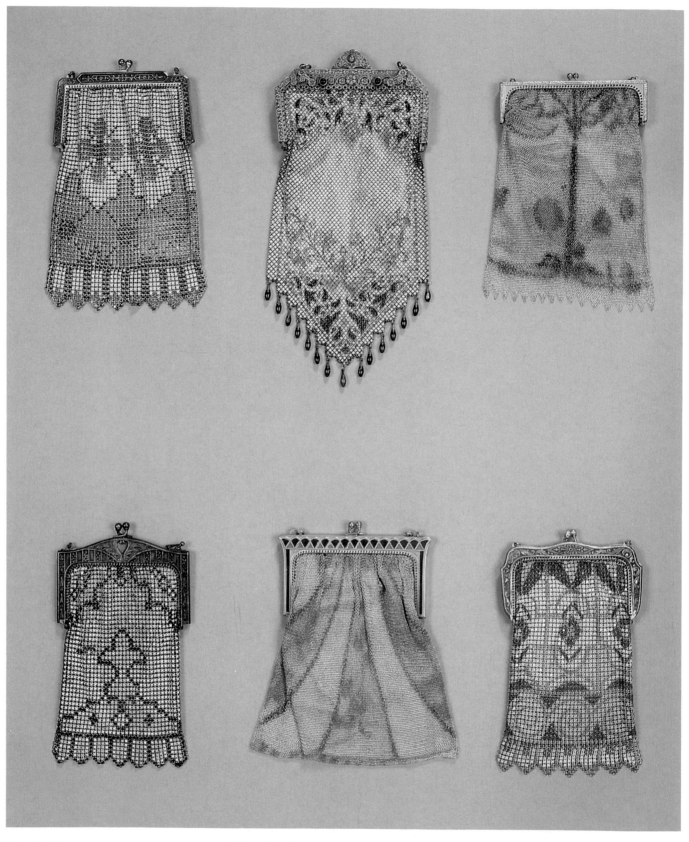

Top Left:
Maker - Whiting & Davis
Size - 4½″ x 7″

Top Center:
Maker - Mandalian
Size - 4½″ x 9½″

Top Right:
Maker - Whiting & Davis
Size - 4½″ x 6½″

Bottom Left:
Maker - Whiting & Davis
Size - 3¾″ x 7″

Bottom Center:
Maker - Whiting & Davis
Size - 5½″ x 6¾″

Bottom Right:
Maker - Whiting & Davis
Size - 3¾″ x 6¾″

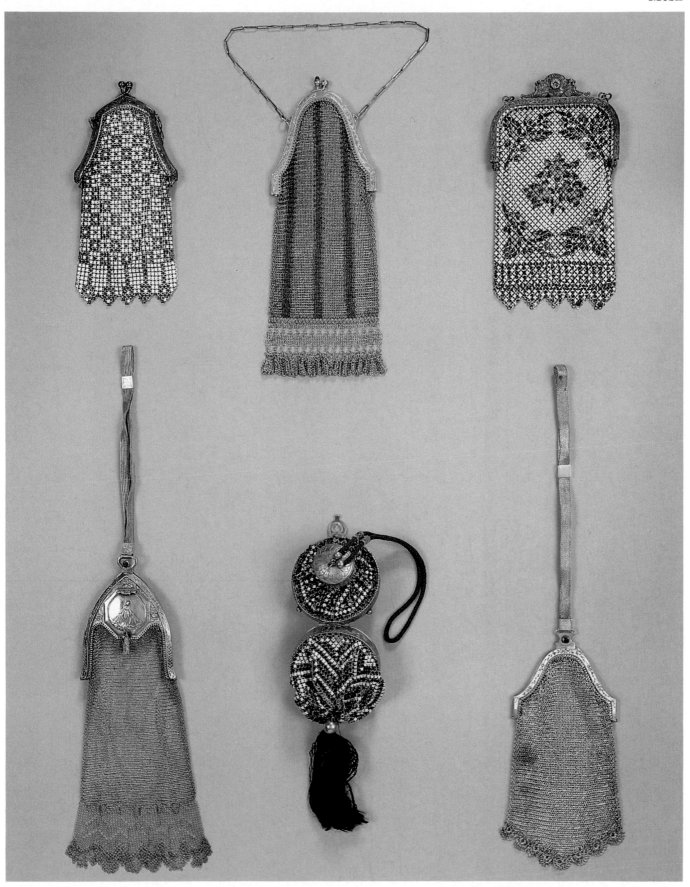

Top Left:
Maker - Whiting & Davis
Size - 3″ x 6¼″

Bottom Left:
Maker - Whiting & Davis
Size - 3¾″ x 9″

Top Center:
Maker - Whiting & Davis
Size - 3¾″ x 8¼″

Bottom Center:
Maker - Whiting & Davis
Size - 2¾″ x 9″

Top Right:
Maker - Mandalian
Size - 3½″ x 6½″

Bottom Right:
Maker - Germany
Size - 3¾″ x 6¾″

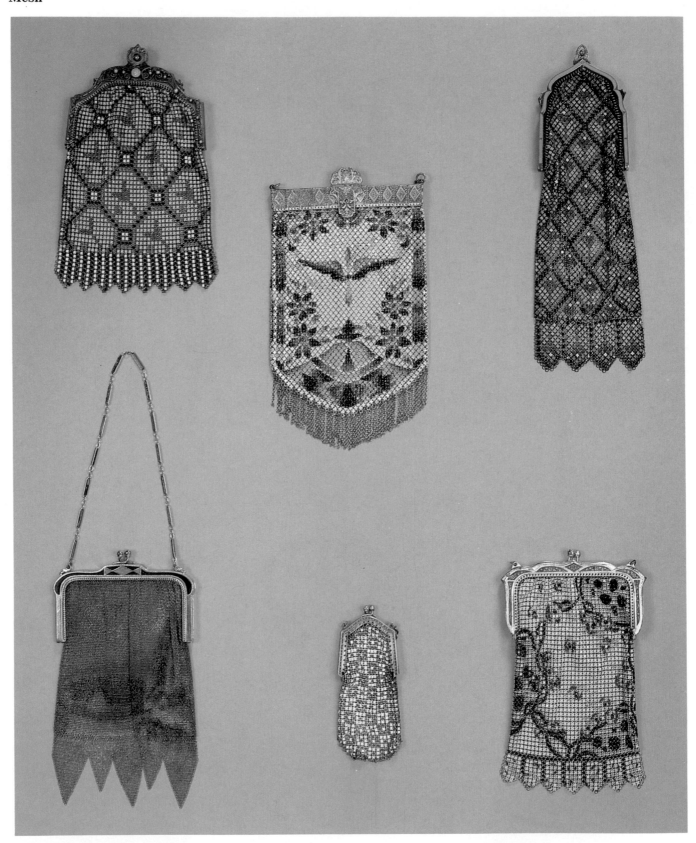

Top Left:
Maker - Whiting & Davis
Size - 4½″ x 6¾″

Bottom Left:
Maker - Whiting & Davis
Size - 4½″ x 7¼″

Top Center:
Maker - Mandalian
Size - 4½″ x 7¾″

Bottom Center:
Maker - Whiting & Davis
Size - 1¾″ x 4¼″

Top Right:
Maker - Whiting & Davis
Size - 3″ x 9″

Bottom Right:
Maker - Whiting & Davis
Size - 4″ x 6¾″

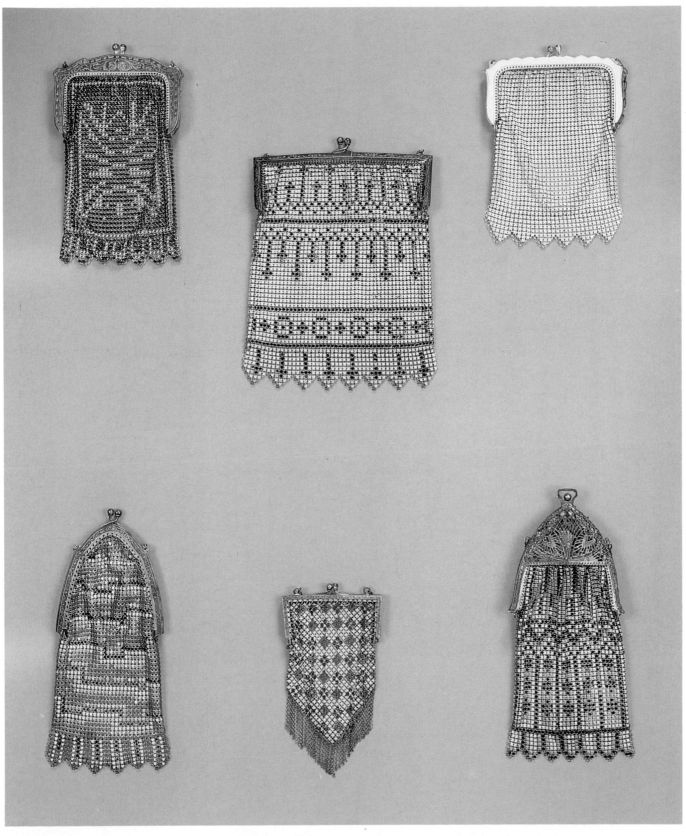

Top Left:
Maker - Whiting & Davis
Size - 3½″ x 6¼″

Top Center:
Maker - Whiting & Davis
Size - 5¼″ x 7″

Top Right:
Maker - Whiting & Davis
Size - 3¾″ x 5½″

Bottom Left:
Maker - Whiting & Davis
Size - 3¼″ x 7½″

Bottom Center:
Maker - Whiting & Davis
Size - 3″ x 5½″

Bottom Right:
Maker - Whiting & Davis
Size - 3½″ x 7½″

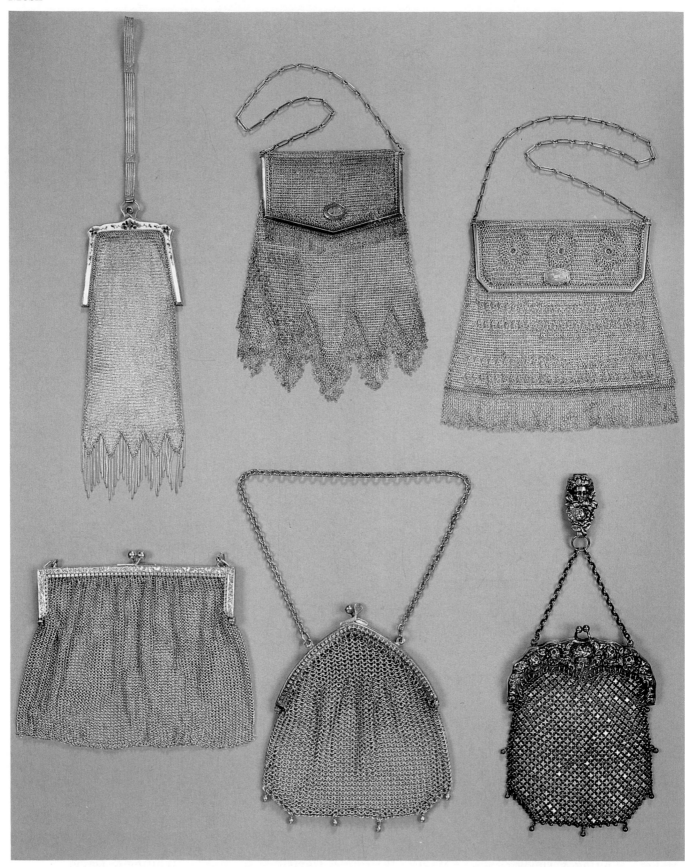

Top Left:
Maker - Germany
Size - 3″ x 8½″
Style - Sterling

Bottom Left:
Size - 9″ x 6″
Style - Sterling

Top Center:
Maker - Whiting & Davis
Size - 5½″ x 7¼″

Bottom Center:
Size - 5½″ x 6½″

Top Right:
Maker - Whiting & Davis
Size - 6½″ x 6″

Bottom Right:
Maker - Whiting & Davis
Size - 4¼″ x 6″
Style - Sterling

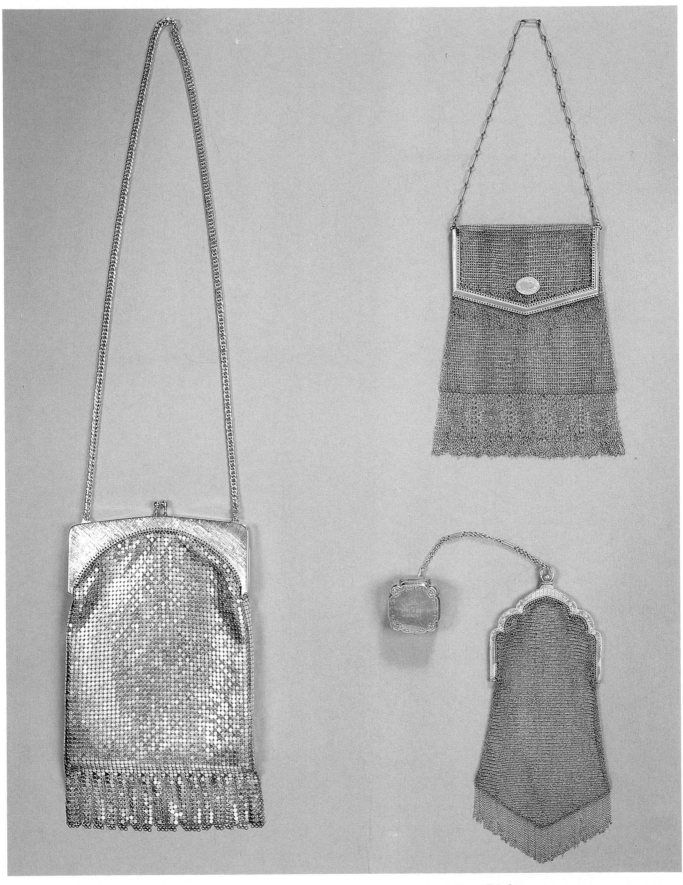

Top Left:
Maker - Whiting & Davis
Size - 5¼" x 9¼"

Top Right:
Maker - Whiting & Davis
Size - 5¼" x 6½"

Bottom Right:
Maker - Napier
Size - 3¾" x 8¼"

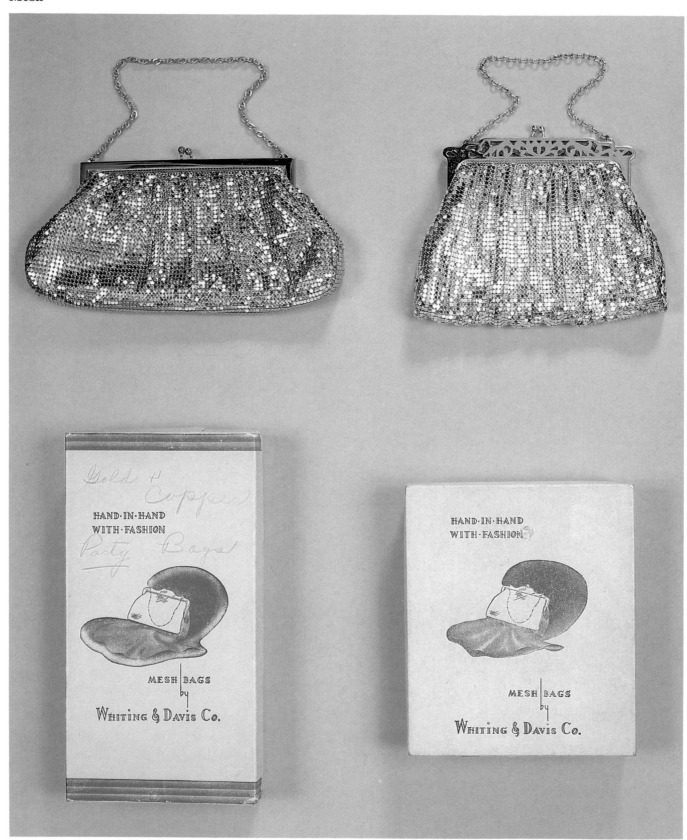

Left:
Maker - Whiting & Davis
Size - 8¾" x 4¾"
(With original Whiting & Davis box)

Right:
Maker - Whiting & Davis
Size - 7" x 5¾"
(With original Whiting & Davis box)

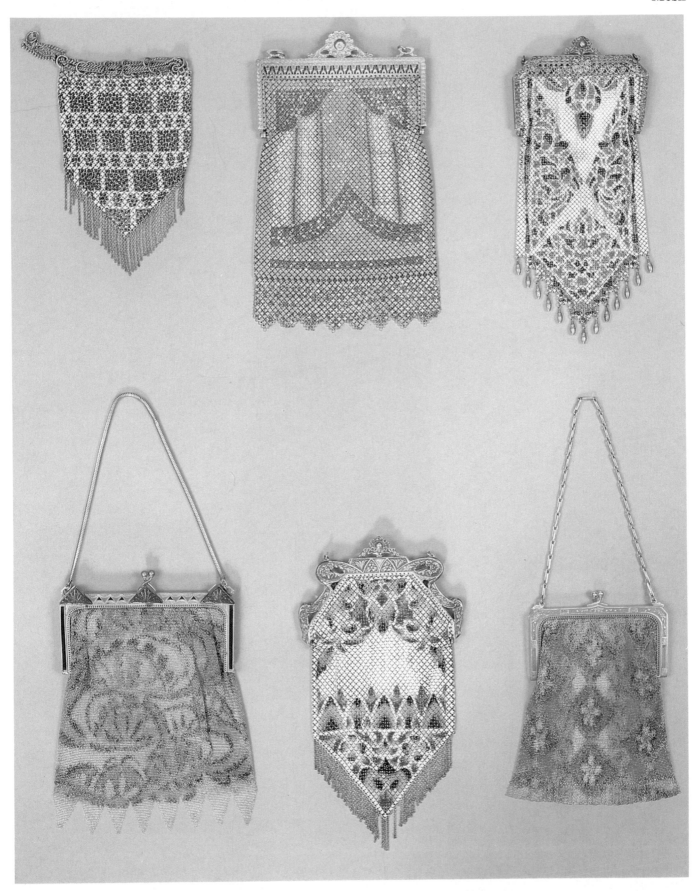

Top Left:
Maker - Whiting & Davis
Size - 3½" x 6"

Top Center:
Maker - Mandalian
Size - 5¼" x 8½"

Top Right:
Maker - Mandalian
Size - 3¾" x 8½"

Bottom Left:
Maker - Whiting & Davis
Size - 5½" x 7½"

Bottom Center:
Maker - Mandalian
Size - 4¾" x 9"

Bottom Right:
Maker - Whiting & Davis
Size - 5¼" x 6"

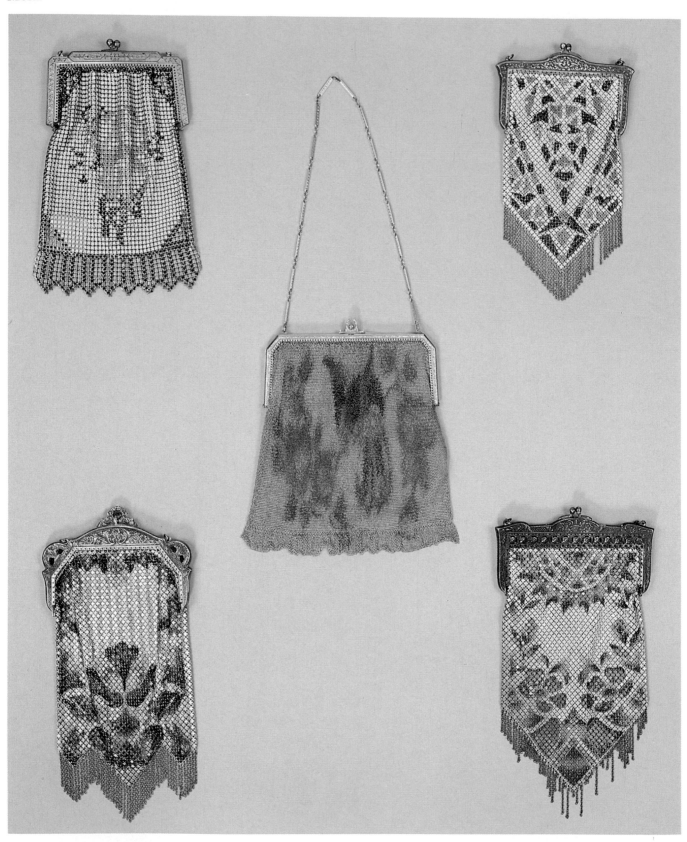

Top Left:
Maker - Whiting & Davis
Size - 4¾" x 7¼"

Center:
Maker - Whiting & Davis
Size - 6½" x 6¾"

Top Right:
Maker - Mandalian
Size - 4" x 7¼"

Bottom Left:
Maker - Mandalian
Size - 4¼" x 9"

Bottom Right:
Maker - Mandalian
Size - 4½" x 9"

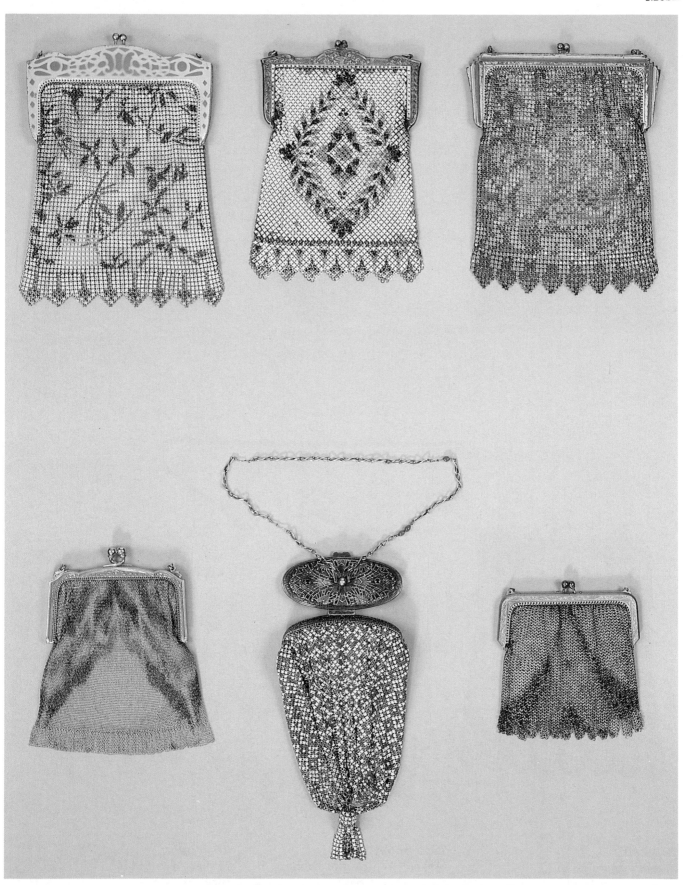

Top Left:
Maker - Whiting & Davis
Size - 5¼″ x 7¾″

Top Center:
Maker - Mandalian
Size - 4¾″ x 7″

Top Right:
Maker - Whiting & Davis
Size - 5½″ x 7″

Bottom Left:
Maker - Whiting & Davis
Size - 5¼″ x 5½″

Bottom Center:
Maker - Whiting & Davis
Size - 3½″ x 8″

Bottom Right:
Maker - Whiting & Davis
Size - 4″ x 4½″

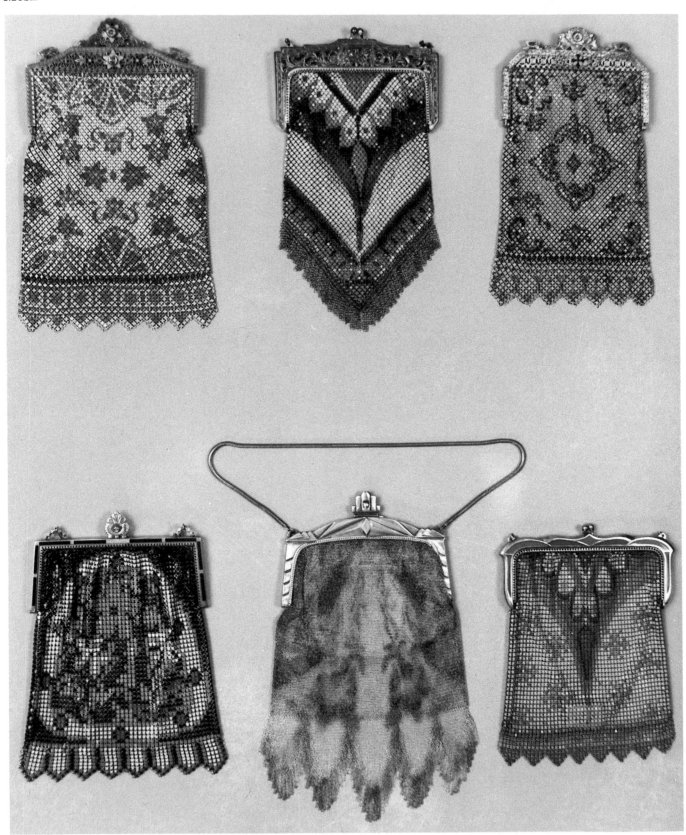

Top Left:
Maker - Mandalian
Size - 5½″ x 8¾″

Top Center:
Maker - Whiting & Davis
Size - 4¾″ x 8½″

Top Right:
Maker - Mandalian
Size - 5″ x 8″

Bottom Left:
Maker - Whiting & Davis
Size - 6″ x 7½″

Bottom Center:
Maker - Whiting & Davis
Size - 6¼″ x 9½″

Bottom Right:
Maker - Whiting & Davis
Size - 5½″ x 7″

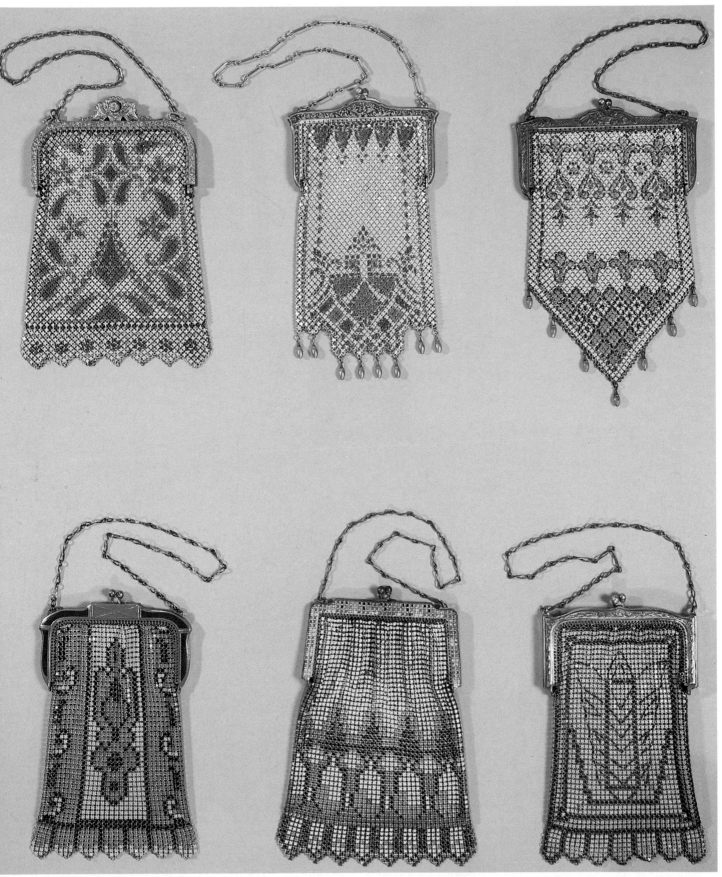

Top Left:
Maker - Mandalian
Size - 5" x 7"

Top Center:
Maker - Mandalian
Size - 4" x 7½"

Top Right:
Maker - Mandalian
Size - 4¼" x 7¾"

Bottom Left:
Maker - Whiting & Davis
Size - 4¼" x 7"

Bottom Center:
Maker - Whiting & Davis
Size - 5" x 7"

Bottom Right:
Maker - Whiting & Davis
Size - 4" x 6¾"

Mesh

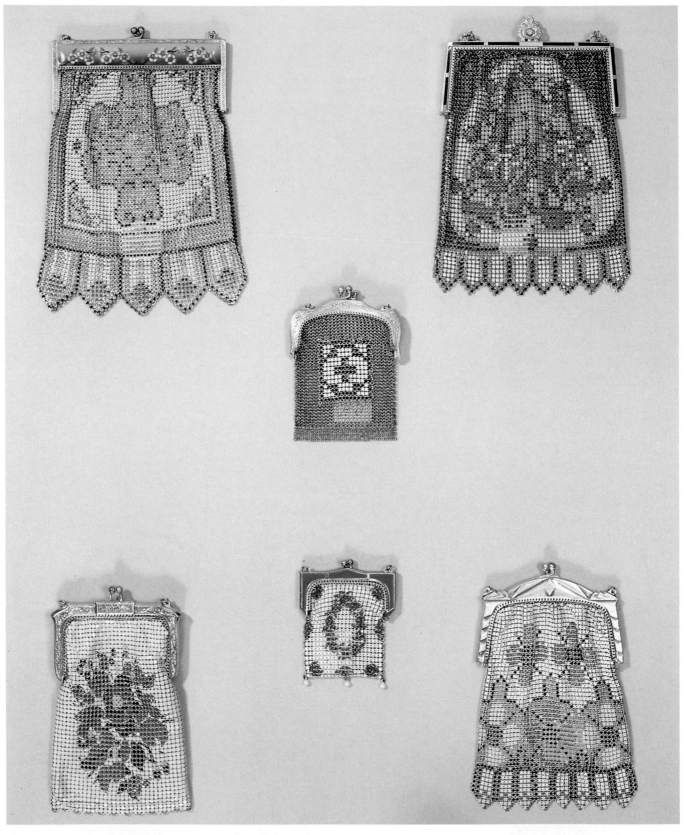

Top Left:
Maker - Whiting & Davis
Size - 6″ x 8″

Top Center:
Maker - Whiting & Davis
Size - 3″ x 4½″

Top Right:
Maker - Whiting & Davis
Size - 5½″ x 8″

Bottom Left:
Maker - Whiting & Davis
Size - 4″ x 6¼″

Bottom Center:
Maker - Whiting & Davis
Size - 2½″ x 3¼″

Bottom Right:
Maker - Whiting & Davis
Size - 4½″ x 6½″

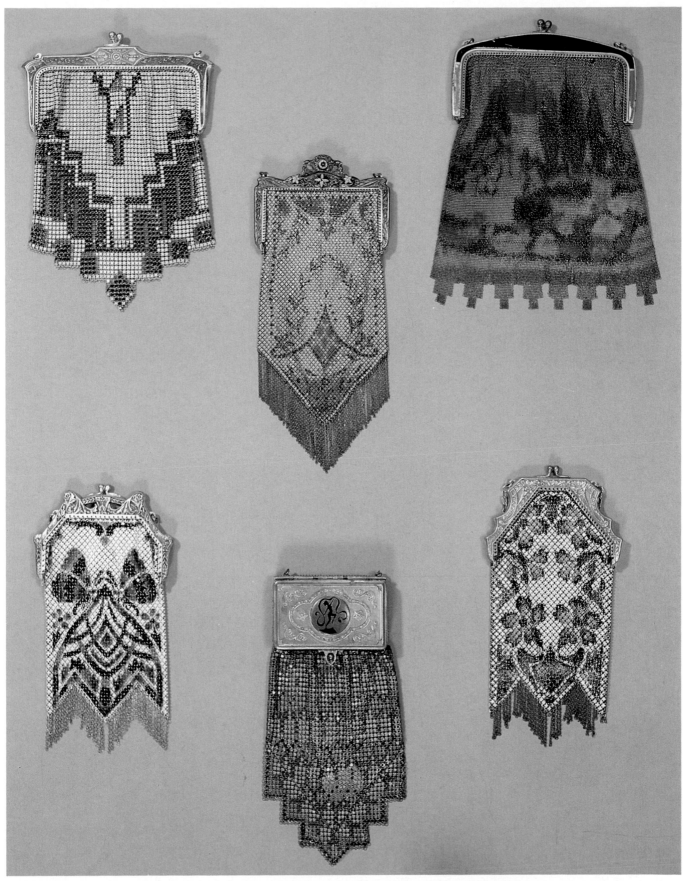

Top Left:
Maker - Whiting & Davis
Size - 5¼" x 8"

Bottom Left:
Maker - Mandalian
Size - 3¼" x 7¼"

Top Center:
Maker - Mandalian
Size - 4¾" x 8½"

Bottom Center:
Maker - Whiting & Davis
Size - 4" x 8"

Top Right:
Maker - Whiting & Davis
Size - 6¼" x 8"

Bottom Right:
Maker - Mandalian
Size - 3¾" x 7½"

Mesh

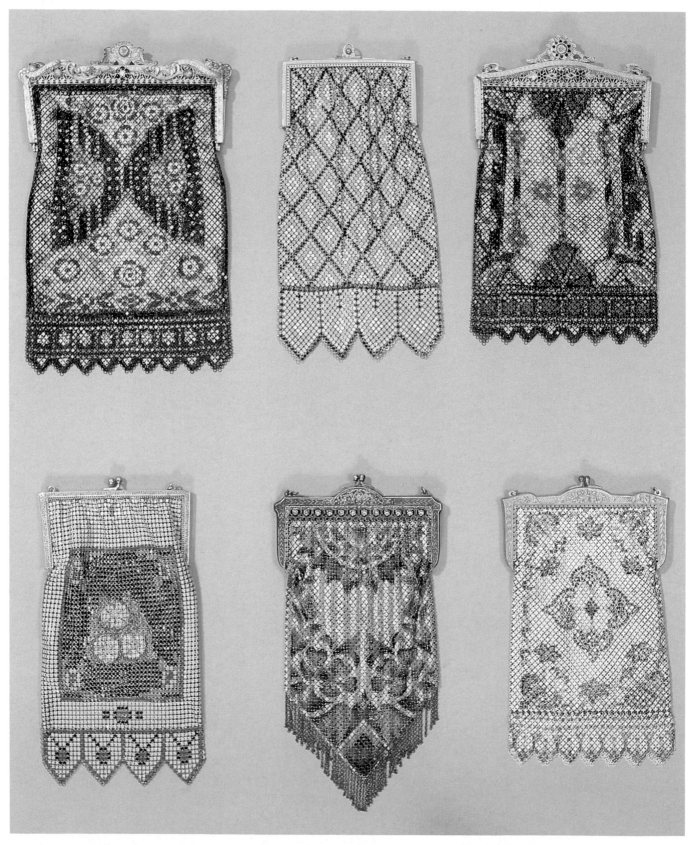

Top Left:
Maker - Mandalian
Size - 6″ x 9″

Top Center:
Maker - Whiting & Davis
Size - 4½″ x 9″

Top Right:
Maker - Mandalian
Size - 5″ x 8½″

Bottom Left:
Maker - Whiting & Davis
Size - 4½″ x 8½″

Bottom Center:
Maker - Mandalian
Size - 4½″ x 9″

Bottom Right:
Maker - Mandalian
Size - 4½″ x 8″

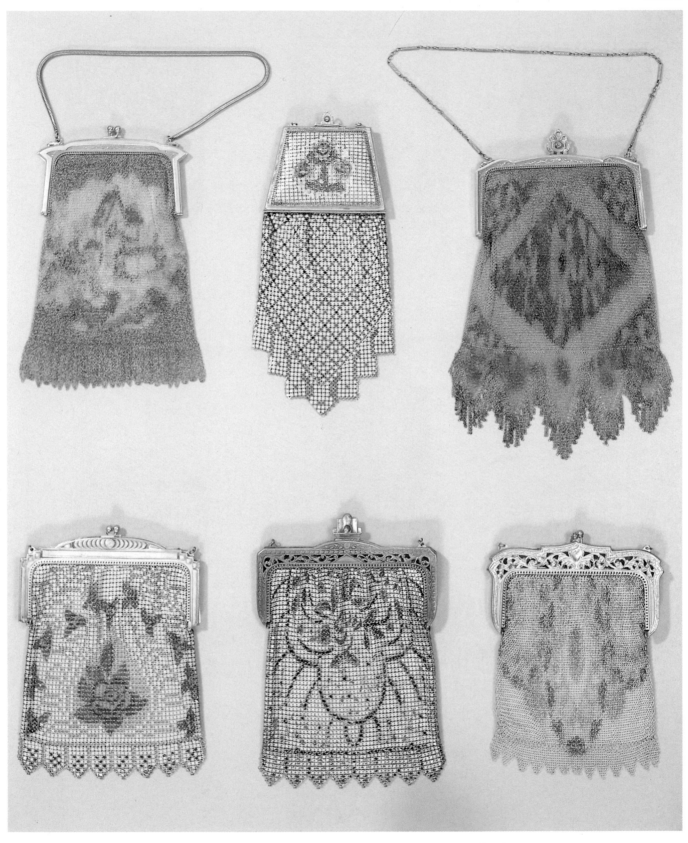

Top Left:
Maker - Whiting & Davis
Size - 5¼″ x 7½″

Top Center:
Maker - Whiting & Davis
Size - 4½″ x 8½″

Top Right:
Maker - Whiting & Davis
Size - 6½″ x 9¼″

Bottom Left:
Maker - Whiting & Davis
Size - 5¼″ x 7¼″

Bottom Center:
Maker - Whiting & Davis
Size - 5¼″ x 8″

Bottom Right:
Maker - Whiting & Davis
Size - 5″ x 7″

Mesh

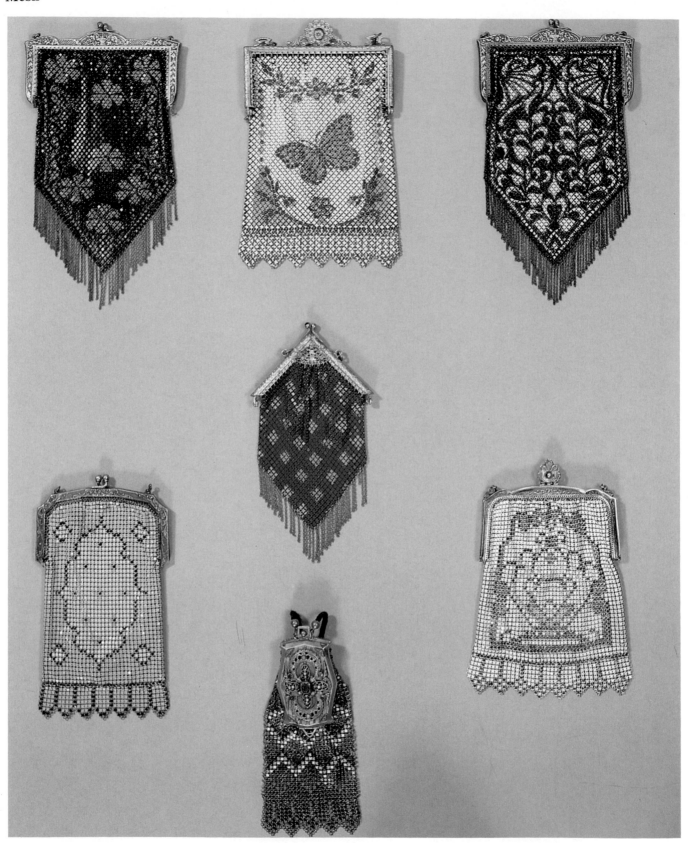

Top Left:
Maker - Mandalian
Size - 4½″ x 8¼″

Bottom Left:
Maker - Whiting & Davis
Size - 4″ x 7″

Top Center:
Maker - Mandalian
Size - 4¾″ x 7¼″

Center:
Maker - Whiting & Davis
Size - 3½″ x 6½″

Bottom Center:
Maker - Whiting & Davis
Size - 3″ x 6″

Top Right:
Maker - Mandalian
Size - 4½″ x 8¼″

Bottom Right:
Maker - Whiting & Davis
Size - 4½″ x 6¾″

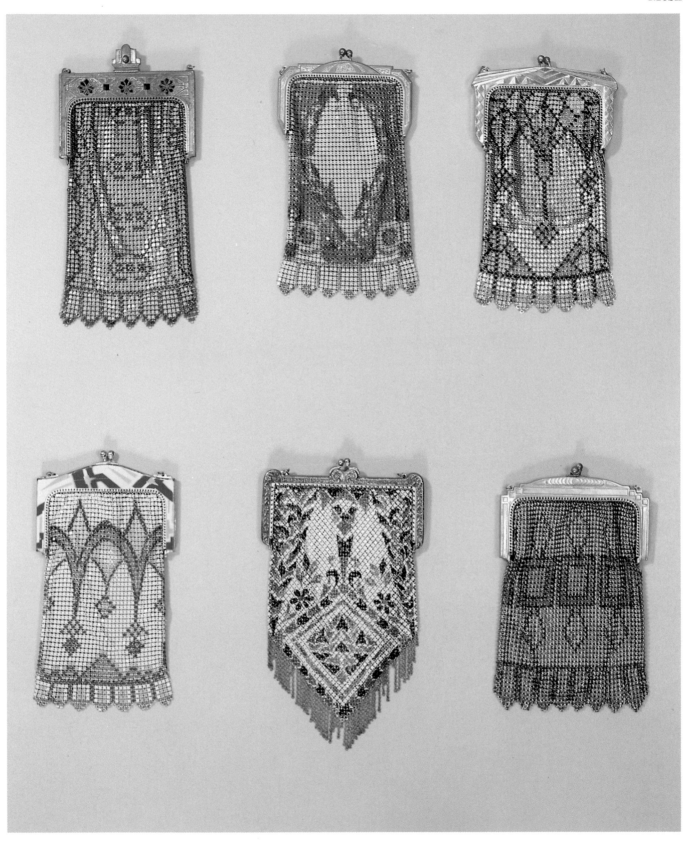

Top Left:
Maker - Whiting & Davis
Size - 4″ x 7¾″

Top Center:
Maker - Whiting & Davis
Size - 4″ x 7″

Top Right:
Maker - Whiting & Davis
Size - 4″ x 7″

Bottom Left:
Maker - Whiting & Davis
Size - 4″ x 7″

Bottom Center:
Maker - Mandalian
Size - 4½″ x 8″

Bottom Right:
Maker - Whiting & Davis
Size - 4¼″ x 6½″

Mesh

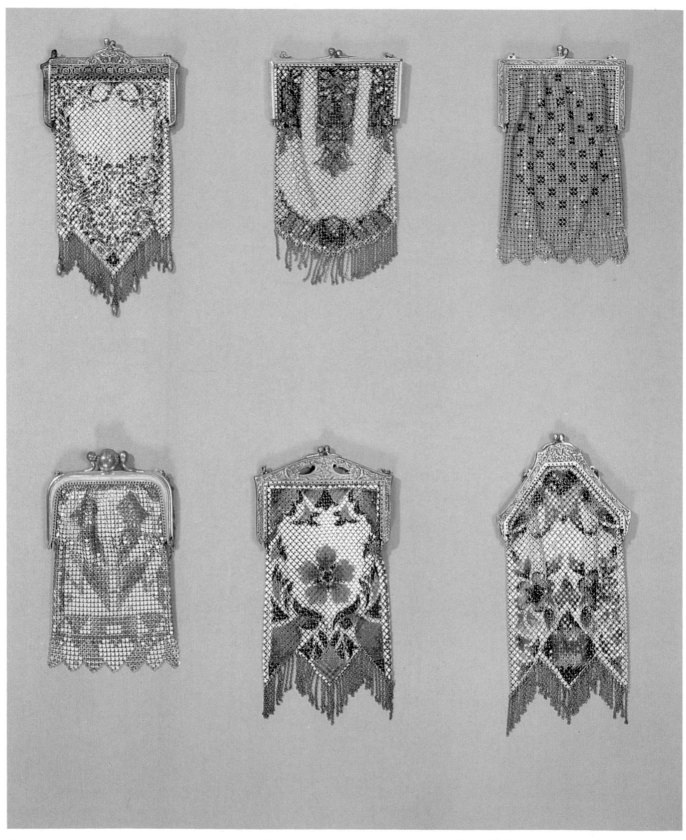

Top Left:
Maker - Mandalian
Size - 4″ x 7¾″

Top Center:
Maker - Whiting & Davis
Size - 3¾″ x 6¾″

Top Right:
Maker - Whiting & Davis
Size - 3¾″ x 6¾″

Bottom Left:
Maker - Whiting & Davis
Size - 3¾″ x 6″

Bottom Center:
Maker - Mandalian
Size - 4″ x 7½″

Bottom Right:
Maker - Mandalian
Size - 3¾″ x 8″

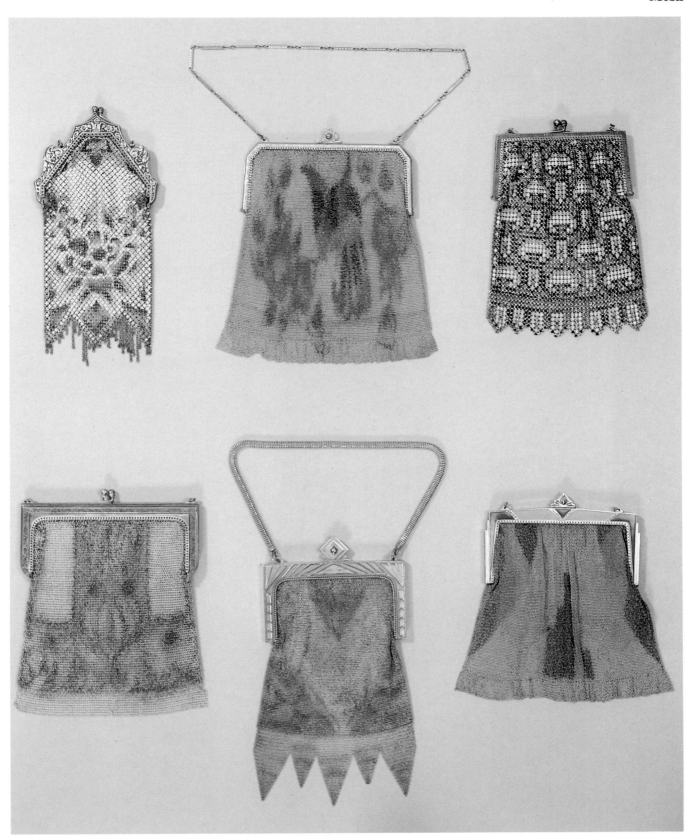

Top Left:
Maker - Mandalian
Size - 3¾″ x 7½″

Top Center:
Maker - Whiting & Davis
Size - 6½″ x 6¾″

Top Right:
Maker - Whiting & Davis
Size - 4¾″ x 6¼″

Bottom Left:
Maker - Whiting & Davis
Size - 5½″ x 6½″

Bottom Center:
Maker - Whiting & Davis
Size - 4¾″ x 7¾

Bottom Right:
Maker - Whiting & Davis
Size - 6″ x 6″

Mesh

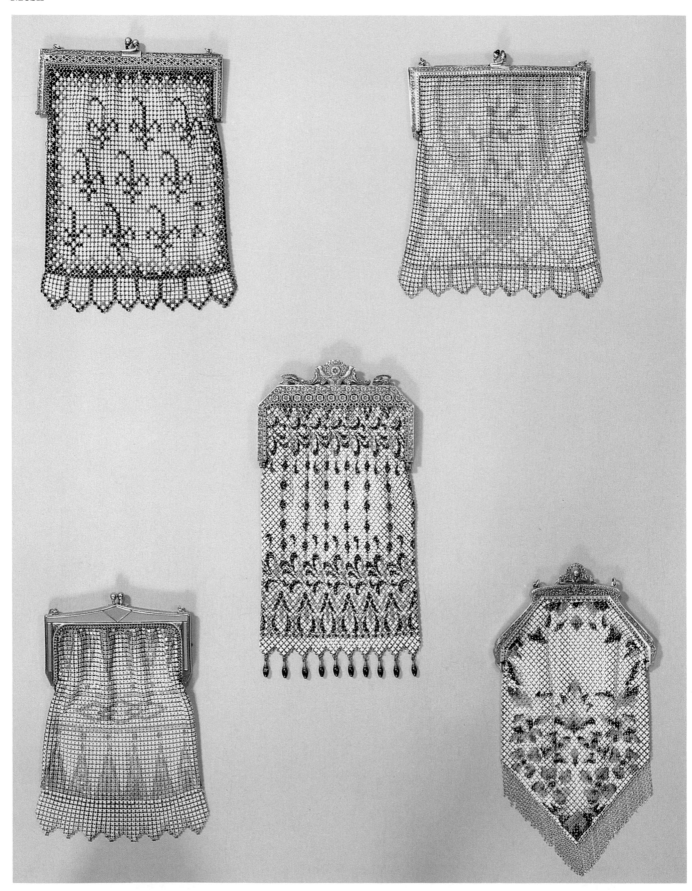

Top Left:
Maker - Whiting & Davis
Size - 5″ x 7½″

Bottom Left:
Maker - Whiting & Davis
Size - 5″ x 7″

Center:
Maker - Mandalian
Size - 4½″ x 9″

Top Right:
Maker - Whiting & Davis
Size - 5½″ x 7″

Bottom Right:
Maker - Mandalian
Size - 4½″ x 9″

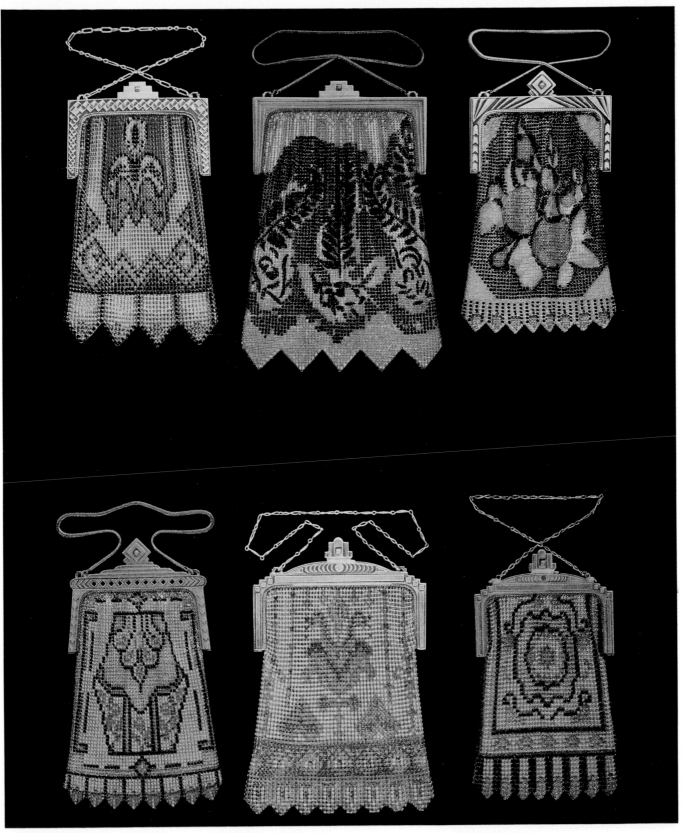

<table>
<tr><td>Top Left:
Maker - Whiting & Davis</td><td>Top Center:
Maker - Whiting & Davis</td><td>Top Right:
Maker - Whiting & Davis</td></tr>
<tr><td>Bottom Left:
Maker - Whiting & Davis</td><td>Bottom Center:
Maker - Whiting & Davis</td><td>Bottom Right:
Maker - Whiting & Davis</td></tr>
</table>

Purses on this page were photographed from original Catalog sheets.

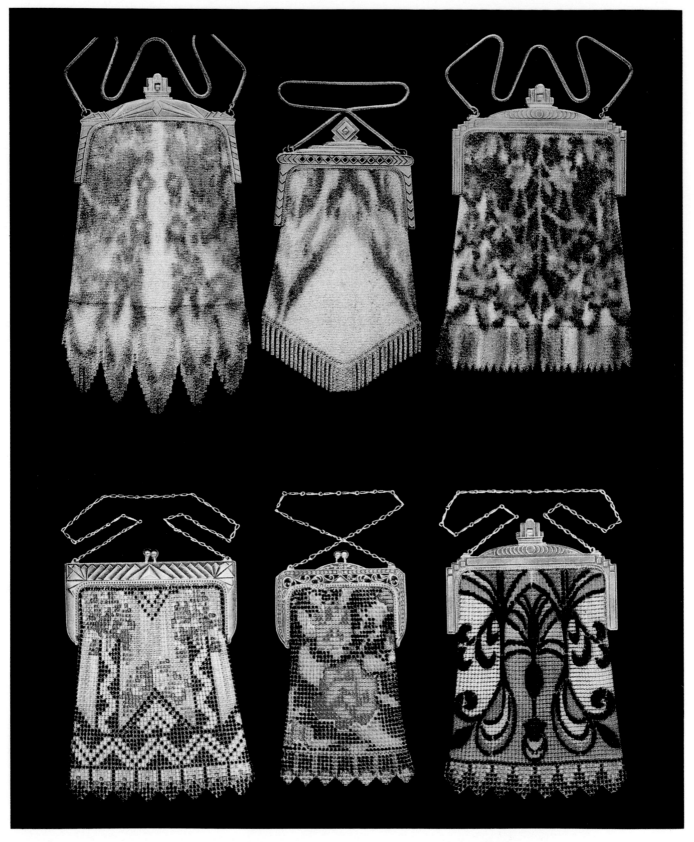

Top Left:
Maker - Whiting & Davis

Top Center:
Maker - Whiting & Davis

Top Right:
Maker - Whiting & Davis

Bottom Left:
Maker - Whiting & Davis

Bottom Center:
Maker - Whiting & Davis

Bottom Right:
Maker - Whiting & Davis

Purses on this page were photographed from original Catalog sheets.

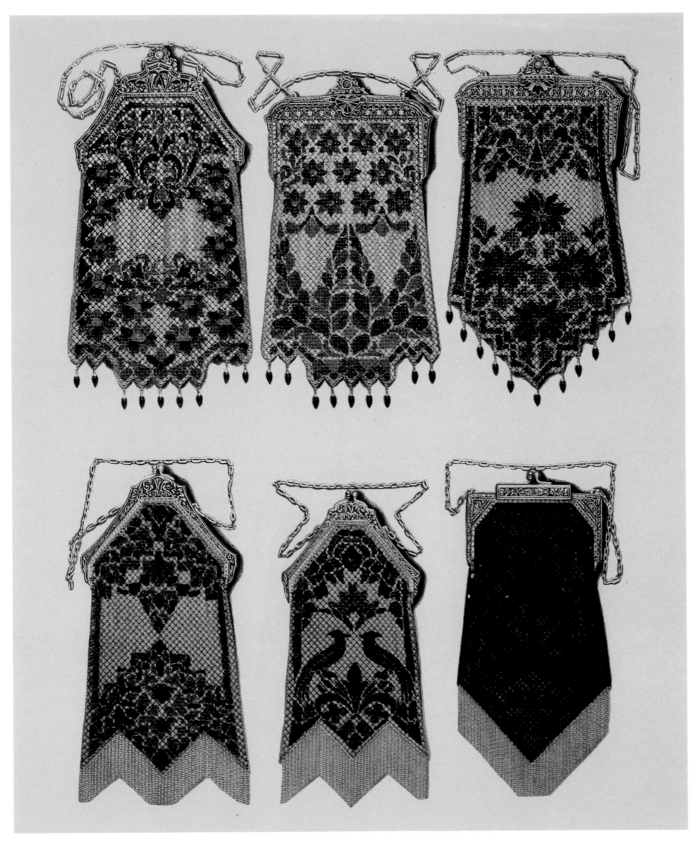

Top Left:
Maker - Mandalian

Top Center:
Maker - Mandalian

Top Right:
Maker - Mandalian

Bottom Left:
Maker - Mandalian

Bottom Center:
Maker - Mandalian

Bottom Right:
Maker - Mandalian

Purses on this page were photographed from original Catalog sheets.

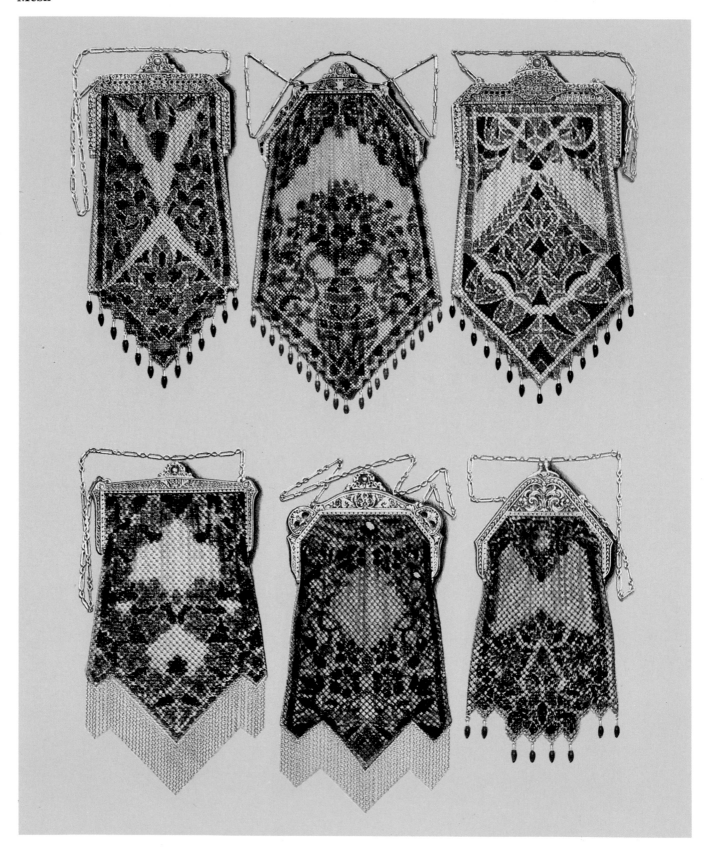

Top Left:
Maker - Mandalain

Top Center:
Maker - Mandalian

Top Right:
Maker - Mandalian

Bottom Left:
Maker - Mandalian

Bottom Center:
Maker - Mandalian

Bottom Right:
Maker - Mandalian

Purses on this page were photographed from original Catalog sheets.

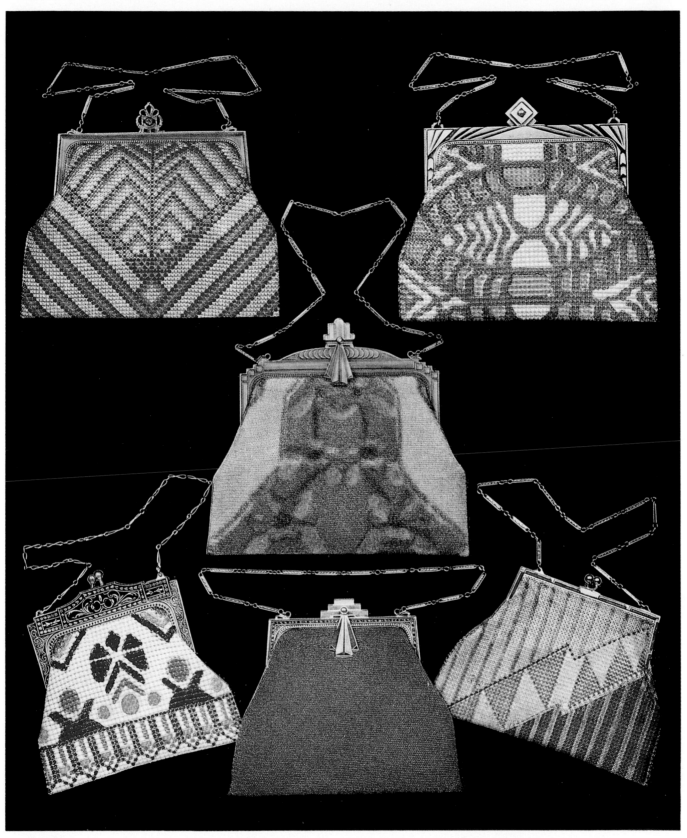

Top Left:
Maker - Whiting & Davis

Center:
Maker - Whiting & Davis

Top Right:
Maker - Whiting & Davis

Bottom Left:
Maker - Whiting & Davis

Bottom Center:
Maker - Whiting & Davis

Bottom Right:
Maker - Whiting & Davis

Purses on this page were photographed from original Catalog sheets.

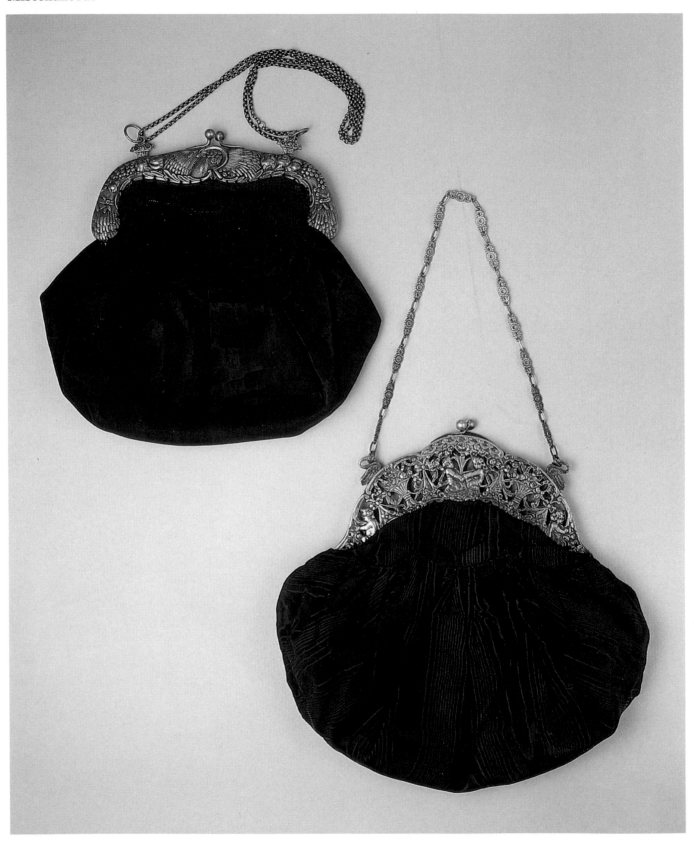

Left:
Maker - Germany
Size - 9½" x 9¼"
Style - 800 Silver Frame

Right:
Size - 10¼" x 10½"
Style - 800 Silver Frame

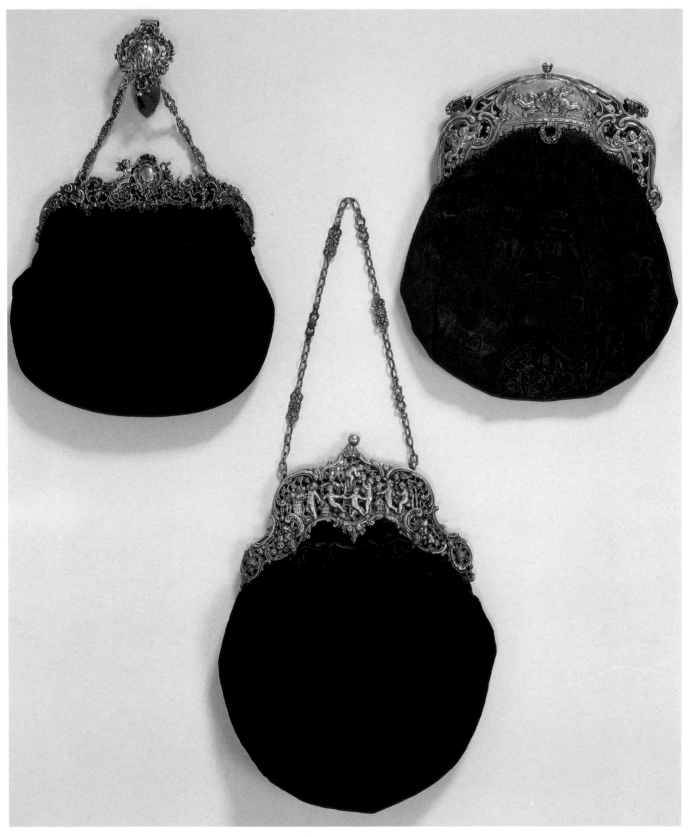

Top Left:
Size - 7½″ x 7½″
Style - 800 Silver Frame

Bottom Center:
Size - 7¾″ x 10″
Style - 800 Silver Frame

Top Right:
Size - 7¾″ x 9½″
Style - Sterling Frame

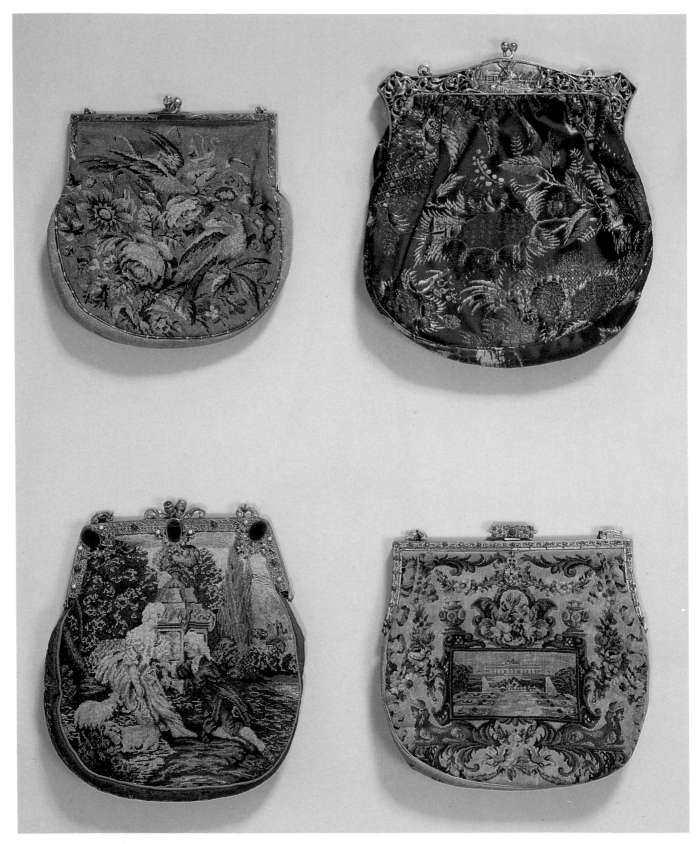

Top Left:
Size - 7″ x 7¼″
Style - Sterling Frame

Bottom Left:
Size - 7¼″ x 8¼″
Style - Jeweled Frame:
 Lapis, Pearls and
 Carnelian

Top Right:
Maker - Holland
Size - 8″ x 9¼″

Bottom Right:
Maker - Austria
Size - 7½″ x 7¼″
Style - Jeweled Frame:
 Lapis, Moonstone, etc.

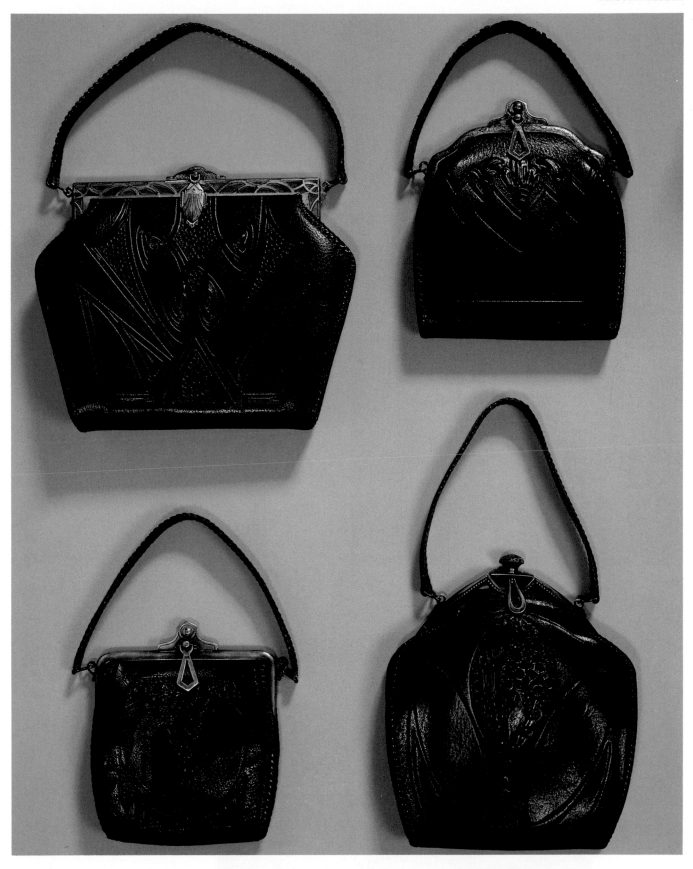

Top Left:
Maker - Jemco
Size - 9″ x 7½″

Bottom Left:
Maker - Jemco
Size - 5″ x 6¼″

Top Right:
Maker - Jemco
Size - 5¾″ x 6¾″

Bottom Right:
Maker - Jemco
Size - 6¾″ x 8″
Style - Frederick Kranz

Russian Coin Purse
Size - 2½″ x 3″
Style - 840 Silver

Jeweled Purse
Size - 6½″ x 8″
Style - 800 Silver
 Gemstones: Emeralds,
 Sapphires, Rubies, Pearls.
Extremely rare, one of a
kind. No price established.

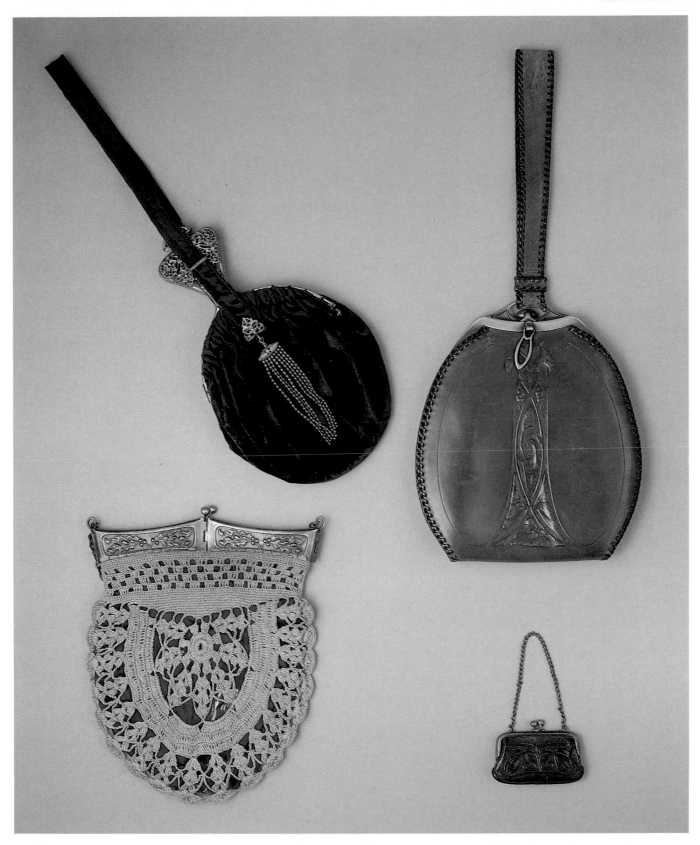

Top Left:
Size - 5″ x 8¾″

Bottom Left:
Size - 6½″ x 8¼″

Top Right:
Size - 7½″ x 6″
Style - German Silver

Bottom Right:
Size - 2½″ x 1¾″

Top Left:
Size - 7″ x 7¼″

Bottom Left:
Size - 7″ x 7¼″

Right Center:
Size - 9½″ x 9″

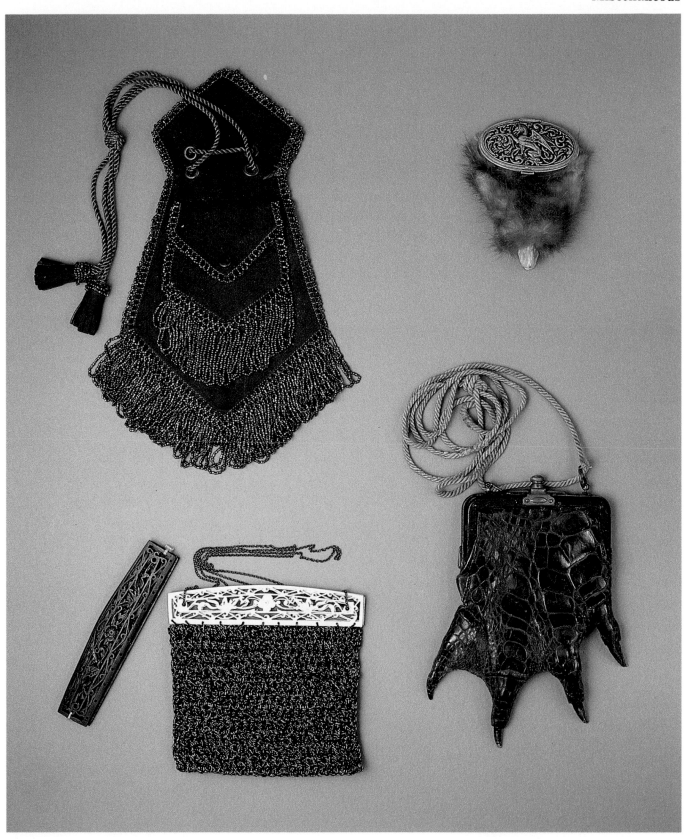

Top Left:
Size - 6¾" x 11½"

Bottom Left:
Maker - China
Size - 5½" x 5¼"
Style - Matching Teakwood
 and Ivory Frames

Top Right:
Size - 3¼" x 4½"
Style - Stuffed Mink's Head
 Coin Purse

Bottom Right:
Size - 5¾" x 7¾"
Style - Alligator Paw Purse

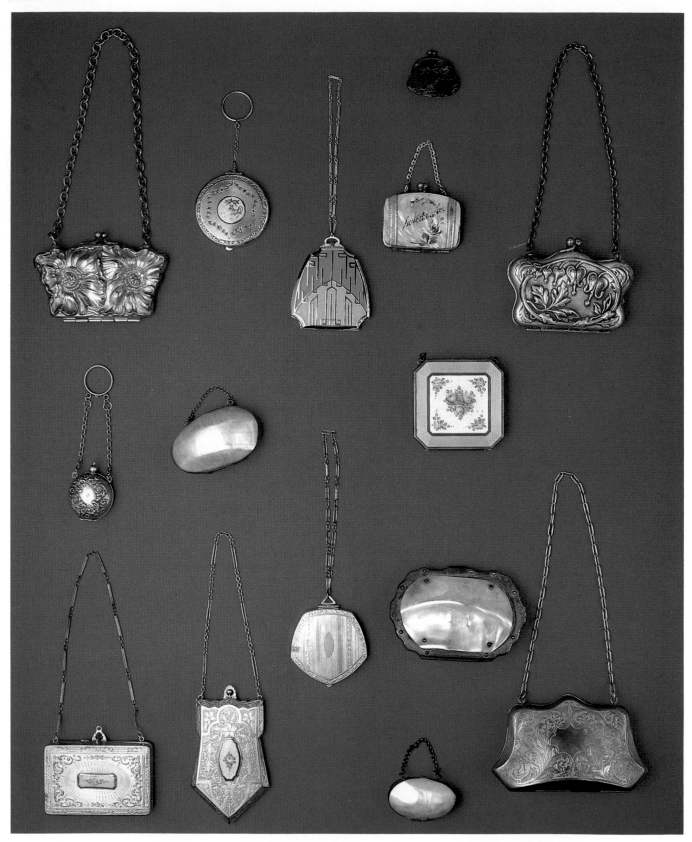

Top Row:
1. Size - 3¾″ x 2½″
2. Size - 2″ x 2″
3. Size - 2¼″ x 2¾″
4. Size - 1½″ x 1½″
5. Size - 2¼″ x 2″
6. Size - 3½″ x 3½″
 Style - German Silver

Center Row:
7. Size - 1¼″ x 1¾″
 Style - German Silver
8. Size - 2½″ x 1¾″
9. Size - 2½″ x 2½″
 Style - German Silver

Bottom Row:
10. Size - 3″ x 2½″
11. Size - 2¼″ x 4″
12. Size - 2¼″ x 2¼″
13. Size - 3¾″ x 2¾″
14. Size - 2″ x 1¼″
15. Size - 4¼″ x 2¾″
 Style - Gold filled

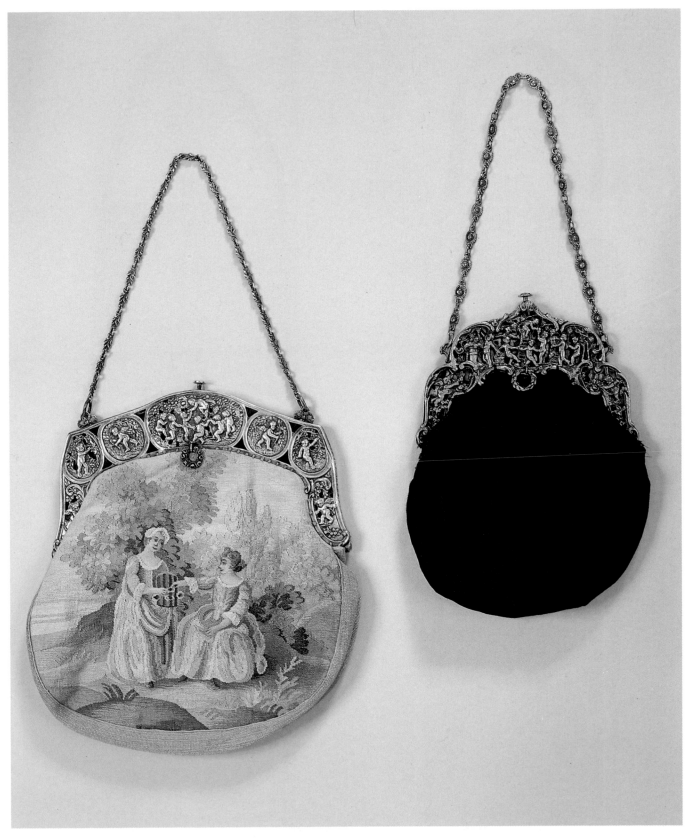

Left:
Size - 9½″ x 10¾″
Style - Sterling Frame

Right:
Size - 6½″ x 9¼″
Style - 800 Silver Frame

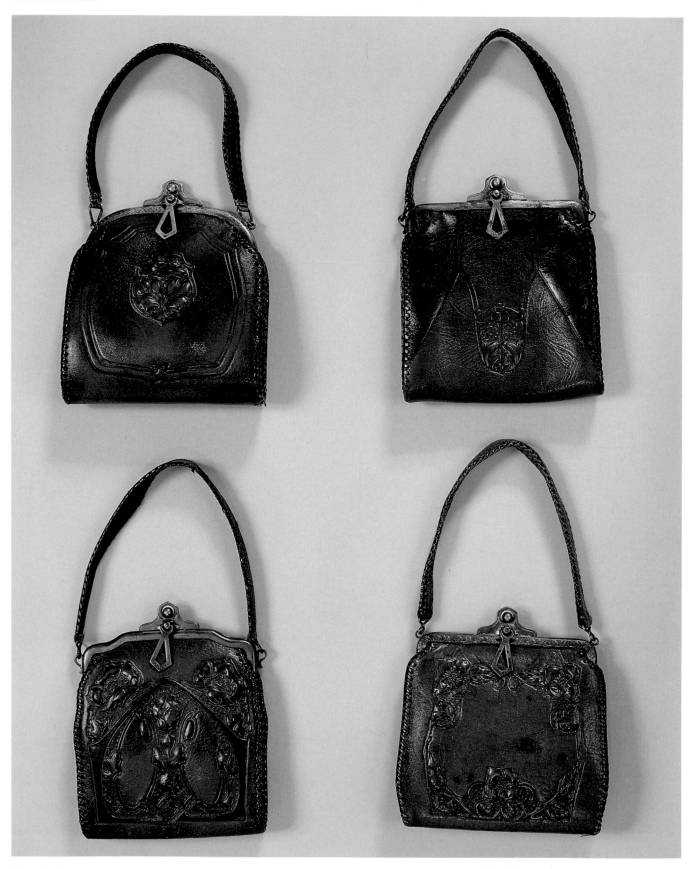

Top Left:
Maker - Jemco
Size - 5¾″ x 6¾″

Bottom Left:
Maker - Jemco
Size - 5¼″ x 6¾″

Top Right:
Maker - Jemco
Size - 5½″ x 6¾″

Bottom Right:
Maker - Jemco
Size - 5¾″ x 6½″

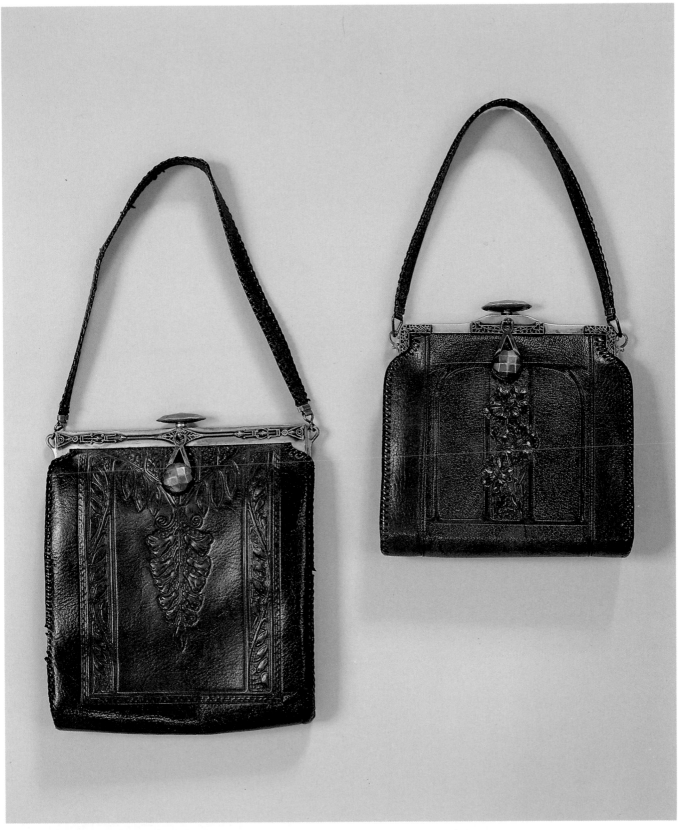

Left:
Maker - Jemco
Size - 7½″ x 9¼″

Right:
Maker - Jemco
Size - 7″ x 7¼″

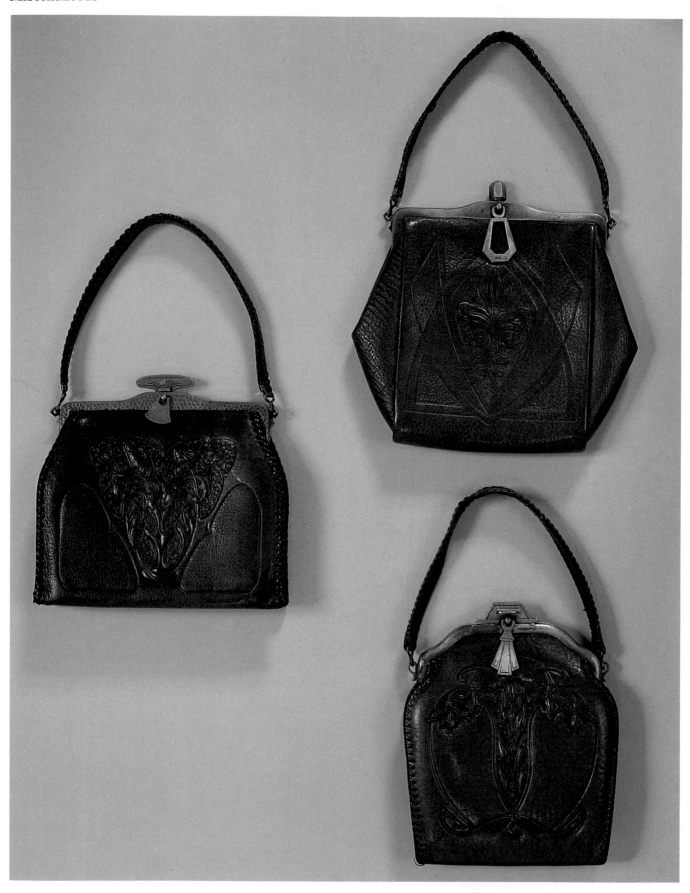

Left:
Maker - Jemco
Size - 7″ x 6¾″

Top Right:
Maker - Jemco
Size - 8″ x 7¾″

Bottom Right:
Maker - Jemco
Size - 6″ x 7½″

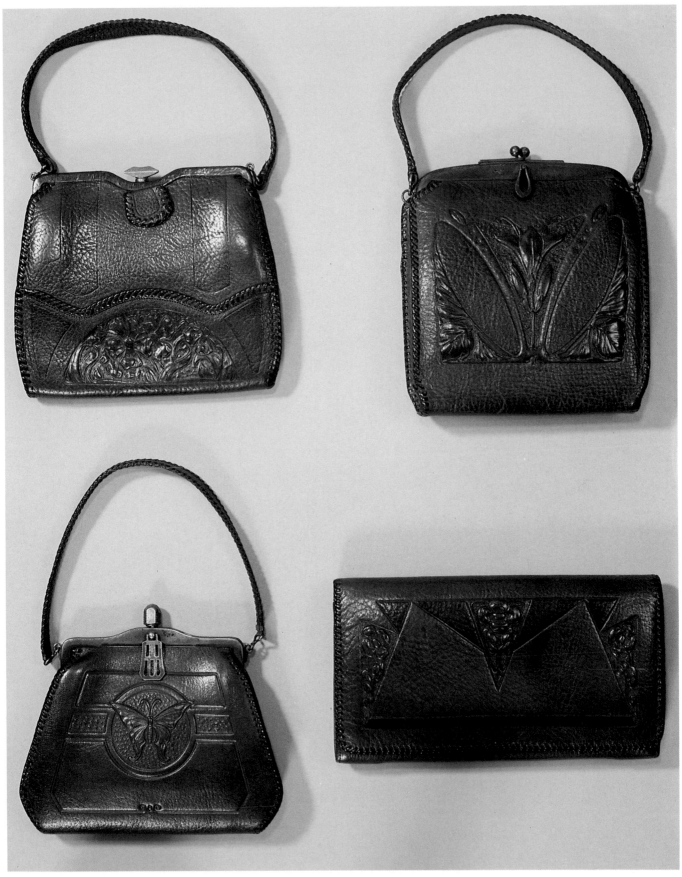

Top Left:
Maker - Meeker
Size - 6½″ x 7″

Bottom Left:
Maker - Jemco
Size - 6¼″ x 7″

Top Right:
Maker - Meeker
Size - 7½″ x 6½″

Bottom Right:
Maker - Meeker
Size - 5¼″ x 9¼″

Size - 4½″ x 4″
Style - Cloisonne'

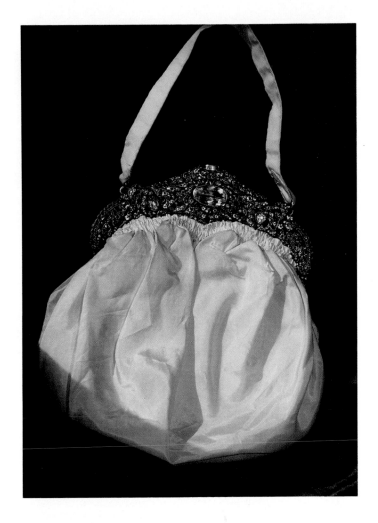

Size - 7″ x 10″
Style - Handmade silver top, with large aquamarine (approx. 25 karats); white sapphires and rubies.

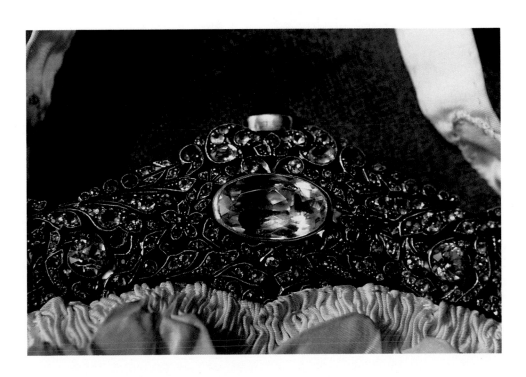

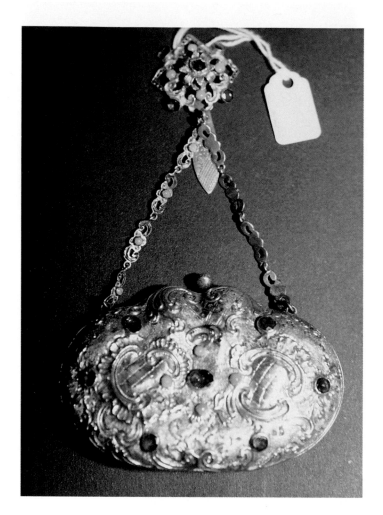

Size - 2½″ x 3½″
Style - Coin purse with belt
 clip; silver; rubies and
 Persian turquoise

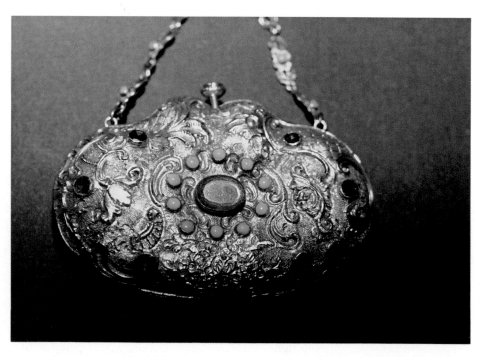

Price Guide

Page	Location	Value
9	left center	$350.00
	top right	$225.00
	bottom right	$50.00
10	top left	$65.00
	bottom left	$55.00
	top center	$65.00
	bottom center	$70.00
	top right	$55.00
	bottom right	$60.00
11	top left	$65.00
	bottom left	$75.00
	top right	$70.00
	bottom right	$60.00
12	top left	$300.00
	right	$325.00
13	left center	$175.00
	top right	$50.00
	bottom right	$75.00
14	top left	$80.00
	bottom left	$50.00
	center right	$225.00
15	bottom left	$90.00
	top right	$50.00
	bottom right	$45.00
16	top left	$65.00
	bottom left	$55.00
	top right	$50.00
	bottom right	$175.00
17	top left	$50.00
	bottom left	$100.00
	top right	$55.00
	bottom right	$60.00
18	top left	$65.00
	bottom left	$100.00
	top right	$25.00
	bottom right	$60.00
19	top left	$145.00
	bottom left	$50.00
	top right	$60.00
	bottom right	$95.00
20	center left	$150.00
	top right	$50.00
	bottom right	$50.00
21	top left	$45.00
	bottom left	$150.00
	top right	$50.00
	bottom right	$95.00
22	top left	$60.00
	bottom left	$100.00
	right center	$125.00
23	top left	$60.00
	bottom left	$75.00
	top right	$70.00
	bottom right	$50.00
24	top left	$70.00
	bottom left	$65.00
	top right	$60.00
	bottom right	$100.00
25	top left	$55.00
	bottom left	$60.00
	top right	$85.00
	bottom right	$55.00
26	left	$125.00
	right	$200.00
27	top left	$55.00
	bottom left	$140.00
	top right	$60.00
	bottom right	$80.00
28	top left	$70.00
	bottom left	$60.00
	top right	$75.00
	bottom right	$85.00
29	top left	$70.00
	bottom left	$80.00
	top right	$85.00
	bottom right	$65.00
30	top left	$55.00
	bottom left	$75.00
	top right	$135.00
	bottom right	$55.00
31	top left	$70.00
	bottom left	$75.00
	top right	$75.00
	bottom right	$85.00
32	top left	$50.00
	bottom left	$70.00
	center	$80.00
	top right	$50.00
	bottom right	$75.00
33	top left	$50.00
	center left	$30.00
	bottom left	$45.00
	center	$45.00
	top right	$45.00
	center right	$35.00
	bottom right	$55.00
34	top left	$65.00
	bottom left	$55.00
	center	$35.00
	top right	$60.00
	bottom right	$45.00
35	top left	$55.00
	bottom left	$70.00
	top right	$60.00
	bottom right	$95.00
36	top left	$65.00
	bottom left	$70.00
	top right	$55.00
	bottom right	$95.00
37	top left	$50.00
	bottom left	$80.00
	top right	$60.00
	bottom right	$50.00
38	top left	$50.00
	bottom left	$70.00
	center	$25.00
	top right	$55.00
	bottom right	$90.00
39	top left	$75.00
	bottom left	$70.00
	top right	$60.00
	bottom right	$125.00
40	top left	$55.00
	bottom left	$70.00
	top right	$60.00
	bottom right	$60.00
41	top left	$55.00
	bottom left	$70.00
	top right	$60.00
	bottom right	$85.00
42	top left	$65.00
	bottom left	$45.00
	right	$165.00
43	top left	$65.00
	bottom left	$120.00
	top right	$55.00
	bottom right	$55.00
44	top left	$95.00
	bottom left	$50.00
	top right	$75.00
	bottom right	$85.00
45	top left	$60.00
	bottom left	$70.00
	top right	$55.00
	bottom right	$55.00
46	top left	$45.00
	bottom left	$75.00
	top right	$45.00
	bottom right	$65.00
47	left	$175.00
	right	$80.00
48	top left	$50.00
	bottom left	$55.00
	top right	$45.00
	bottom right	$145.00
49	top left	$60.00
	bottom left	$125.00
	top right	$55.00
	bottom right	$325.00
50	left	$100.00
	right	$90.00
51	top left	$85.00
	bottom left	$65.00
	top right	$60.00
	bottom right	$65.00
52	left	$100.00
	right	$350.00
53	bottom left	$75.00
	top center	$75.00
	bottom right	$125.00
54	left	$95.00
	right	$85.00
55	top left	$65.00
	bottom left	$55.00
	top right	$50.00
	bottom right	$55.00
56	top left	$65.00
	bottom left	$85.00
	top right	$65.00
	bottom right	$65.00
57	top left	$45.00
	bottom left	$65.00
	top right	$110.00
	bottom right	$60.00
58	left	$125.00
	right	$120.00

Page	Location	Value
59	left	$225.00
	right	$100.00
60	left	$125.00
	right	$135.00
61	top left	$80.00
	bottom left	$125.00
	top right	$115.00
	bottom right	$85.00
62	top left	$175.00
	bottom left	$75.00
	top right	$175.00
	bottom right	$150.00
63	left	$50.00
	top center	$60.00
	bottom center	$70.00
	right	$75.00
64	left	$275.00
	right	$145.00
65	left	$225.00
	right	$165.00
66	left	$175.00
	right	$150.00
67	left	$145.00
	top right	$100.00
	bottom right	$85.00
68	left	$145.00
	top right	$225.00
	bottom right	$85.0
69	left	$175.00
	right	$250.00
70		$350.00
71	top left	$80.00
	bottom left	$35.00
	top right	$85.00
	bottom right	$125.00
72	left	$200.00
	right	$275.00
73	left	$175.00
	right	$165.00
74	left	$200.00
	right	$145.00
75	left	$185.00
	right	$250.00
76	top left	$165.00
	bottom left	$125.00
	right	$185.00
77	left	$195.00
	right	$115.00
78	top left	$70.00
	bottom left	$50.00
	top center	$30.00
	bottom center	$135.00
	top right	$50.00
	bottom right	$50.00
79	top left	$45.00
	bottom left	$65.00
	center	$135.00
	top right	$50.00
	bottom right	$75.00
80	top left	$80.00
	bottom left	$55.00
	top center	$50.00
	bottom center	$125.00
	top right	$60.00
	bottom right	$95.00
81	top left	$50.00
	bottom left	$75.00
	top center	$25.00
	bottom center	$250.00
	top right	$25.00
	center right	$25.00
	bottom right	$65.00
82	top left	$75.00
	bottom left	$85.00
	top center	$35.00
	bottom center	$85.00
	top right	$75.00
	bottom right	$50.00
83	top left	$75.00
	bottom left	$60.00
	top center	$55.00
	bottom center	$75.00
	top right	$25.00
	bottom right	$90.00
84	top left	$75.00
	bottom left	$60.00
	center	$110.00
	top right	$75.00
	bottom right	$55.00
85	top left	$50.00
	bottom left	$70.00
	top center	$70.00
	bottom center	$40.00
	top right	$80.00
	bottom right	$110.00
86	top left	$70.00
	bottom left	$50.00
	top center	$85.00
	bottom center	$60.00
	top right	$50.00
	bottom right	$85.00
87	top left	$45.00
	bottom left	$40.00
	top center	$35.00
	bottom center	$135.00
	top right	$50.00
	bottom right	$50.00
88	top left	$60.00
	bottom left	$60.00
	bottom center	$250.00+
	top right	$85.00
	bottom right	$55.00
89	top left	$50.00
	bottom left	$55.00
	top center	$65.00
	bottom center	$70.00
	top right	$75.00
	bottom right	$50.00
90	top left	$75.00
	bottom left	$60.00
	bottom center	$115.00
	top right	$135.00
	bottom right	$65.00
91	top left	$45.00
	bottom left	$85.00
	top center	$55.00
	bottom center	$125.00
	top right	$55.00
	bottom right	$80.00
92	top left	$250.00
	bottom left	$250.00
	top center	$125.00
	bottom center	$400.00
	top right	$250.00
	bottom right	$300.00
93	top left	$55.00
	bottom left	$55.00
	bottom center	$275.00
	top right	$110.00
	bottom right	$25.00
94	top left	$115.00
	bottom left	$65.00
	center	$135.00
	top right	$70.00
	bottom right	$65.00
95	top left	$100.00
	bottom left	$80.00
	bottom center	$145.00
	top right	$60.00
	bottom right	$95.00
96	top left	$70.00
	bottom left	$140.00
	center	$125.00
	top right	$60.00
	bottom right	$85.00
97	top left	$65.00
	bottom left	$60.00
	center	$135.00
	top right	$65.00
	bottom right	$70.00
98	top left	$70.00
	bottom left	$50.00
	bottom center	$85.00
	top right	$70.00
	bottom right	$65.00
99	top left	$75.00
	bottom left	$75.00
	top center	$125.00
	bottom center	$80.00
	top right	$60.00
	bottom right	$55.00
100	top left	$70.00
	bottom left	$80.00
	center	$115.00
	top right	$65.00
	bottom right	$85.00
101	top left	$90.00
	bottom left	$50.00
	top center	$100.00
	bottom center	$85.00
	top right	$150.00
	bottom right	$85.00
102	top left	$55.00
	bottom left	$110.00
	center	$125.00
	top right	$60.00
	bottom right	$110.00
103	top left	$75.00
	bottom left	$70.00
	center	$110.00
	to right	$55.00
	bottom right	$70.00
104	top left	$55.00
	bottom left	$60.00
	center	$135.00
	top right	$65.00
	bottom right	$70.00
105	top left	$60.00
	bottom left	$65.00
	center	$125.00
	top right	$55.00
	bottom right	$65.00
106	top left	$70.00
	bottom left	$70.00

Page	Location	Value	Page	Location	Value	Page	Location	Value
	bottom center	$125.00	119	top left	$65.00		bottom right	$75.00
	top right	$85.00		bottom left	$60.00	132	top left	$65.00
	bottom right	$75.00		bottom center	$75.00		bottom left	$45.00
107	top left	$65.00		top right	$65.00		center	$75.00
	bottom left	$60.00		bottom right	$65.00		top right	$125.00
	top center	$200.00	120	top left	$70.00		bottom right	$135.00
	bottom center	$65.00		bottom left	$60.00	133	top left	$85.00
	top right	$50.00		top center	$35.00		bottom left	$80.00
	bottom right	$60.00		bottom center	$55.00		*top center	$125.00
108	top left	$60.00		top right	$45.00		bottom center	$140.00
	bottom left	$75.00		bottom right	$75.00		top right	$85.00
	center	$150.00	121	top left	$55.00		bottom right	$95.00
	top right	$90.00		bottom left	$70.00	134	top left	$60.00
	bottom right	$100.00		center	$95.00		bottom left	$85.00
109	top left	$95.00		top right	$125.00		top center	$85.00
	bottom left	$85.00		bottom right	$65.00		top right	$45.00
	center	$85.00	122	top left	$85.00		center right	$75.00
	top right	$65.00		bottom left	$60.00		bottom right	$75.00
	bottom right	$85.00		center	$135.00	135	top left	$55.00
110	top left	$55.00		top right	$65.00		bottom left	$75.00
	bottom left	$65.00		bottom right	$65.00		center	$120.00
	top center	$45.00	123	top left	$45.00		top right	$75.00
	bottom center	$110.00		bottom left	$55.00		bottom right	$65.00
	top right	$85.00		top center	$50.00	136	top left	$55.00
	bottom right	$55.00		bottom center	$85.00		bottom left	$60.00
111	top left	$55.00		top right	$55.00		center	$95.00
	bottom left	$55.00		bottom right	$55.00		top right	$55.00
	center	$125.00	124	top left	$50.00		bottom right	$65.00
	top right	$85.00		bottom left	$125.00	137	top left	$65.00
	bottom right	$65.00		center	$95.00		bottom left	$75.00
112	top left	$55.00		top right	$65.00		top center	$65.00
	bottom left	$75.00		bottom right	$55.00		bottom center	$110.00
	top center	$70.00	125	top left	$60.00		top right	$60.00
	bottom center	$125.00		bottom left	$55.00		bottom right	$60.00
	top right	$60.00		top center	$65.00	138	top left	$105.00
	bottom right	$60.00		bottom center	$125.00		bottom left	$65.00
113	top left	$95.00		top right	$60.00		top center	$85.00
	bottom left	$110.00		bottom right	$75.00		top right	$65.00
	center	$145.00	126	top left	$55.00		bottom right	$75.00
	top right	$75.00		bottom left	$75.00	139	top left	$65.00
	bottom right	$85.00		top center	$60.00		center left	$50.00
114	top left	$55.00		bottom center	$125.00		bottom left	$65.00
	bottom left	$125.00		top right	$55.00		top center	$45.00
	top center	$60.00		bottom right	$55.00		bottom center	$75.00
	bottom center	$65.00	127	top left	$125.00		top right	$65.00
	top right	$55.00		bottom left	$65.00		center right	$50.00
	bottom right	$65.00		top center	$125.00		bottom right	$70.00
115	top left	$80.00		bottom center	$135.00	140	top left	$135.00
	bottom left	$70.00		top right	$60.00		bottom left	$45.00
	center	$95.00		bottom right	$55.00		center	$75.00
	top right	$55.00	128	top left	$125.00		top right	$135.00
	bottom right	$95.00		bottom left	$50.00		bottom right	$50.00
116	top left	$55.00		center	$125.00	141	top left	$75.00
	bottom left	$95.00		top right	$85.00		bottom left	$60.00
	center	$95.00		bottom right	$25.00		center	$125.00
	top right	$55.00	129	top left	$65.00		top right	$135.00
	bottom right	$85.00		bottom left	$75.00		bottom right	$65.00
117	top left	$60.00		top right	$125.00	142	top left	$100.00
	bottom left	$95.00		bottom right	$75.00		bottom left	$125.00
	top center	$50.00	130	top left	$65.00		top center	$125.00
	bottom center	$95.00		bottom left	$65.00		bottom center	$65.00
	top right	$55.00		center	$60.00		top right	$110.00
	bottom right	$95.00		top right	$55.00		bottom right	$110.00
118	top left	$60.00		bottom right	$65.00	143	top left	$80.00
	bottom left	$70.00	131	top left	$70.00		bottom left	$75.00
	center	$125.00		bottom left	$65.00		top center	$85.00
	top right	$55.00		center	$85.00		bottom center	$95.00
	bottom right	$75.00		top right	$70.00		top right	$65.00

* Add gold content at current market value.

Page	Location	Value
	bottom right	$90.00
144	top left	$110.00
	bottom left	$60.00
	top center	$135.00
	bottom center	$65.00
	top right	$70.00
	bottom right	$65.00
145	top left	$125.00
	bottom left	$70.00
	top center	$65.00
	bottom center	$150.00
	top right	$75.00
	bottom right	$135.00
146	top left	$75.00
	bottom left	$95.00
	top center	$135.00
	bottom center	$55.00
	top right	$75.00
	bottom right	$75.00
147	top left	$75.00
	bottom left	$85.00
	center	$60.00
	top right	$75.00
	bottom right	$145.00
148	top left	$110.00
	bottom left	$95.00
	center	$125.00
	top right	$120.00
	bottom right	$95.00
149	top left	$70.00
	bottom left	$85.00
	top center	$125.00
	bottom center	$125.00
	top right	$75.00
	bottom right	$110.00
150	top left	$60.00
	bottom left	$65.00
	top center	$135.00
	bottom center	$125.00
	top right	$75.00
	bottom right	$60.00
151	top left	$80.00
	bottom left	$85.00
	top center	$65.00
	bottom center	$135.00
	top right	$125.00
	bottom right	$85.00
152	top left	$75.00
	bottom left	$125.00
	top center	$125.00
	bottom center	$120.00
	top right	$80.00
	bottom right	$110.00
153	top left	$85.00
	bottom left	$65.00
	top center	$85.00
	bottom center	$85.00
	top right	$70.00
	bottom right	$65.00
154	top left	$65.00
	bottom left	$85.00
	top center	$85.00
	bottom center	$85.00
	top right	$60.00
	bottom right	$65.00
155	top left	$85.00
	bottom left	$75.00
	top center	$110.00
	bottom center	$55.00
	top right	$75.00
	bottom right	$85.00
156	top left	$85.00
	bottom left	$95.00
	top center	$135.00
	bottom center	$65.00
	top right	$75.00
	bottom right	$75.00
157	top left	$70.00
	bottom left	$70.00
	top center	$85.00
	bottom center	$75.00
	top right	$75.00
	bottom right	$70.00
158	top left	$65.00
	bottom left	$70.00
	top center	$115.00
	bottom center	$110.00
	top right	$85.00
	bottom right	$110.00
159	top left	$70.00
	bottom left	$75.00
	top center	$35.00
	center	$35.00
	bottom center	$80.00
	top right	$70.00
	bottom right	$70.00
160	top left	$75.00
	bottom left	$65.00
	top center	$125.00
	bottom center	$75.00
	top right	$70.00
	bottom right	$65.00
161	top left	$60.00
	bottom left	$115.00
	top center	$90.00
	bottom center	$90.00
	top right	$70.00
	bottom right	$75.00
162	top left	$90.00
	bottom left	$85.00
	top center	$125.00
	bottom center	$45.00
	top right	$100.00
	bottom right	$65.00
163	top left	$60.00
	bottom left	$65.00
	top center	$75.00
	bottom center	$45.00
	top right	$55.00
	bottom right	$70.00
164	top left	$135.00
	bottom left	$100.00
	top center	$80.00
	bottom center	$75.00
	top right	$80.00
	bottom right	$400.00
165	left	$50.00
	top right	$90.00
	bottom right	$110.00
166	left	$85.00
	right	$85.00
167	top left	$45.00
	bottom left	$135.00
	top center	$125.00
	bottom center	$125.00
	top right	$120.00
	bottom right	$75.00
168	top left	$75.00
	bottom left	$125.00
	center	$85.00
	top right	$75.00
	bottom right	$120.00
169	top left	$75.00
	bottom left	$70.00
	top center	$70.00
	bottom center	$85.00
	top right	$75.00
	bottom right	$55.00
170	top left	$115.00
	bottom left	$90.00
	top center	$95.00
	bottom center	$110.00
	top right	$110.00
	bottom right	$75.00
171	top left	$80.00
	bottom left	$60.00
	top center	$80.00
	bottom center	$70.00
	top right	$85.00
	bottom right	$65.00
172	top left	$115.00
	bottom left	$65.00
	top center	$40.00
	bottom center	$45.00
	top right	$90.00
	bottom right	$75.00
173	top left	$90.00
	bottom left	$85.00
	top center	$115.00
	bottom center	$125.00
	top right	$110.00
	bottom right	$75.00
174	top left	$145.00
	bottom left	$115.00
	top center	$125.00
	bottom center	$125.00
	top right	$135.00
	bottom right	$100.00
175	top left	$85.00
	bottom left	$85.00
	top center	$125.00
	bottom center	$80.00
	top right	$115.00
	bottom right	$85.00
176	top left	$85.00
	bottom left	$65.00
	top center	$95.00
	center	$55.00
	bottom center	$75.00
	top right	$85.00
	bottom right	$75.00
177	top left	$65.00
	bottom left	$65.00
	top center	$65.00
	bottom center	$95.00
	top right	$65.00
	bottom right	$65.00
178	top left	$75.00
	bottom left	$65.00
	top center	$70.00
	bottom center	$75.00
	top right	$65.00
	bottom right	$75.00
179	top left	$75.00

Page	Location	Value	Page	Location	Value		Location	Value
	bottom left	$75.00	185	top left	$55.00		2.	$20.00
	top center	$85.00		bottom left	$65.00		3.	$30.00
	bottom center	$85.00		center	$75.00		4.	$5.00
	top right	$65.00		bottom center	$45.00		5.	$5.00
	bottom right	$65.00		top right	$65.00		6.	$45.00
180	top left	$85.00		bottom right	$50.00		center row	
	bottom left	$75.00	186	left	$150.00		7.	$15.00
	center	$120.00		right	$250.00		8.	$25.00
	top right	$75.00	187	top left	$200.00		9.	$50.00
	bottom right	$125.00		bottom center	$200.00		bottom row	
181	top left	$75.00		top right	$225.00		10.	$30.00
	bottom left	$75.00	188	top left	$85.00		11.	$35.00
	top center	$85.00		bottom left	$225.00		12.	$25.00
	bottom center	$85.00		top right	$110.00		13.	$50.00
	top right	$75.00		bottom right	$175.00		14.	$20.00
	bottom right	$75.00	189	top left	$85.00		15	$50.00
182	top left	$135.00		bottom left	$65.00	195	left	$275.00
	bottom left	$80.00		top right	$75.00		right	$200.00
	top center	$75.00		bottom right	$95.00	196	top left	$75.00
	bottom center	$75.00	190	coin purse	$400.00		bottom left	$75.00
	top right	$125.00		jeweled	No Price Available		top right	$65.00
	bottom right	$95.00	191	top left	$50.00		bottom right	$75.00
183	top left	$135.00		bottom left	$65.00	197	left	$85.00
	bottom left	$95.00		top right	$85.00		right	$75.00
	top center	$135.00		bottom right	$10.00	198	left	$75.00
	bottom center	$95.00	192	top left	$85.00		top right	$65.00
	top right	$135.00		bottom left	$85.00		bottom right	$75.00
	bottom right	$95.00		right center	$165.00	199	top left	$55.00
184	top left	$125.00	193	top left	$75.00		bottom left	$75.00
	bottom left	$125.00		bottom left	$75.00		top right	$75.00
	top center	$145.00		top right	$50.00		bottom right	$55.00
	bottom center	$125.00		bottom right	$50.00	200		$450.00
	top right	$125.00	194	top row		201		No Price Available
	bottom right	$115.00		1.	$35.00	202		$850.00

Purse values for the most part are based on purchases and prices noted in the Midwest and Southeastern United States. Keep in mind that prices run generally higher on both the east and west coast, especially in California. Another exception to the rule, finer antique shows which usually show only the nicer purses are higher on comparable merchandise than flea-markets, antique shops, etc. Sterling or solid gold bags and frames will fluctuate when the current price of silver or gold changes.

Values established on purses are based on exampls in excellent or better condition.

Bibliography

Buck, Anne *Victorian and Costume Accessories*, Thomas Nelson & Sons, Nashville, Tennessee, 1961.

Lester & Oerke *Accessories of Dress*, The Pantagraph Printing & Stationery Co., Bloomington, IL, 1941.

Mebane, John *The Poor Man's Guide to Trivia Collecting*, Doubleday, Garden City, NJ, 1975.

Schroeder's Antiques Price Guide

Schroeder's Antiques Price Guide has become THE household name in the antiques & collectibles industry. Our team of editors work year around with more than 200 contributors to bring you our #1 best-selling book on antiques & collectibles.

With more than 50,000 items identified & priced, *Schroeder's* is a must for the collector & dealer alike. If it merits the interest of today's collector, you'll find it in *Schroeder's.* Each subject is represented with histories and background information. In addition, hundreds of sharp original photos are used each year to illustrate not only the rare and unusual, but the everyday "fun-type" collectibles as well -- not postage stamp pictures, but large close-up shots that show important details clearly.

Our editors compile a new book each year. Never do we merely change prices. Accuracy is our primary aim. Prices are gathered over the entire year previous to publication, from ads and personal contacts. Then each category is thoroughly checked to spot inconsistencies, listings that may not be entirely reflective of actual market dealings, and lines too vague to be of merit. Only the best of the lot remains for publication. You'll find *Schroeder's Antiques Price Guide* the one to buy for factual information and quality.

No dealer, collector or investor can afford not to own this book. It is available from your favorite bookseller or antiques dealer at the low price of $12.95. If you are unable to find this price guide in your area, it's available from Collector Books, P.O. Box 3009, Paducah, KY 42001 at $12.95 plus $2.00 for postage and handling.

8½ x 11", 608 Pages **$12.95**

COLLECTOR BOOKS
A Division of Schroeder Publishing Co., Inc.